# Light on the Water

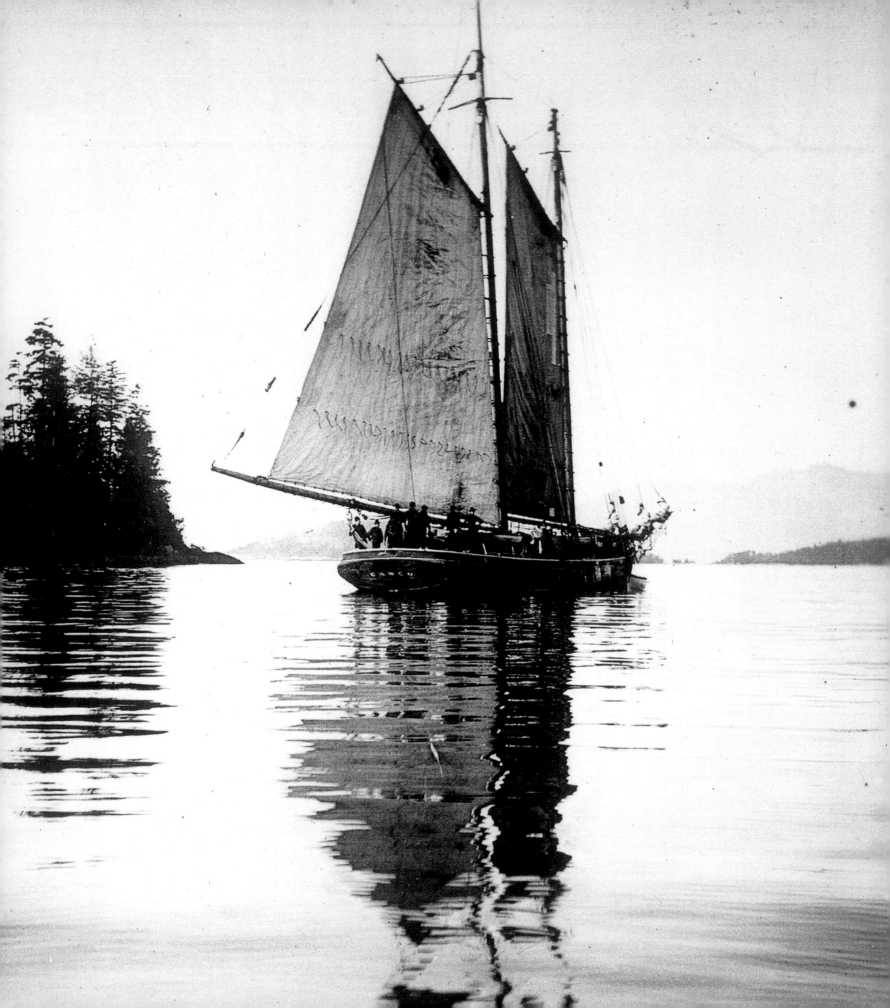

# Light on the Water

## EARLY PHOTOGRAPHY OF COASTAL BRITISH COLUMBIA

### KEITH McLAREN

Douglas & McIntyre
Vancouver/Toronto

University of Washington Press
Seattle

(*Frontispiece*) **Sealing schooner** *Casco*, **c. 1910.**
**Photographer: Unknown**
Originally built for a wealthy San Francisco physi-
cian, the *Casco* was designed for luxury. She sailed
the waters off California until 1888, when Robert
Louis Stevenson, during the last years of his life,
chartered her to cruise the South Seas. The vessel
was then auctioned off to a Victoria sealing syndicate
and, in spite of the original intentions of her
builder, quickly gained a reputation as a swift sturdy
sailer, fit for the rough trade of the North Pacific. In
1898, she was used for smuggling and halibut fishing
and, at the beginning of the First World War,
worked out of Coal Harbour in Vancouver as a
training vessel for sea cadets. In 1919, the *Casco*
headed north once again to the Bering Sea in search
of gold. Shortly after, her long and varied career
ended when she was shipwrecked off King Island.
BRITISH COLUMBIA ARCHIVES A-07163

Copyright © 1998 by Keith McLaren

98 99 00 01 02   5 4 3 2 1

Douglas & McIntyre Ltd.
1615 Venables Street
Vancouver, British Columbia V5L 2H1

CANADIAN CATALOGUING IN PUBLICATION DATA
McLaren, R. Keith, 1950–
    Light on the water
    ISBN 1-55054-658-9
    1. Pacific Coast (B.C.)—History—Pictorial
works. 2. Photography—British Columbia—Pacific
Coast—History. I. Title.
FC3812.M362 1998    779.9'99711103    C98-910553-9
F1087.8.M362 1998

Originated in Canada by Douglas & McIntyre and published
in the United States of America by the University of
Washington Press, P.O. Box 50096, Seattle, WA 98145-5096

LIBRARY OF CONGRESS CATALOGING-IN-PUBLICATION DATA
McLaren, R. Keith, 1950–
    Light on the water : early photography of coastal
British Columbia / Keith McLaren
    p.    cm.
    Includes bibliographical references.
    ISBN 0-295-97748-5 (acid-free paper)
    1. Pacific Coast (B.C.)—Pictorial works. 2. Seafaring
life—British Columbia—Pacific Coast—Pictorial
works. I. Title.
F1089.P2M35   1998                            98-25896
917.11'0964 DC21                                  CIP

Editing by Saeko Usukawa
Design by Val Speidel
Front jacket photo of Victoria harbour, c. 1900, photog-
    rapher unknown, BRITISH COLUMBIA ARCHIVES
    G-01111; back jacket photo of Betty Brown at the launch
    of the *Mabel Brown*, North Vancouver, 1917, Dominion
    Photo Company, VANCOUVER PUBLIC LIBRARY 20099.
Printed and bound in Singapore by C.S. Graphics Pte. Ltd.
Printed on acid-free paper ∞

The publisher gratefully acknowledges the support of the
Canada Council for the Arts and of the British Columbia
Ministry of Tourism, Small Business and Culture. We
acknowledge the financial support of the Government of
Canada through the Book Publishing Industry Development
Program for our publishing activities.

To Judy, Kate and Alex

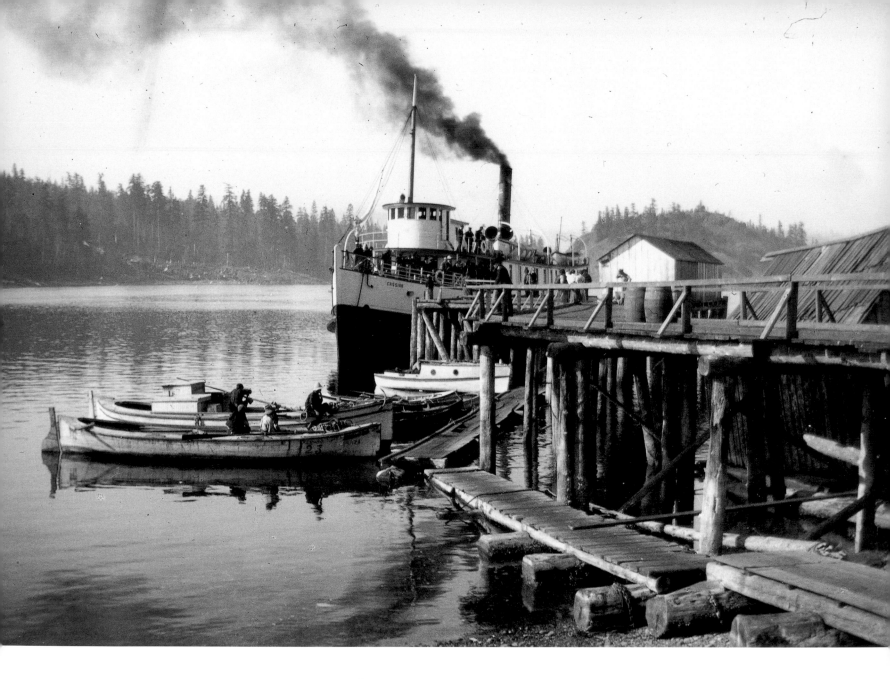

**Steamship *Cassiar*, n.d. Photographer: Unknown**
The *Cassiar* joined the Union Steamship Company of B.C. fleet in 1901 and made regular voyages into what was known as "the jungles," the upcoast inlets. Often the only link with the outside world, she delivered crews to camps in some of the most remote regions of the coast. On the *Cassiar*, affectionately dubbed the "loggers' palace," returning workers felt completely at home, drinking and carousing and even wearing their studded caulk boots to bed if they pleased. They were treated graciously by the ship's stewards, who had been directed by the company to treat all passengers as if they were royalty. The little ship was quirky to pilot and not exactly handsome to look at, but she served Union Steamship and her customers well. She had made over 1,700 voyages by the time she was ready to retire in 1923. VANCOUVER PUBLIC LIBRARY 35404

**Propeller of the *Empress of Japan* (II), c. 1930.**
**Photographer: Carey and McCallister**
One of the two propellers of the steamship *Empress of Japan* towers above workers in dry-dock. The bronze blades have been covered with canvas cloth bags to protect the polished surface from sandblasting grit and paint. The second Empress liner to be given that name, the ship was powered by six turbine engines, fed by six Yarrow-type oil-fired boilers. The main engines operated at almost 1,500 revolutions per minute and the shaft speed, after being reduced by gearing, was 120 rpm. In her initial sea trials, the *Empress of Japan* easily attained 23 knots. BRITISH COLUMBIA ARCHIVES A-00576

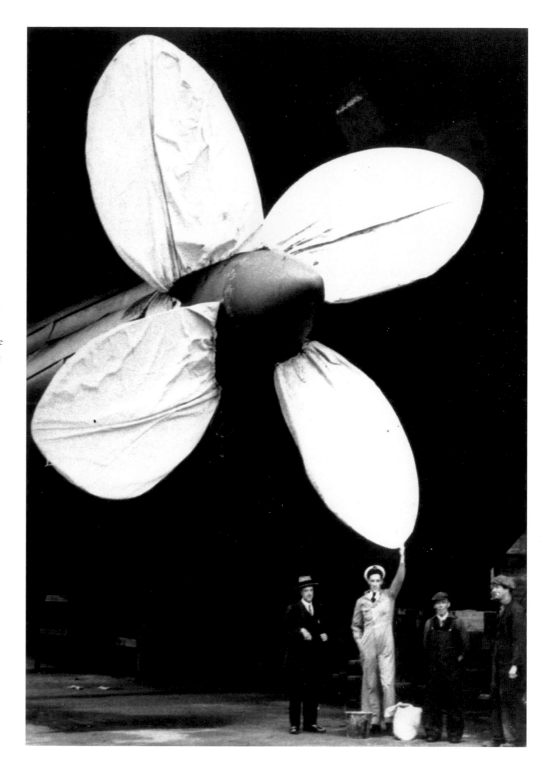

*T*HE INSPIRATION FOR this book came during an exploration of the British Columbia Archives. At the time, I was searching for early images of commercial shipping in the province. However, as the collection became familiar to me, I was struck by the great number of crisp and wonderfully detailed photographs of our maritime past that, to a large extent, were little known to the general public. I expanded my search to include all things of a maritime nature and ventured into other collections, both public and private. The organic nature of these collections became readily apparent. Constantly fed by generous donations of treasures discovered in basements and attics, they are in a state of flux, kept organized and controlled by dedicated archivists, professional and volunteer. A tribute must be paid to these guardians of our past, whose diligence and hard work, as well as obvious love of history, will ensure the passage of these collections to future generations. Without their help and enthusiasm for this project, my task would have been so much more difficult.

This book is not meant to be an illustrated maritime history of British Columbia, but rather a collection of photographs that belong to a common location and time: the British Columbia coast from the late 1850s to the 1940s. The history that accompanies the photographs is there to illuminate them and place them in context. So often, archival photographs are regarded as secondary to the text and reproduced with little expense and care. Because the best reproductive technology has been used, the viewer of this book is given the opportunity to appreciate the aesthetic value of each photograph and to explore its detail. As windows to our past, these images are valuable and accurate accounts of some of the ships, industries and people who depended on the sea for their way of life.

The photographs in this book represent the rich and diverse holdings of our public and private institutions. My criteria for inclusion were simple: first, the quality of

the image must be superb; and second, the photograph must have a clarity of vision and purpose. The task of selection, however, was anything but simple. Long hours have been spent over the past six years, scouring photographic collections. Occasionally frustrating, sometimes fruitless, the search was most often rewarding and even exciting, as when a "new" image turned up, something perhaps unseen for half a century or more. As word of my purpose spread, many families lent me their own albums, for which I am very grateful. The number of "qualifying" photographs grew, so that reducing the number to a manageable size became more and more difficult. Ultimately, the choice had to be personal and was limited by the constraints of time and travel. As so many of the photographs exist in negative form only and as the collections are never finite, to see all of them would have been an impossibility. Wherever I could, I have tried to use a "fresh" image, but if the reader recognizes some of the photographs, it is because these images are of such high quality and universal appeal that to omit them would have been negligent. Many fine photographs could not be included, and I encourage all those who might be inspired by this book to continue the exploration of our archives and other collections and to keep interest in our history alive.

ACKNOWLEDGEMENTS

*I* WOULD LIKE to thank the following people and institutions for their assistance in the creation of this book: Jim Delgado, Leonard McCann, Joan Thornley, Rachel Grant and the "Tuesday morning crowd" of the Vancouver Maritime Museum; Guy Matthias and Lynn Wright of the Maritime Museum of British Columbia; Susan Camilleri Konar of Special Collections, Vancouver Public Library; Kelly Nolan, Leni Hoover and David Mattison of the British Columbia Archives; Carey Pallister of the City of Victoria Archives. In addition, I thank the staffs of those institutions, as well as those of the following: the Royal British Columbia Museum, City of Vancouver Archives, Jewish Historical Society, North Vancouver Museum and Archives, Alberni Valley Museum, Courtenay and District Museum, Campbell River and District Museum and Archives, CFB Esquimalt Naval and Military Museum, Chemainus Valley Historical Society and the Victoria Public Library.

I extend my gratitude to David Matheson and David Demberoski for their legal advice.

I owe a huge debt to Scott McIntyre, who gave me the opportunity to produce this book and who understood that extraordinary archival photographs must be reproduced using the best available technology in order to be fully appreciated. Saeko Usukawa, Douglas & McIntyre's editorial director, has always been there to answer questions, offer encouragement and guide with a gentle hand.

Many others have given their time, insights and advice. Charles Kahn and Judy Norget have given both moral support and literary advice. Most of all, I thank my wife, Judy, for her patience, dedication and countless hours of assistance in the creation of this manuscript.

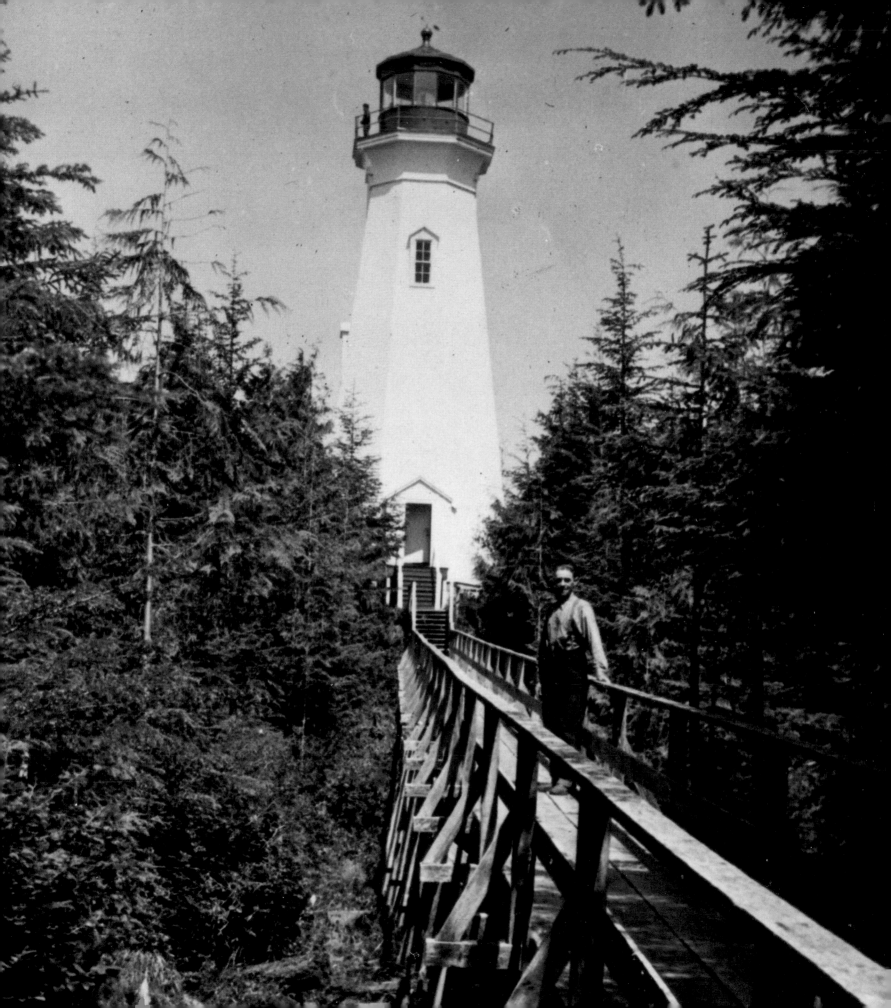

# *Early Photographers on the B.C. Coast*

$F$EW AMONG US can resist a view of a harbour, full of tall-rigged sailing ships and busy with commerce, or a dramatic vista of a wave-tossed shore. These romantic images are often at odds with the harsh reality of life but were as appealing in the past as they are now to those artists, painters and photographers who attempt to capture them on canvas and in print. The early photographers who arrived on the coast felt similarly compelled to document life on the foreshore of the new colony. The sea offered Europeans what it had generations of the Native populace: sustenance, resources and a means of transport. It was, in fact, the dominant influence on the lives of the early settlers and justifiably a favourite subject for the camera. We are fortunate that the art of photography developed concurrently with European settlement on this coast and that part of our history is so vividly documented.

The photograph was also the perfect medium through which to disseminate the benefits of industrial growth and territorial expansion in the late Victorian age. On these and other shores, it was used to evoke the promise of new discoveries and the prosperity that resulted from increased growth and trade. The seemingly inexhaustible supply of fish and timber, the might of the Royal Navy and the exotic qualities of the Native inhabitants were all captured for the "home" market. Industry also took advantage of the new technology. Shipyard owners required visual records to document the size and scope of their operations while proud ship owners demanded portraits of their new acquisitions. During the years of the Fraser River gold rush, the newly and often temporarily wealthy miners acquired proofs of their good fortune. The families and individuals who settled on the British Columbia coast, venturing so far from "civilization," demonstrated, with sombre faces against painted backdrops, that Victorian gentility and propriety had not been left behind.

By the time the west coast of Canada was settled, the photographic process had

**Lawyer Island Light, Chatham Sound, c. 1930. Photographer: Unknown**
The Klondike gold rush of 1898 increased marine traffic on the Inside Passage to such an extent that the Canadian government was compelled to build a series of new lighthouses to protect shipping. Lawyer Island Light was constructed in 1901 and was situated south of Prince Rupert at the bottom end of Chatham Sound. E. DAHLGREN COLLECTION

13

evolved considerably since its invention by Louis Daguerre in 1839. Cameras were still heavy boxes placed on tripods that gave them the stability needed for long exposure times. Photographs, however, were no longer tiny, singular images developed directly onto tin plates; they were printed onto paper from plate glass negatives and could be easily duplicated. The photographs then produced were the crisp, detailed, large-format images which we associate with early black-and-white photography.

Until the 1870s, the photographic process involved a complex and messy chemical procedure. A sticky solution of light-sensitive material called collodion was evenly poured over a heavy and highly polished glass plate, which was then placed in the back of the camera. While the collodion was still moist, the plate was exposed by removing the lens cap and then immediately developed in a studio or portable darkroom. The bulk and the weight of the equipment, as well as the time spent in the preparation and development of the plates, restricted the options of the photographer. The many seconds needed for exposure meant that even the slightest movement of the subject or camera would result in a blurred image. For this reason, in portraiture, a subject's head was often fixed in a sort of vice, and maritime subjects were generally photographed during calm weather and from land, the photo by Lieutenant Roche on the deck of HMS *Satellite* being a rare exception. Considering that the photographer would have to carry glass plates, bottles of chemicals, a portable darkroom, a large wooden-box camera and tripod, and have access to quantities of clean, fresh water, it is amazing that early photographs exist in such numbers.

The development of the dry plate in the early 1870s marked a turning point in photography. The light-sensitive emulsions required a shorter exposure time and, being dry, could be prepared in advance. Moreover, as the negatives could be developed back in the studio, the only equipment the photographer had to carry was the camera, tripod and boxes of plates. For the first time, movement could be frozen, and photographers, allowed more freedom and intimacy by these advances, could capture the image of a ship underway, a bird in flight, a rolling sea or a fleeting smile. Further improvements were made in 1888, when George Eastman produced a smaller, lighter camera containing a roll of film that, after exposure, could be returned to the factory for developing and printing. By the turn of the century, hundreds of amateurs were using this simple and inexpensive instrument to take candid and spontaneous photographs.

The photographers who landed on the shores of British Columbia were as diverse and varied a group as was the rest of the population. With some, the interest in the art

lasted only as long as the economic opportunity, while others set up shop and prepared for a long-term commitment. Visitors and travelling professionals brought a worldly perspective to images of the coast and served the small communities that were unable to support full-time photographers. Despite the fluctuating domestic market and often cutthroat competition between studios, photographers left their mark on almost every household. Landscapes and seascapes were sold as souvenirs, and the market for portraits experienced continuous growth.

One of the first photographers to capture maritime images on the coast was a young officer in the Royal Navy by the name of Richard Roche. He arrived in 1858 on board HMS *Satellite*, a ship that had been sent out from England to help establish the boundaries of Britain's new possession. He brought with him his photographic equipment and his knowledge of the collodion process. The uneven quality of this photograph, showing the ship's gundeck, indicates that the emulsion was improperly applied. However, as one of the earliest records of life on board a Royal Navy ship on the west coast, it is a valuable example of what the enthusiastic and adventurous amateur could produce. During his tour of duty, from 1858 to 1860, Roche took a number of photographs of Esquimalt, Victoria and the British garrison on San Juan Island.

By contrast, the British couple Hannah and Richard Maynard came to the coast under quite different circumstances. They had originally settled in Montreal in 1852, but the Fraser River gold rush lured Richard to the west in 1858, and when he returned to retrieve his wife, he found that she had taken up photography. In 1862, they settled in Victoria, where Hannah opened up a studio. Eventually, Richard also became involved in photography, and, over the next fifty years, both Maynards produced a large volume of work. Richard's talent in wildlife and landscape led him to become an official photographer on government expeditions around Vancouver Island and the Queen Charlottes, while Hannah, although attracted to the possibilities of landscape, preferred studio work and became a successful portraitist. Her constant experiments with the new medium, in collage and photo montage, reveal an eccentric and humorous spirit that has greatly enriched British Columbia's photographic legacy.

Frederick Dally's serious involvement in photography lasted only four years. He ran a dry goods store in Victoria in the early 1860s, began photography in 1866 and left Victoria to study dentistry in the United States in 1870. His obvious affection for the maritime image is evident in his many "on the spot" photos of Royal Navy ships and crews in Esquimalt harbour. At his departure, he left many of his glass plates with the

Maynards, who marketed them under their own studio imprint, a common practice at the time and one that has lead to difficulty with authentication in later years.

The completion of the Canadian Pacific Railway and the birth of the city of Vancouver brought Charles S. Bailey to the coast in 1887. One of the earliest permanent photographers in the new boom town, he was the first to bill himself as a marine specialist, producing many images of the interiors and exteriors of ships visiting Vancouver harbour. He was clearly aware of his position as a witness to history, and whenever any significant event occurred, he and his camera were there to record it. In 1896, his death at the age of twenty-seven cut short a brief but prolific career.

One of the true photographic giants of the west coast was Leonard Frank. Arriving in the small community of Alberni on Vancouver Island in 1898, he quickly established a reputation as a superb, versatile photographer, one of the first in the region. He frequently explored the remote areas on Vancouver Island's coast, photographing Native people, whaling ships, surveyors, miners, loggers and any other subject of interest. He moved to Vancouver in 1917 and continued working until his death in 1944. Always in demand as a commercial photographer specializing in industrial work, he also documented the growth of the city and the workings of its harbour, and did so with constant consideration of aesthetic qualities, leaving as his legacy an important and powerful body of work.

Some of the most beautiful maritime images of the west coast in the last century were taken by William McFarlane Notman. The son of the famed Montreal photographer, he visited the coast on several occasions during the 1880s and 1890s. His scenes of harbours and ships, richly textured and atmospheric, are so beautifully composed that they appear to have been arranged for the camera. Intended for sale in the east, these photographs set the standard for those wishing to supply that market in the future.

Like Lieutenant Roche, many of those who left us these valuable early images belonged to the ranks of the amateur. Bert Howell was one who took advantage of the new accessibility of the camera at the turn of the century. Employed as an electrician in Victoria in 1889, he learned the art from his sister and produced detailed views of Victoria and Esquimalt harbours. Another amateur, who had the right equipment at the right time, stood on the heaving deck of the *Princess Maquinna* in 1915 as the *Carelmapu*, a short distance away, was torn apart by a vicious storm and sank beneath the waves. The heart-wrenching photograph taken by W. N. Kelly later appeared on the front pages of local newspapers, dramatically illustrating the horror of the disaster. As

is the case with many early photographers, little is known about him and no other works are identified as being his. Over half of the photographs contained in this volume cannot, unfortunately, be attributed at all. The unknown photographers behind these images have left no clue to their identities but the scenes they once viewed through a camera lens.

Before the turn of the century, more than one hundred photographers, amateur and professional, were working in the province. After the turn of the century, the numbers, particularly in amateur ranks, continued to grow to such an extent that it would be impossible to document or describe them all. The many photographers included in this book, known and unknown, produced an enormous range and variety of images: sailing ships loaded with lumber, a child at a launching, a Japanese fish boat at Steveston, the luxurious interiors of the CPR Empress liners, crowds waving good-bye to the troops as they go off to war. The combination of chance, cameras and the personalities behind them have left us with a wonderfully evocative and detailed record of past activities on the British Columbia coast.

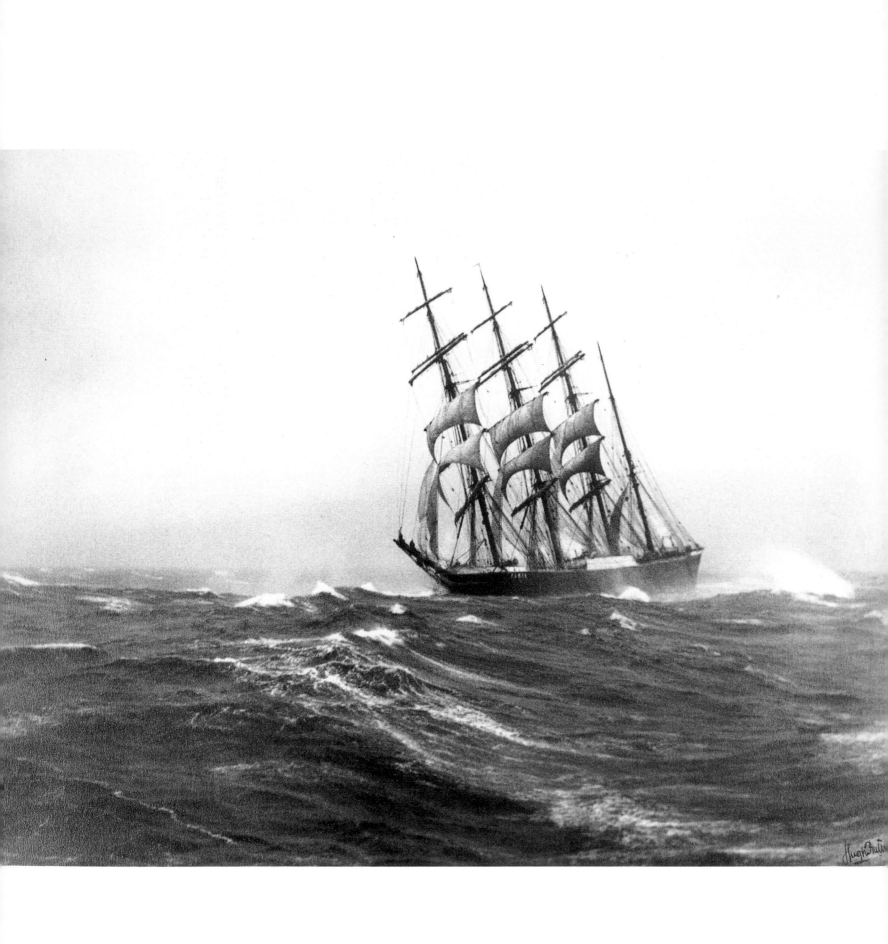

# Days of Sail

In AUGUST 1946, the four-masted barque *Pamir* sailed from Vancouver Island with a cargo of Union Bay coal, bound for Wellington, New Zealand. Shortly before noon and well past Cape Flattery, she let go her towline from the tug *Island Warrior* and, in so doing, took her place in history as the last merchant sailing ship to trade on the west coast of Canada. Her departure marked the passing of the era of shipping under sail, one that had made barques, brigantines and schooners a familiar sight along British Columbia's shores and in its harbours.

At the start of European settlement on the coast, people depended on sailing ships for exploration, transport and trade. The coastline was first charted in the small ships of the British and Spanish navies during the late eighteenth century. Commercial sailing ships arrived on the scene to exploit the riches of the area, trading first in sea otter pelts and then in lumber, coal and fish. As settlement increased and demand from offshore markets grew, mills, mines and canneries became regular destinations for shipping fleets from around the world. Sailing ships dominated trade on the west coast well into the 1880s and frequented British Columbia ports for another fifty years.

Masters of sailing ships were a cautious breed. Navigating from the open ocean to the confines of a coastal shore demanded great skill and courage, and the approaches to the west coast were formidable. The Juan de Fuca Strait, with its rocky outcrops, tidal rips, strong currents, frequent fog and high winds, offered a challenge to the most experienced of deep-sea masters, particularly those on square-rigged ships, which had poor sailing qualities. Yet such ships did sail on these waters for over one hundred years. In the early 1850s, they were assisted by steam-driven tugboats that could tow them into port from the open sea, greatly diminishing the risks of running the strait under sail. Masters making landfall at Cape Flattery, the entrance to the strait, would be on the

**Four-masted barque *Pamir*, Cape Flattery, January 1946. Photographer: Hugh Frith** Laying on her topsails, the New Zealand barque *Pamir* pounds through heavy seas and quickly overhauls her tow, the Island Tug and Barge Company's *Snohomish*. The *Pamir* was almost abeam of the *Snohomish* by the time the towline was slipped free. Snap decisions were required of sailing masters under quickly deteriorating weather conditions. Most preferred to remain under tow until there was plenty of sea room between the ship and a lee shoreline, perhaps as much as 75 miles. The decision to drop a tow close to shore under gale force conditions was not taken lightly. The *Pamir* was a fast sailer and recorded a passage of sixty-five days from Vancouver to Wellington, New Zealand, carrying a cargo of bagged Canadian wheat. VANCOUVER MARITIME MUSEUM 2032

lookout for tugs, but might find themselves waiting for days until one became available, and there were also risks involved in standing off the entrance. Ships were often caught in gales, especially in winter, and driven helplessly onto a hostile lee shore. Since the early nineteenth century, countless lives and hundreds of ships have been lost to the rugged shores and stormy seas of the British Columbia coast.

The types of sailing ships that traded on the coast varied greatly. Large deep-bellied barques competed for space at loading berths with smaller schooners and brigantines. The sizes and shapes and rigs of sailing ships were often dictated by their cargoes and destinations. Large square-riggers, carrying huge amounts of sail that could be adjusted to fit the weather, were best suited for ocean passage. Fore-and-aft rigged schooners and brigantines, which could sail much closer to the wind, were far more nimble than their deep-sea cousins and were most often used in coastal trade, although some did cross the oceans. Ships were often designed to take on and carry specific goods such as tea, lumber, grain or coal. Lumber schooners had cavernous holds and large flat decks to accommodate their enormous loads, while wall-sided barques had deep holds better suited to grain and coal. General cargo vessels, which had 'tween-decks and compartmentalized holds that enabled them to transport a variety of products, were more difficult to load.

Most nations that had a sailing fleet sent them at one time or another to the Pacific Northwest, to ports such as Victoria, Vancouver, Alberni, Nanaimo or Steveston, for coal, salmon or lumber. Some ships entered berths immediately, while others had to sit at anchor, waiting their turn. All the vessels had to make changes to rigging, clear hatches and open ports, as well as discharge ballast rock or sand, before loading could begin. Up to a dozen ships could lie rafted alongside each other, stern or bow to the wharf to allow as many as possible to take on cargo at the same time.

Most goods were stowed by hand by shoreside stevedores, working under the watchful eye of the mate. The process was exacting and time consuming, as each length of timber, sack of coal or grain, or box of canned salmon had to be put in place one at a time until the hold was full, protected from movement by the installation of shifting boards, dunnage and lashings. A poorly loaded cargo could spell disaster for ship and crew, should it begin to shift in rough weather at sea. A minimum of ten days was needed to load an average-sized sailing ship, longer if the vessel was taking on a variety of goods or needed to change berths. A prudent master always inspected his cargo carefully before closing the hatches and putting his ship to sea.

The demise of commercial sailing ships began before the turn of the century, when they were slowly replaced by fleets of the more reliable, if less picturesque, steamers. The spread of railways and the building of the Suez Canal also contributed to the decline of sail, which did not go without a fight. The transitional period saw sailing ships reach their peak in efficiency and design, and at the beginning of the twentieth century, many still worked the shipping lanes. However, the building of new vessels, for the most part, died out. The First World War brought about a short-lived revival for sailing ships and their builders, as losses on the Atlantic left commercial enterprises desperately short of transport vessels. Hundreds of wooden schooners were built, and older square-riggers were refitted and brought back into service. By the 1920s, however, only two major sail shipping lines, one from Germany, the other from Finland, continued in operation. Large square-riggers were seen at sea and in harbours right up to the Second World War, when they all but disappeared from the world's oceans.

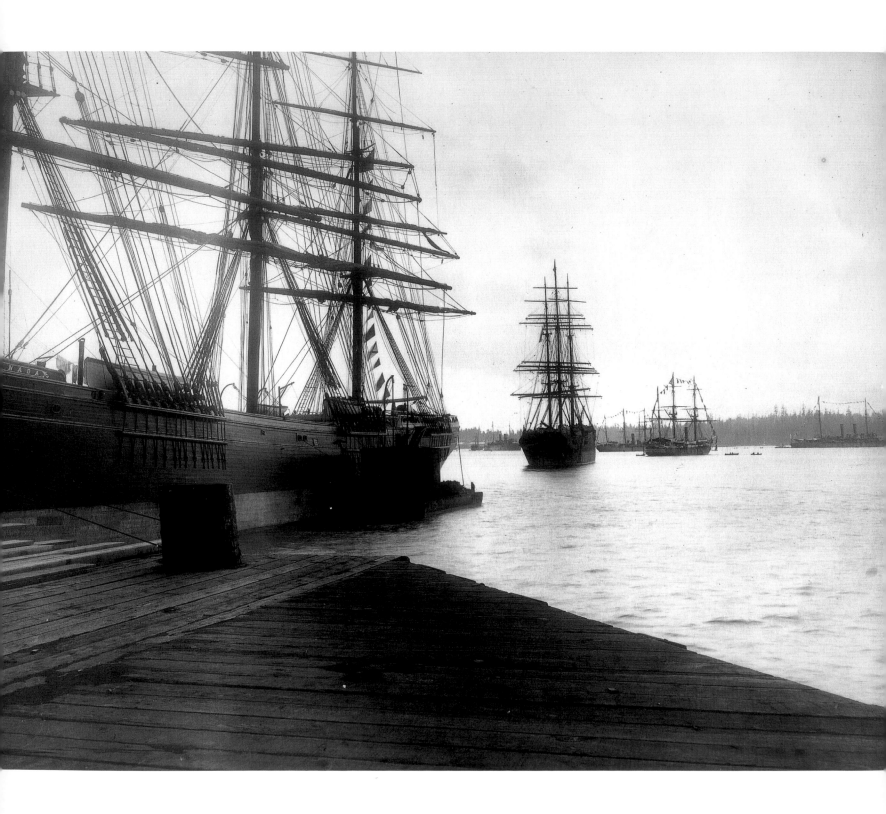

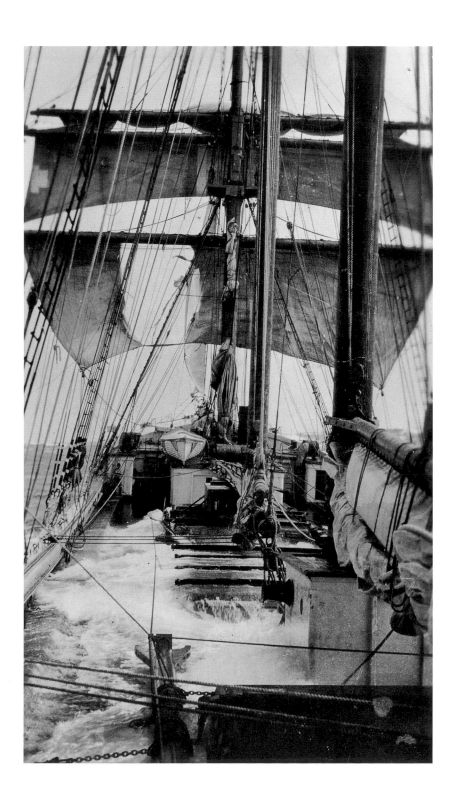

(*Facing page*) **Vancouver harbour, July 1, 1905.**
**Photographer: Unknown**

The scene shows part of the Dominion Day celebrations on July 1, 1905. The Royal Navy's Pacific Squadron sits at anchor in the distance, its ships dressed for the occasion. In the foreground are merchant vessels in Vancouver harbour. The three-masted ship *Canada*, alongside the Hastings Mill wharf, is also flying her signal flags to add colour to the celebration. The *Canada* was built in 1891 in Kingsport, Nova Scotia, and was commanded by Captain C. R. Burgess. She was a general cargo ship typical of the period and is here loading timber.
BRITISH COLUMBIA ARCHIVES A-00357

**Four-masted barquentine *S. F. Tolmie*, 1922.**
**Photographer: Unknown**

Built in 1921 at the Cholberg Shipyard in Victoria, the *S. F. Tolmie* was to be the first of three vessels ordered by Victoria Ship Owners Ltd. As her construction costs greatly exceeded the original estimates, the remaining two orders were cancelled, the frames of the sister ships broken up, and the company forced into bankruptcy. The *S. F. Tolmie* sailed for the Canadian Government Merchant Marine from 1921 to 1923, carrying cargoes to Japan and Australia. While returning from Australia in 1922, the vessel encountered severe weather and was forced into Hawaii to repair heavy damage aloft. The photo, taken by a crew member during the storm, shows the ship's decks awash and a panel blown out of her lower foresail. The ship was later sold to the owners of Hastings Mill in Vancouver and made two more voyages across the Pacific before being converted into a barge. MARITIME MUSEUM OF BRITISH COLUMBIA P986.31.29

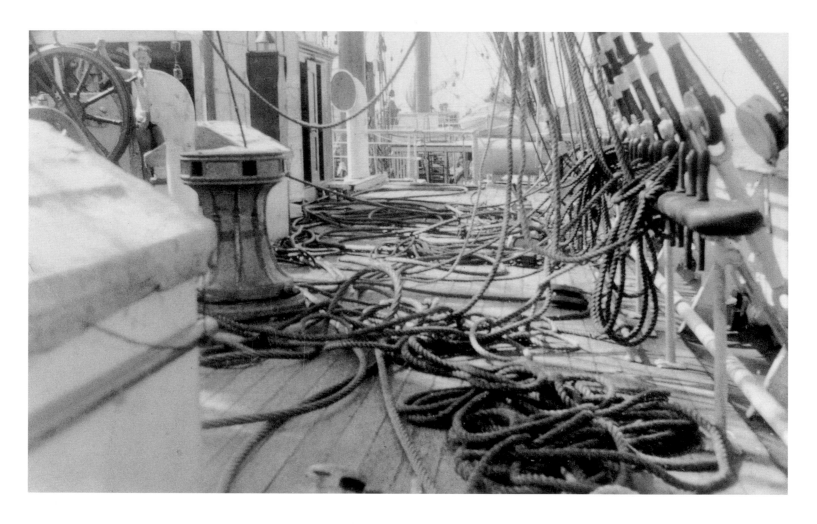

**Four-masted barque *Pamir*, c. 1945.**
**Photographer: Unknown**

These two photographs, taken by an unknown crew member of the barque *Pamir* during one of her last voyages from Vancouver, measure only four by six centimetres. Despite their size, these tiny images, enlarged here, show a surprisingly intimate and detailed view of life aboard a sailing ship at sea. The scene above illustrates the complex and confusing array of lines, sheets, halyards and braces needed to manoeuvre a large square-rigged ship. No mate would allow such chaos for long, and the crew would quickly be at work coiling and stowing these lines in an orderly and efficient manner. The photo on the facing page shows sailors sewing panels of what looks like a new set of sail. As was the custom aboard deepwater ships of the day, dependence on shore-side maintenance was kept to an absolute minimum in order to keep expenses and overhead low, and all aboard were assigned duties in repair and ship's husbandry. Training was given to apprentices in every aspect of the art of seamanship such as steering, maintaining the rigging and working sail aloft. MARITIME MUSEUM OF BRITISH COLUMBIA 990.058.0018/19

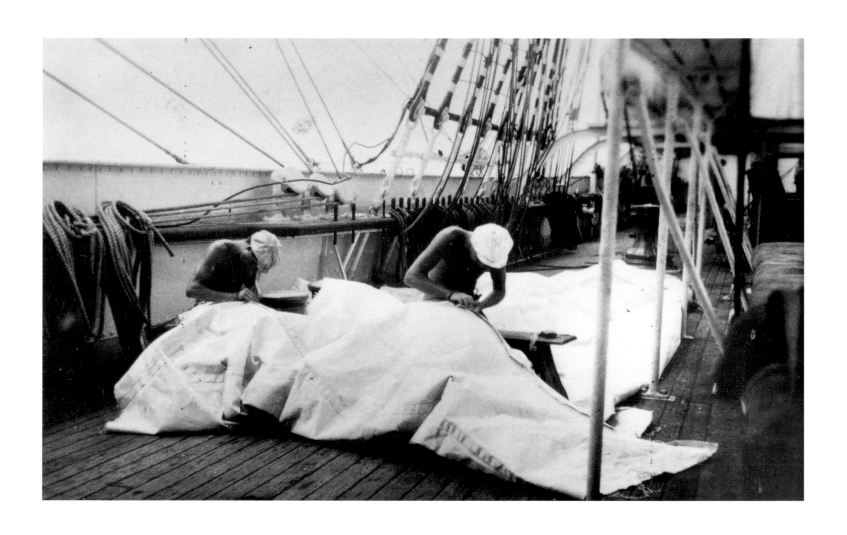

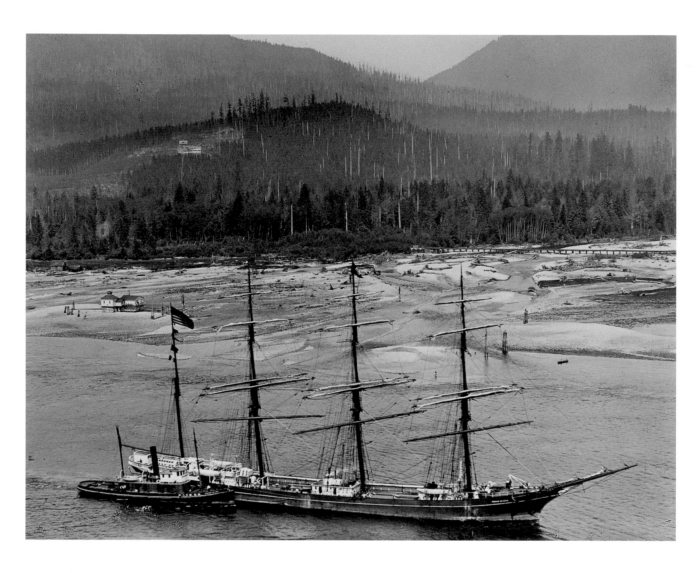

**Four-masted barque** *Annie M. Reid*, **Vancouver, 1920.**
**Photographer: Leonard Frank**
Built in Scotland in 1892 as the *Howard D. Troop* for
Troop and Son of New Brunswick, this vessel soon
gained a reputation as a "flyer." On her maiden
voyage, she boasted a record Atlantic crossing of
fourteen days, beating by one full day the record
held by the American clipper *Andrew Jackson*. In 1912,
the ship was sold to American interests and rechris-
tened *Annie M. Reid*. She is seen here transiting the
First Narrows in Vancouver harbour with a load of

Australian flour. The *Annie M. Reid* continued sailing
until 1921, when she was broken up for scrap in San
Francisco. VANCOUVER MARITIME MUSEUM

(*Facing page*) **Four-masted barque** *Pamir*, **1945.**
**Photographer: B. G. Moodie**
One of the most photographed ships of her time,
the *Pamir* is shown here under full dress of sail in
light airs. She frequented Vancouver harbour in 1945
and 1946, the last commercial sailing vessel to do so.
Originally part of the German-owned Laeisz Flying

"P" line (all the ships had names beginning with
"P"), she carried nitrates and trained sailors on voy-
ages between Europe and South America. During
the 1940s, she was owned by a New Zealand com-
pany and ran grain and timber across the Pacific. In
1951, the *Pamir* and another "P" line ship, the *Passet*,
were saved from being broken up for scrap by a
German shipowner who had both vessels converted
into cargo-carrying training ships. The *Pamir* was
lost in a hurricane in the Atlantic on September 21,
1957. VANCOUVER MARITIME MUSEUM

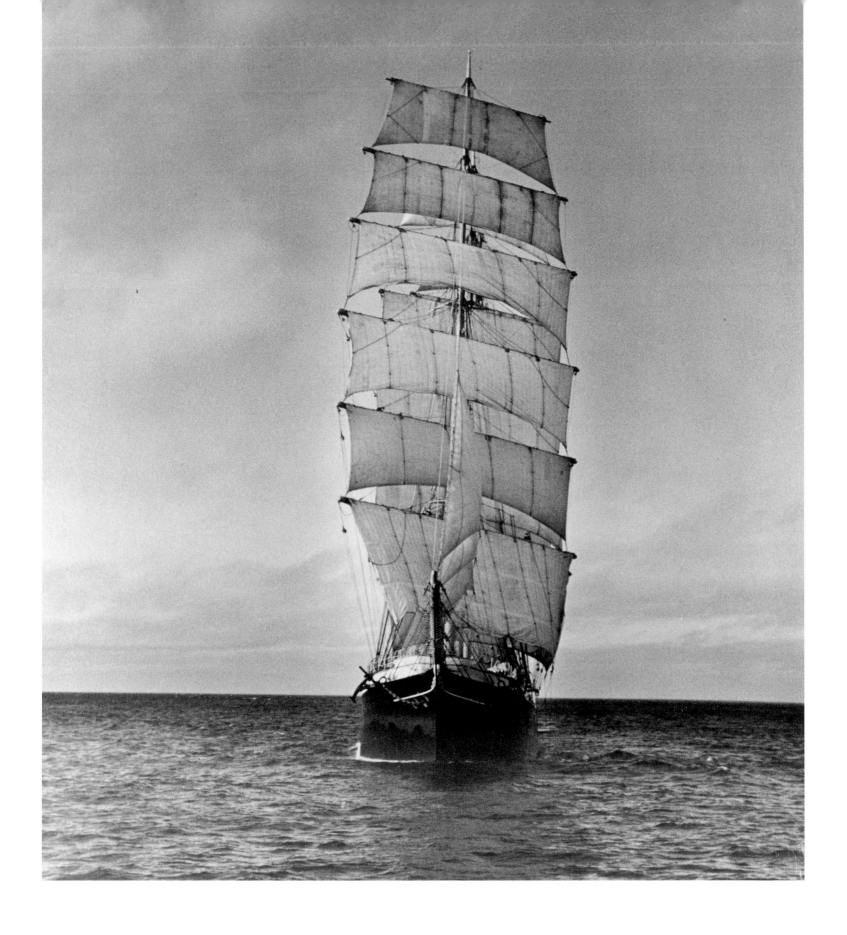

**Schooner *C. D. Rand*, Quatsino Sound, Vancouver Island, c. 1910. Photographer: Ben Leeson**

The crew of the sealing schooner *C. D. Rand* poses casually for a portrait, its members typifying the mix of cultures, Native and Western, that sailed to the sealing grounds in the Bering Sea. In the foreground and holding a cigar is the captain, with the European members of his crew standing beside an east coast dory. Behind them are the Native crew members, probably Ahousats from Clayquot Sound, grouped around a traditional dugout canoe, brought aboard for their own use when sealing. A large number of Northwest Coast Native men were included in sealing crews, the Ahousat particularly favoured because of their reputation as skilled hunters. VANCOUVER PUBLIC LIBRARY 13966

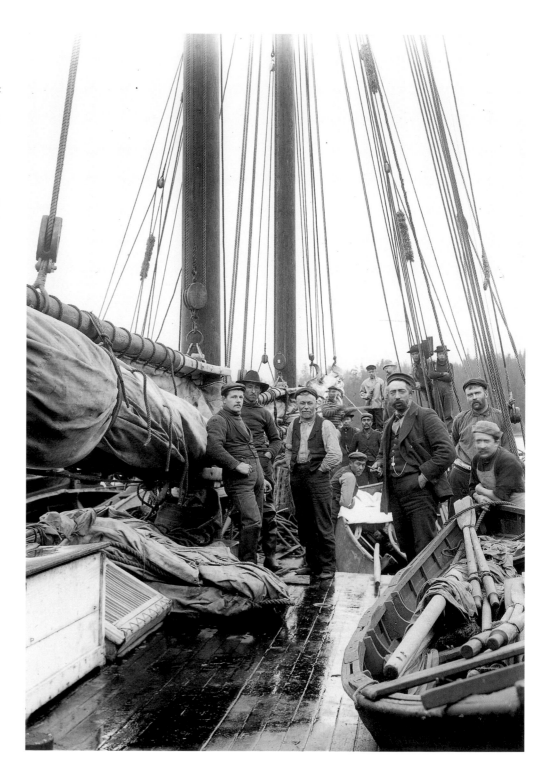

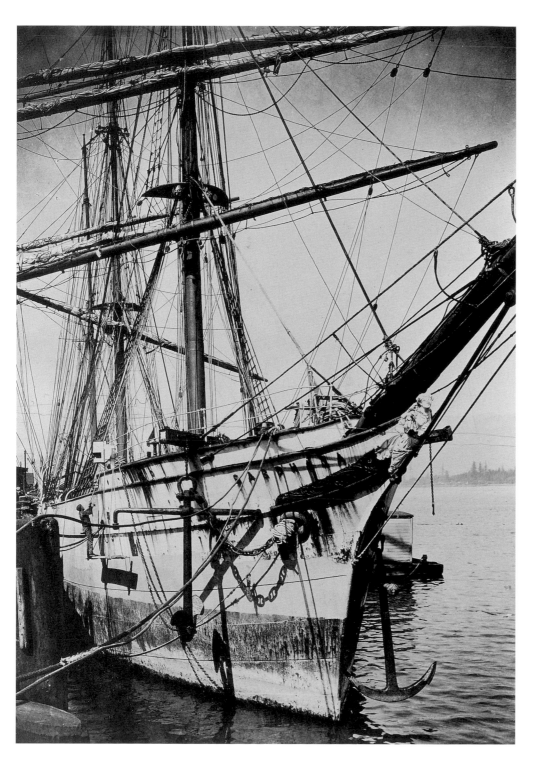

**Three-masted barque *Sardhana*, Vancouver, c. 1905.
Photographer: Philip Timms**

One of the better known photographers in the early days of Vancouver was Philip Timms, who arrived in 1898 at the age of twenty-four. He established a business the following year and earned a reputation as an urban photographer with his images of street and harbour scenes. Here, the barque *Sardhana* is lying quietly alongside a pier in the harbour, her sails furled. A staging has been rigged over the side to allow seamen to chip and paint the rust-streaked hull, maintenance work that could not be done at sea. The anchors, taken aboard and lashed to the deck when the ship is underway, have been hung from the cat heads in readiness to let go, while the anchor chains remain parcelled with canvas to muffle their clanking. VANCOUVER MARITIME MUSEUM

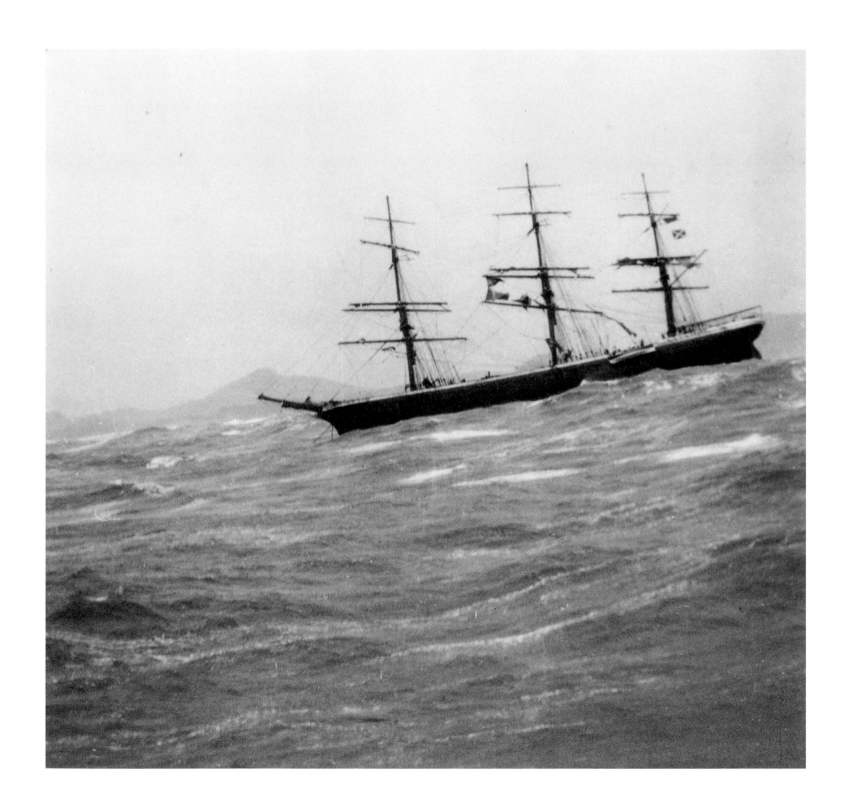

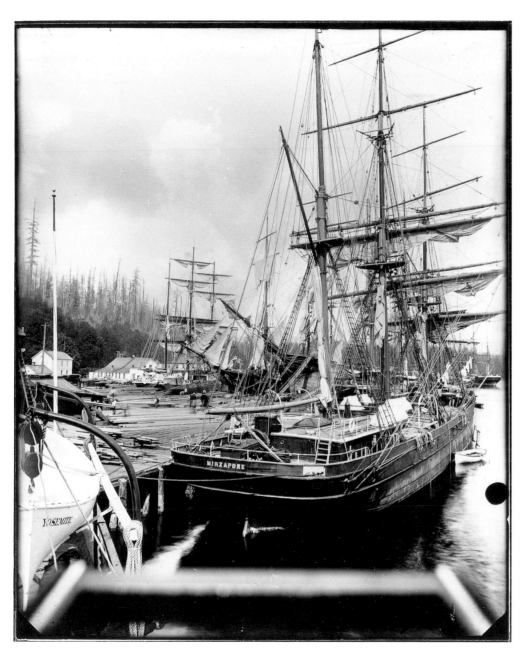

(*Facing page*) **Chilean ship *Carelmapu*, Gowland Rocks, Vancouver Island, November 25, 1915. Photographer: W. N. Kelly**

Her code flags flying "I cannot save my vessel," the *Carelmapu* rides heavily on both anchors off a lee shore. The vessel had arrived off Cape Flattery the previous day and spent hours in a fruitless search for a tow up the straits. Later, caught in a southeast gale, she was driven up the west coast of Vancouver Island. The master ordered both anchors away as the wind blew the vessel landward. The CPR steamer *Princess Maquinna* arrived on the scene and attempted rescue, but huge seas parted the anchor chains, and the *Carelmapu*, her sails in shreds, was pounded into the shore with her twenty-five passengers and crew. Five survived. The photo was taken by W. N. Kelly, a passenger on board the *Princess Maquinna*. BRITISH COLUMBIA ARCHIVES F-2229

**Sailing ship *Mirzapore*, Moodyville, c. 1887. Photographer: Richard Maynard**

This photograph was taken from the deck of the Canadian Pacific Navigation Company steamer *Yosemite* as she departed the Moodyville docks. The number of masts and rigs is evidence of at least six vessels sitting alongside the timber docks. These ships, part of the large foreign fleet that frequented the lumber ports of the Pacific Northwest, could hold huge cargoes. As much as two million board feet of dressed lumber could be lashed onto the deck and stowed in the holds before the ship picked up a tow to the open ocean and set sail for destinations overseas. BRITISH COLUMBIA ARCHIVES G-4910

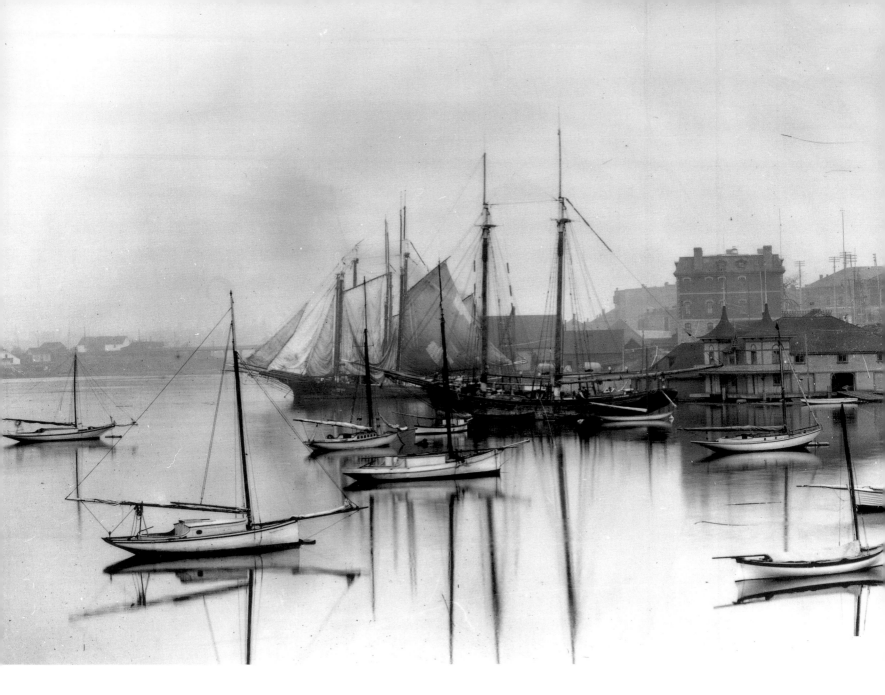

**Victoria harbour, c. 1900. Photographer: Unknown**
At the turn of the century, Victoria was very much a
working harbour with vessels of all descriptions
using the facilities. Recreational boating was growing
in popularity in the capital city, as evidenced by the
large variety of small sailing craft sitting at anchor
in front of the floating boathouse. Built in 1895, this
was the first clubhouse of the Victoria Yacht Club.

Alongside these boats are several schooners from the
sealing fleet, lying stern to the wharves below the
customs house. Their patched sails have been hoisted
to dry in the light airs. BRITISH COLUMBIA
ARCHIVES G-01111

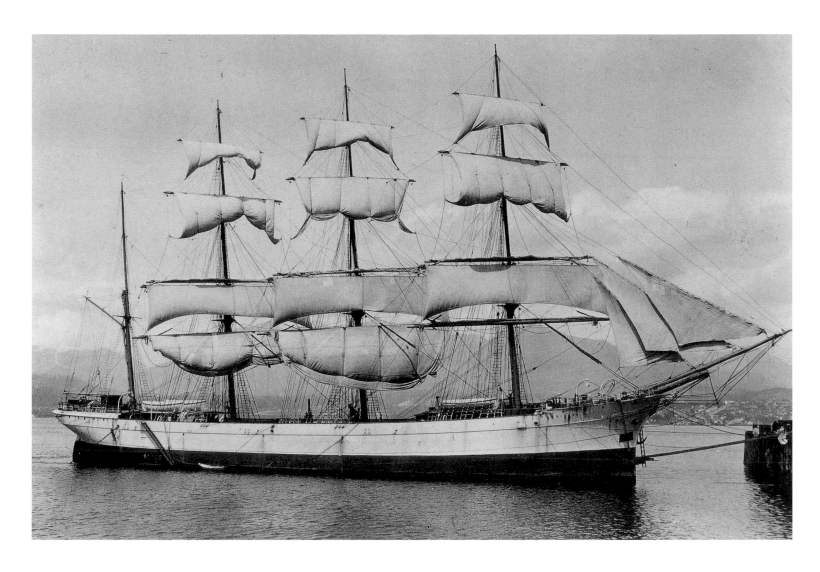

**Barque *Lucipara* at Hastings Mill, Vancouver, n.d.**
**Photographer: James Crookall**

Awaiting a cargo of lumber, the four-masted barque *Lucipara* is moored bow-on to the Hastings Mill wharf. The mate has had the sails loosened to dry in the fine weather. As rot and mildew quickly destroy canvas sails stowed away wet, every opportunity had to be taken to air them. The *Lucipara* was considered the fastest ship in the Denniston Island Fleet, a German-owned company that sailed under British registry. The 1,863-ton ship was built in 1885 for Peter Denniston by the Russel and Company shipyard in Port Glasgow, Scotland. She was sold to a Finnish outfit just before the First World War and disappeared shortly after. VANCOUVER MARITIME MUSEUM 2676

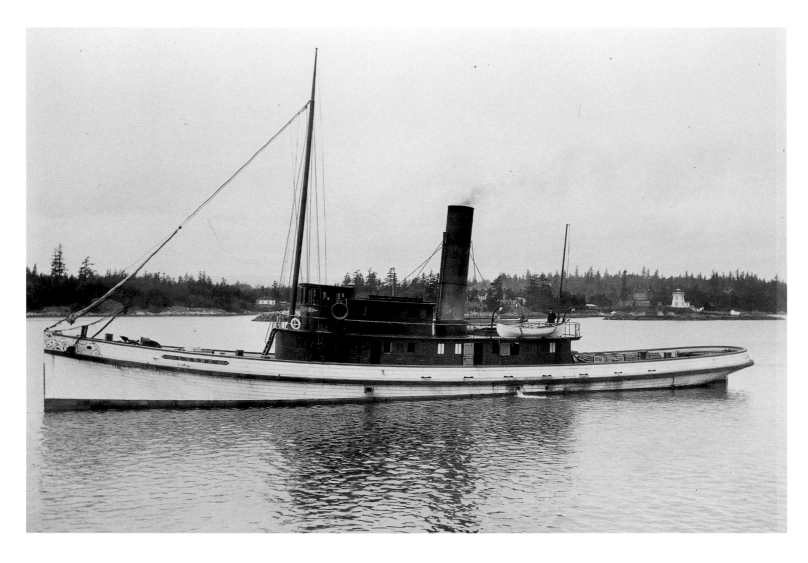

**Tug *Lorne*, Victoria c. 1890. Photographer: Unknown**

The tug *Lorne* was built in 1889 by Robert Laing of Victoria for coal baron Robert Dunsmuir, for the specific purpose of towing deep-sea sailing ships from the open sea to the coal ports on the east coast of Vancouver Island. Albion Iron Works, also of Victoria, built the triple-expansion steam engines, and at 1,300 horsepower, the *Lorne* was one of the most powerful tugs on the coast. She was 150 feet long and had a service speed of 14 knots, carried a crew of seventeen and earned a reputation that reached almost legendary status. She was a work-horse much admired on both sides of the border for towing ships, barges and booms, as well as for participating in many rescues. The *Lorne* continued to work on the coast until she was scrapped in 1937.

MARITIME MUSEUM OF BRITISH COLUMBIA P3321

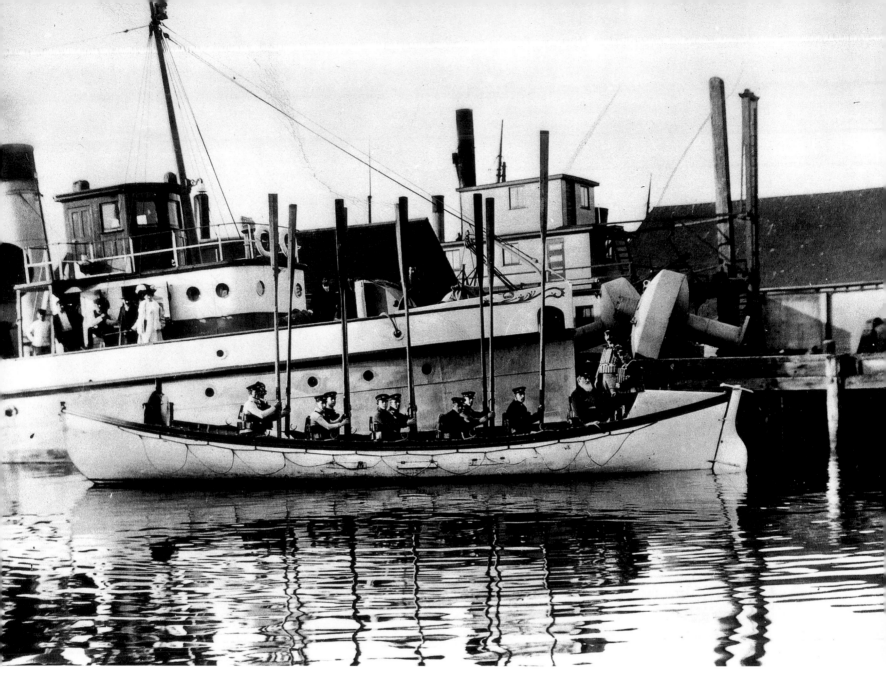

**Dominion lifeboat, Victoria, 1902. Photographer: Unknown**

With trade on the B.C. coast growing at an ever-increasing pace, ship owners and crews were demanding basic protection in the form of light-house service and life-saving stations. The rise in casualties, particularly from ships being blown onto lee shores, made the latter a necessity. The winter months became known as the shipwreck season,

when sudden gale force winds, fog and unpredictable currents took huge tolls on commercial shipping. The Beebe-McLellan lifeboat, originally designed by the United States Coast Guard, was found to be an excellent surf boat, easily manageable by a crew of trained oarsmen. Four stations operated on the west coast of Vancouver Island, and these, combined with the West Coast Trail and emergency shelters, gave some comfort to shipwrecked sailors. Completed in

1912, the trail ran from Bamfield to Port Renfrew and had, at intervals, survival huts stocked with provisions and telegraph stations. BRITISH COLUMBIA ARCHIVES F-02889

35

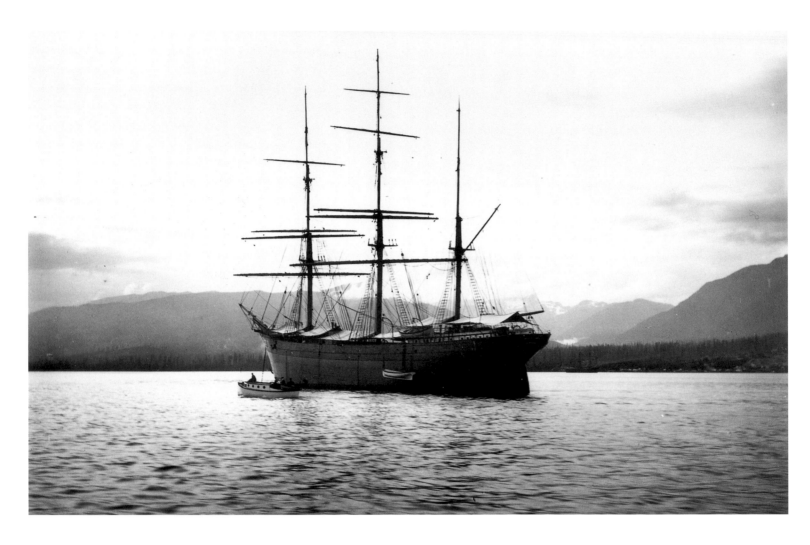

**Unidentified three-masted barque, Vancouver, 1908. Photographer: Philip Timms**

A large iron-hulled merchant sailing ship settles in at anchor in Vancouver harbour. Rain awnings have been rigged to give some comfort from the predictable raincoast showers. The ship is likely waiting for a berth at Hastings Sawmill. Loading timber was a lengthy and laborious process as it was done by hand, under the watchful eye of the mate. An average rate of stow for timber was 150,000 board feet a day, and some ships could carry over two million board feet. A liberty boat hangs off the port-side davits in readiness to ferry crew members ashore for their leave. VANCOUVER PUBLIC LIBRARY 2912

*(Facing page)* **Four-masted barque *Moshulu*, Esquimalt harbour, 1935. Photographer: Carey and McAllister**

The *Moshulu* was built in 1904 for G. H. J. Siemers of Hamburg, at the Wm. Hamilton & Company Shipyard in Port Glasgow, Scotland. Originally named *Kurt*, she ran coal to South America and Mexico, returning to Germany laden with nitrates. On the tenth such voyage, after discharging coal in Mexico, she sailed for Portland, Oregon, to load grain. After her arrival, the First World War broke out, and she was confiscated by the Americans, who renamed her, first *Dreadnought* and then *Moshulu*. When this photograph was taken, she was the largest commercial sailing vessel afloat, weighing 3,116 gross tons and carrying 45,000 square feet of sail. At anchor in Esquimalt harbour, the *Moshulu* has finished an extensive refit and will soon set sail for Australia. BRITISH COLUMBIA ARCHIVES F-07477

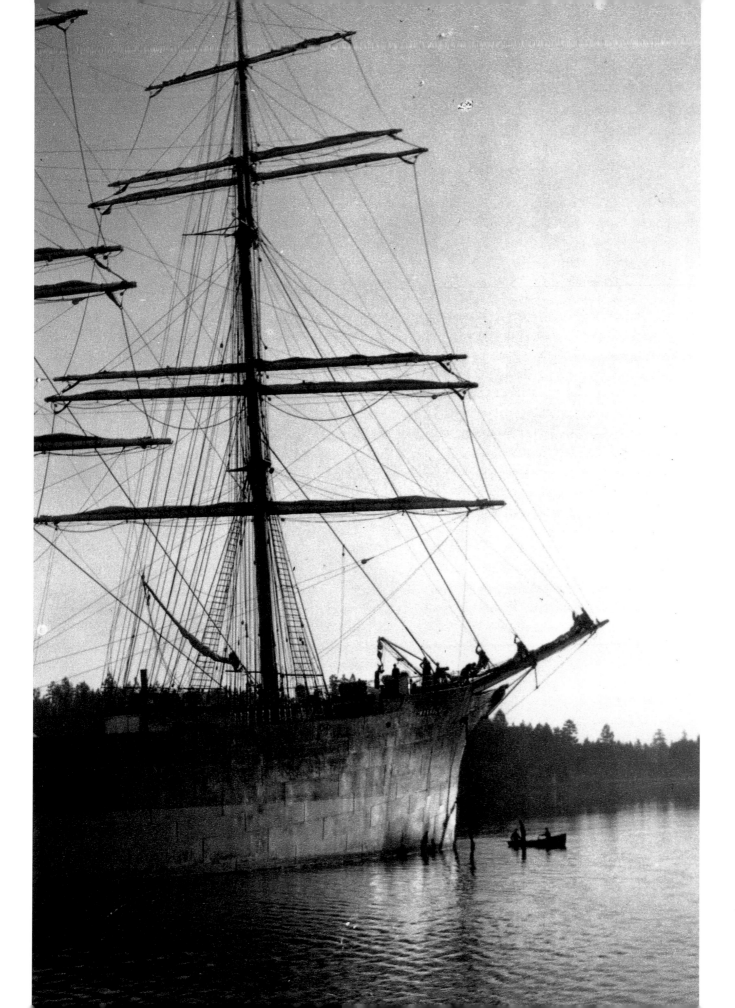

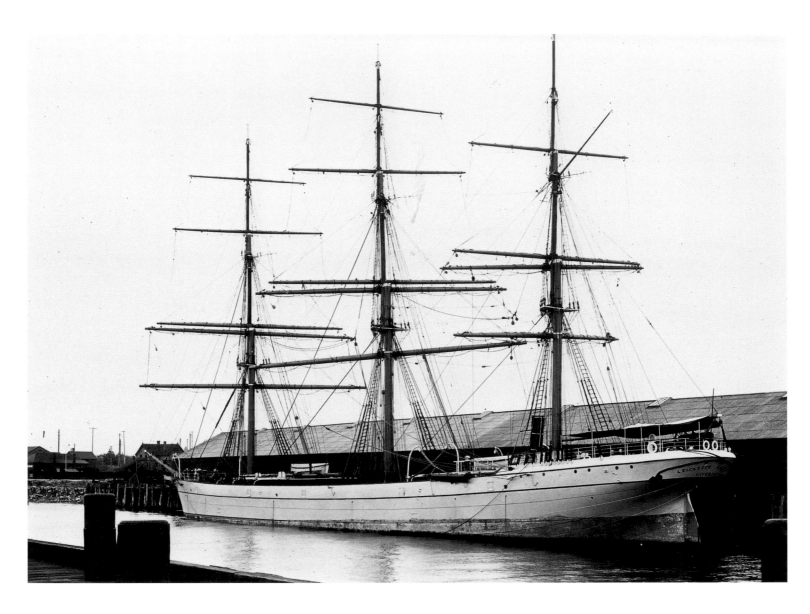

**Sailing ship** *Leicester Castle*, **Victoria, 1903.**
**Photographer: Unknown**

The 2,067-ton full-rigged ship *Leicester Castle* lies alongside the outer wharf in Victoria harbour. During the previous year, this same ship had been the scene of mutiny and murder. Putting out from San Francisco for Queensland, Australia, on July 26, 1902, under the command of Captain Peattie, she carried a very mixed crew of sailors, some of whom had been shanghaied upon departure from the American port. On the evening of September 2, the captain was roused from his cabin by an American seaman carrying a revolver. During the ensuing struggle, the captain was shot four times and beaten severely but still managed to fight off his assailant. The second mate, who arrived to help, was shot dead on the spot. The chief mate took charge, but the American and two fellow mutineers escaped from the ship in a small raft. The three were never seen again. Incredibly, the captain resumed his duties after a layup of only twenty-four hours and continued to sail his vessel on to Queensland. MARITIME MUSEUM OF BRITISH COLUMBIA PI531

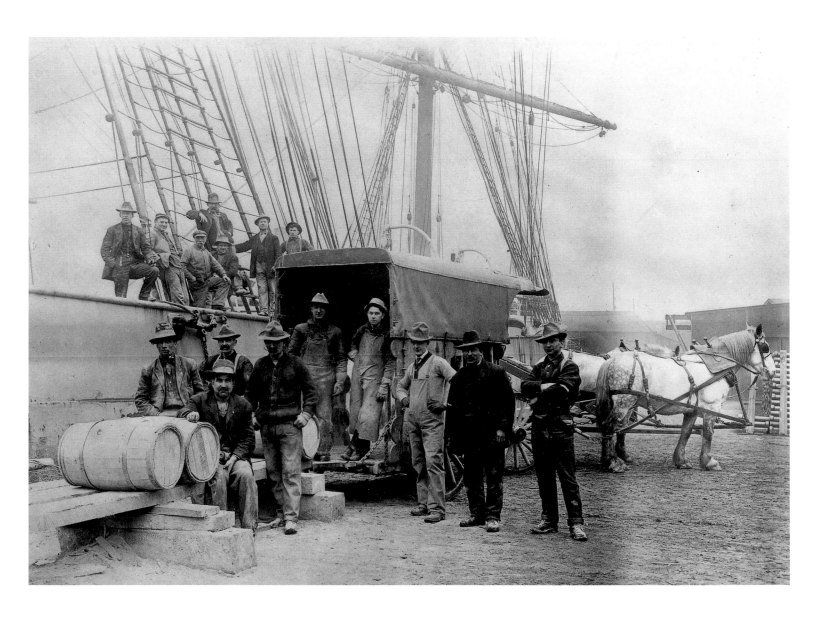

**Stevedore group, Vancouver, 1908. Photographer: Philip Timms**

Taking a break to pose for a photograph, these men are unloading barrels of Portland cement from a large unidentified sailing ship alongside Stimson's wharf in Vancouver harbour. The carriage and horses belong to Merchants Cartage Company Ltd. Stevedores and carriage firms were essential in any port town for the transport of the vast quantities of goods arriving and departing. CITY OF VANCOUVER ARCHIVES BO.P.157.N.48

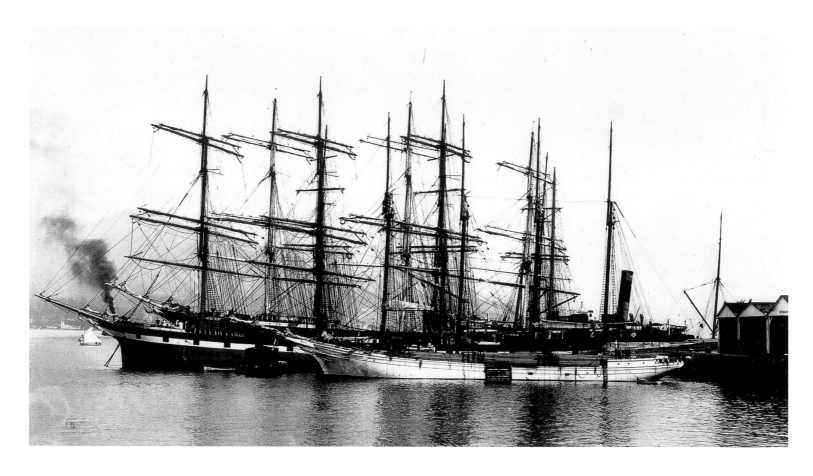

**Sailing vessels at Hastings Mill, Vancouver, n.d. Photographer: Leonard Frank**

The vessel in the foreground is the schooner *Robert R. Hind*. She lies weighed down to her marks with a cargo of timber stowed in her holds and lashed onto her deck, shortly before departure from Hastings Mill dock. Three other deep-sea sailing ships lie moored in the background, their sterns to the mill's wharves. At a time when steamships were becoming the dominant form of sea transport because of their more reliable schedules, large numbers of sailing ships continued to be involved in trade throughout the world. Sailing ships were still considered incomparable as training vessels, and they were used to transport cargoes and train seamen until the Second World War. BRITISH COLUMBIA ARCHIVES B-01476

**Hastings Mill, Vancouver, c. 1900. Photographer: Philip Timms**

Working conditions aboard a deep-sea sailing ship were generally dismal. Seaman were grossly underpaid, food was meagre, and living conditions squalid. The long voyages, often exceeding one hundred days at sea, involved arduous and dangerous work, and it was not uncommon for sailors, once in port, to desert. On shore, these seamen would often find themselves the unwitting dupes of "crimps," unsavoury businessmen who, for a price, supplied ship masters with crews. One such crimp ran a seamen's hostel in Vancouver. He would convince sailors to leave their ships, put them up at his hotel, help them spend their money and then, when the time was right, sell them back to a ship short of crew. The unfortunate sailor could find himself hung-over, disoriented and at sea with no idea of how he got there. VANCOUVER PUBLIC LIBRARY 3007

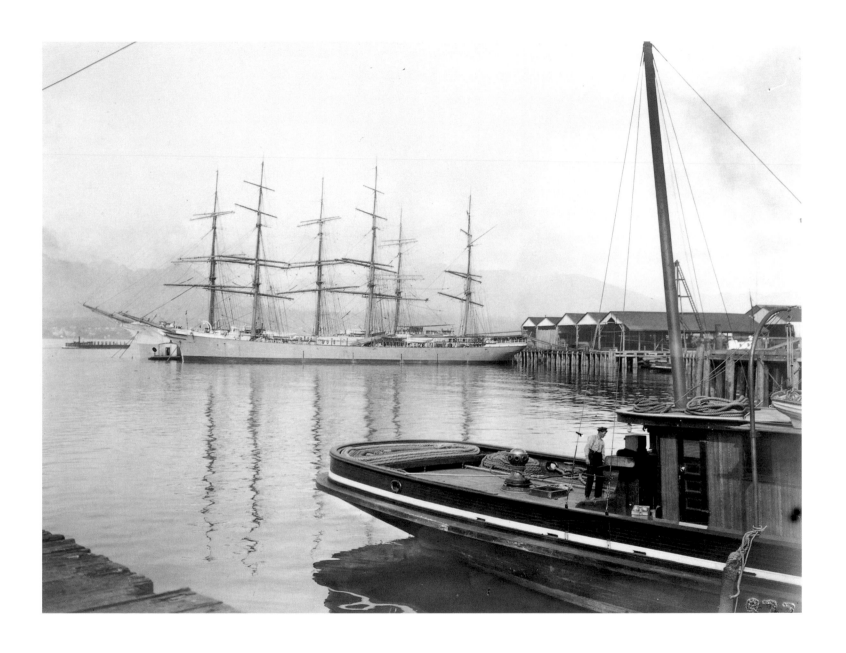

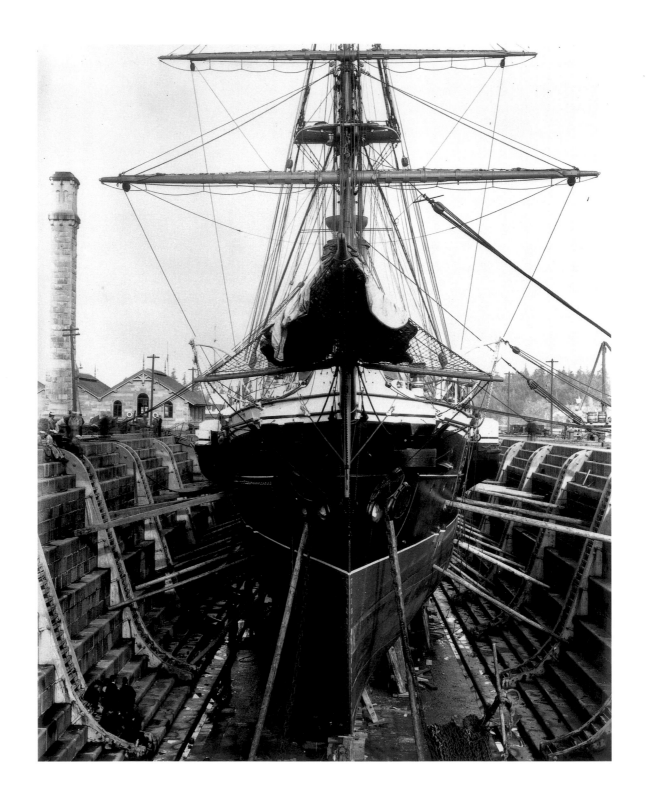

# $Local\ Shipbuilding$ CHAPTER TWO

$T$HE HISTORY OF SHIPBUILDING on the North Pacific coast began modestly in 1788 with the launch of the small 40-ton *Northwest America* at Nootka Sound on Vancouver Island. Captain John Meares, who built the ship, had brought, from China, artisans, shipwrights and tools to build a craft intended for use in the trade of sea otter pelts. Ten years previous, Captain James Cook had been the first European to land on what was later called Vancouver Island, and he had found, in the lush forests of the northern part of the island, the timbers for new masts and other repairs required by both his ships. The west coast forests quickly became a source of interest to Great Britain, and, after settlement was established, a shipbuilding industry, which grew to become a vital part of the economic development of British Columbia, seemed an inevitable consequence of the region's resources and location.

As with all fledgling industries, the beginnings were slow. However, the Fraser River gold rush of 1858 created the need for large numbers of locally built boats. Thousands of gold miners descended on the new colony, arriving in Victoria to buy supplies and, from there, travelling to the mainland and the Fraser River gold fields. The demand for transport was, for the most part, supplied by imported vessels, but many flat-bottomed, sternwheeler river boats were constructed on the shores of Victoria harbour and New Westminster. Not long after, rudimentary repair facilities and marine railways were developed in Victoria and Esquimalt, but many years passed before the appearance of dry-docks needed for larger or more complex work. For a long time, such jobs had to be sent further south to San Francisco. The federal graving dock in Esquimalt, opened in 1871, also lacked the machinery and cranes necessary to engage in major jobs and was restricted to minor bottom repair. Its main customer was the Royal Navy, installed at

HMS *Amphion*, Esquimalt, 1889. Photographer: Richard Maynard

On the morning of November 6, 1889, HMS *Amphion* steamed to Vancouver from Victoria with the Governor General, Lord Stanley, and his vice-regal party aboard. With no pilot to navigate and surrounded by dense fog, the vessel struck bottom at Kellet Bluff in Haro Strait. The hull was breached through both the inner and outer bottoms, and the ship began to take on water. All hands manning the pumps and listing badly to starboard, she limped into Esquimalt harbour. The damage to the ship's bottom was found to be extensive; an estimated thirty-five plates needed to be replaced. Until this time, ships received temporary repairs locally and were sent back to Britain for the actual work. *Amphion*'s were the first permanent repairs done for the British Admiralty by a local company. The Victoria Machinery Depot was engaged to do the job at a cost of $150,000. BRITISH COLUMBIA ARCHIVES G-04384

its new base in Esquimalt, where its ships were often required to sit at anchor, awaiting the arrival of parts from Britain.

In the early years of the new century, the success of some companies brought about expansion. Wallace Shipyard moved from its small False Creek location to larger facilities in North Vancouver and introduced the first marine railway to the north shore of Burrard Inlet. In Esquimalt, Bullens Shipyard was bought out by Yarrows Ltd., an established British company, which modernized the repair and construction capabilities and gave much guidance to the industry.

The first great boom came during the First World War. At that time, the British Columbia lumber industry was in crisis as unrestricted submarine warfare had taken a huge toll on merchant shipping. With no ships available for charter, lumberyards in the province had no means of exporting their product to foreign markets. The provincial government stepped in and enacted the Shipping Assistance Act of 1916 to help underwrite the building of a fleet of wooden schooners. Construction of twelve of these five-masted auxiliary schooners was well underway by Wallace Shipyard of North Vancouver and the Cameron-Genoa Mills Shipyard in Victoria when their existence was brought to the attention of the Imperial Munitions Board in London. Impressed with the abundant timber supply and quick building techniques, it ordered twenty-seven wooden cargo steamers from west coast builders. The foreshores of Victoria and Vancouver and the banks of the Fraser River became alive with shipbuilding activity as new companies sprang up overnight to meet the demand. The French government followed suit, placing an order for more than forty wooden cargo steamers. During the last years of the war, steel became the preferred material for ship construction. B.C. builders were able to accommodate this demand by using steel plate transported from eastern Canada and the United States.

As more orders came in from the British and Canadian governments, the industry boomed until the early 1920s, when it fell into a postwar slump. Only the shipyards that could competitively make repairs survived. In spite of high unemployment, the skilled personnel that had relocated to the coast were reluctant to move, and the machinery and docking facilities, though often lying dormant, remained ready for use. In 1926, the federal government gave a minor boost to the industry by building a large new dry-dock in Esquimalt, but it was not until the late 1930s and the beginning of a new war that the industry became seriously active again.

The Second World War brought far greater demand than the First. With British

shipyards stretched to absolute capacity, Canada was called upon to help supply the war effort with a merchant fleet. As well, the Royal Canadian Navy required frigates, corvettes, minesweepers and various other support vessels. British Columbia shipyards went into full production almost overnight, with existing facilities expanded to accommodate the massive task. Production was efficient and enormous. Of the 400 10,000-ton merchant cargo ships built in Canada during the Second World War, 244 were built in west coast yards. In one year alone a single shipyard, Burrard, produced 33 ships.

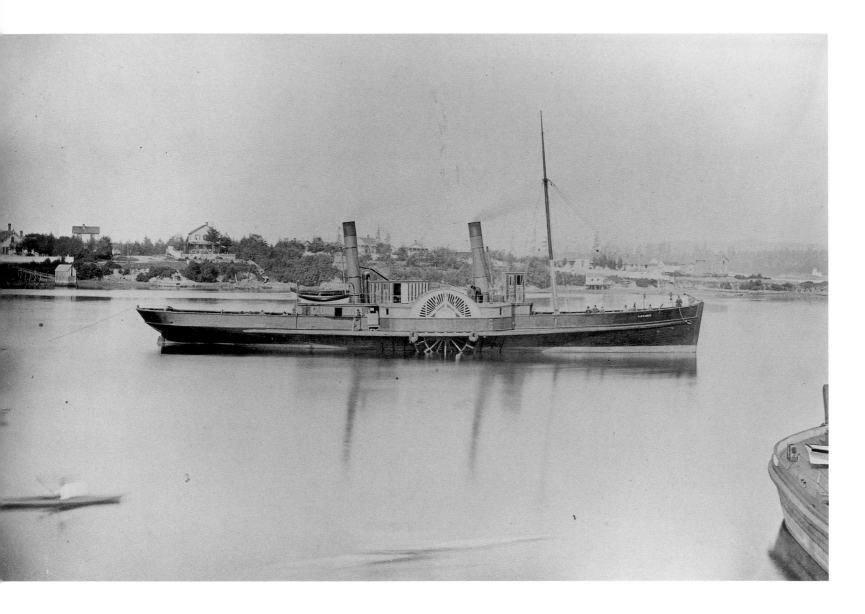

**Tug *Alexander*, Victoria, c. 1880. Photographer: Richard Maynard**

The *Alexander*, built in 1875 on the Skeena River at Port Essington, was one of the last side-wheel ships to be constructed on the coast. The tug was enormous, 180 feet in length, and cost $80,000 to build, considered a huge price at the time. She was put to work towing sailing ships from the open ocean off Cape Flattery to the mills and mines around the lower coast, primarily to the lumber mills in Vancouver harbour and to the coal docks at Nanaimo and Union Bay. Unfortunately, she was a costly vessel to run, and forced her builders, the McAllister brothers, into bankruptcy. She was bought by Robert Dunsmuir for hauling coal until 1890, when she was converted to a whaler and then a barge. MARITIME MUSEUM OF BRITISH COLUMBIA 7776

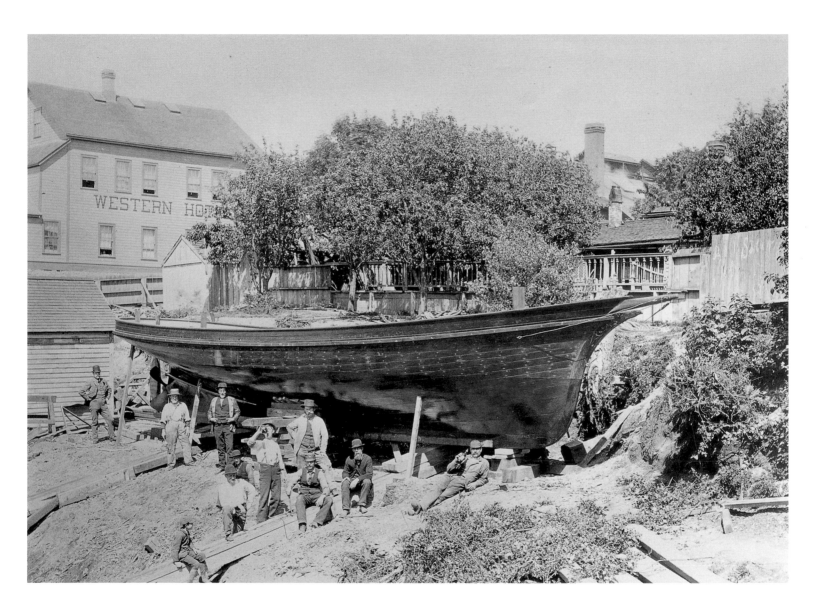

**Unidentified schooner, Victoria, c. 1895.**
**Photographer: Unknown**
Friends and workers pose informally under the sleek hull of this unidentified schooner on Victoria's waterfront. With bottles in hand, the small crowd appears to be taking a well-deserved break from their labours. A number of schooners were imported from the east coast, but many others, such as this one, were contracted by and built locally for the sealing syndicates, headquartered in Victoria from the 1880s until 1911. Her bottom freshly painted and the carved eagle on her fine clipper bow primed and gilded, this vessel seems ready for launching. Then she will be fitted out with new masts, rigging and sails, and will join the dozens of schooners at anchor in the harbour awaiting another sealing season. MARITIME MUSEUM OF BRITISH COLUMBIA P1819.02

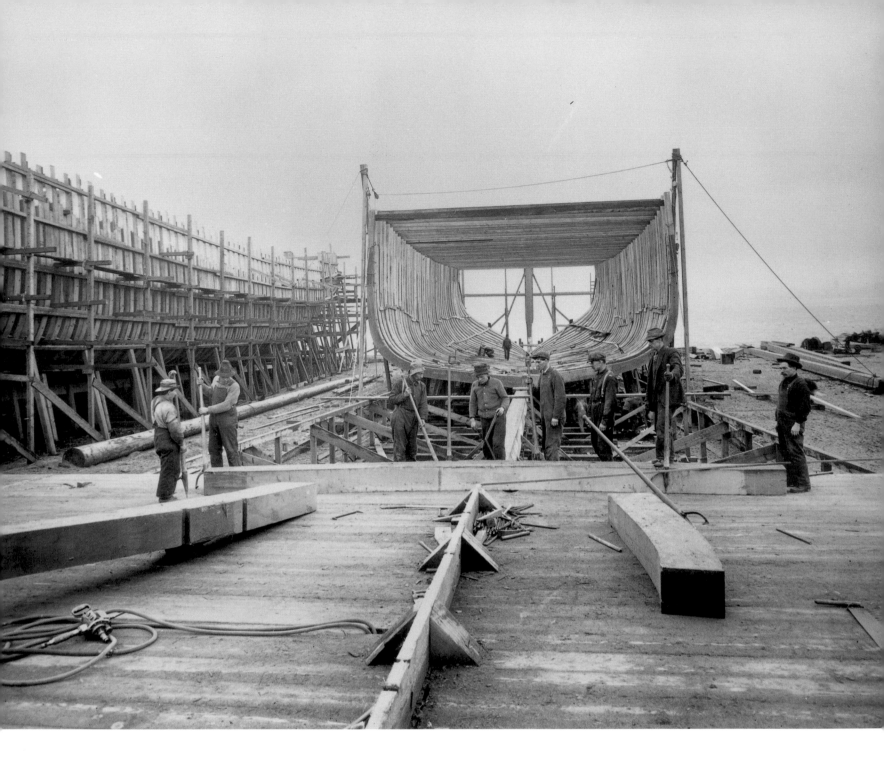

**Schooner *Mabel Brown*, North Vancouver, 1917.**
**Photographer: Dominion Photo Company**
Shipyard workers at Wallace Shipyard in North
Vancouver prepare to fit the bottom section of a
frame to the keel of the *Mabel Brown*. Six of these
large five-masted schooners were built alongside each
other in the yard. The size of the workers gives scale
to the enormous cargo-carrying capacity of the inte-
rior hull. The strength of the hull is apparent by the
size and number of frames needed to build the 240-
foot ship. Each of the frames was made up of a
number of different pieces of timber, fitted or
scarfed together by skilled shipwrights. Once in
place, the frames formed the shape of the hull and
were covered by an outer skin of planking, bolted to
the side. The enormous quantity of timber used to
construct these ships, and the merchant steamships
that followed, kept the British Columbia lumber
industry very busy for the duration of the wartime
shipbuilding program. VANCOUVER PUBLIC LIBRARY
20089

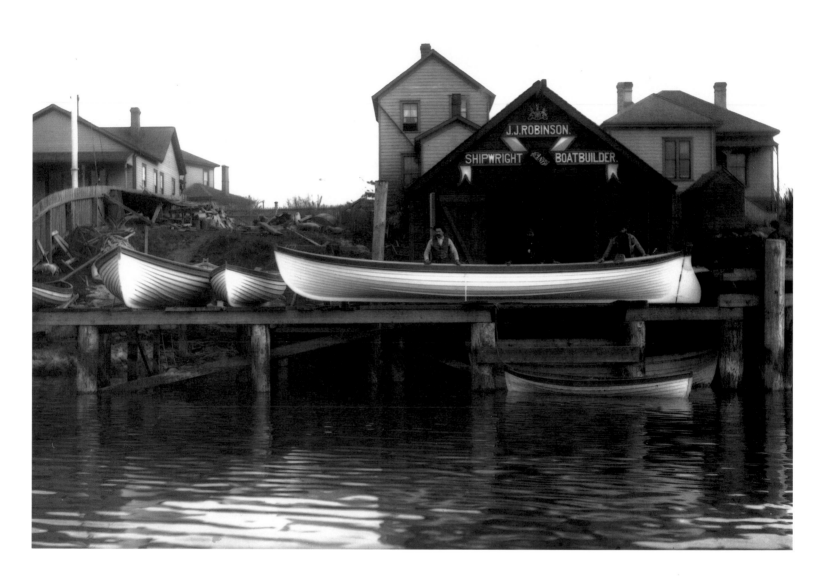

**J. J. Robinson, Boatbuilder, Victoria, c. 1900.**
**Photographer: E. W. A. Crocker**
At the foot of Montreal Street in Victoria was situated the boat-building shop of J. J. Robinson. Listed in the city directory as early as 1882, the shop produced high-quality boats and yachts for recreation and the commercial trade. The craftsmen employed were obviously pleased enough with their work to have this formal portrait taken, showing a selection of exquisite double-ended rowing boats of lapstrake construction. There were many boatyards on Victoria's waterfront, but few photographs of them show evidence of such fine craftsmanship. BRITISH COLUMBIA ARCHIVES I-51553

**Victoria Machinery Depot, Victoria, c. 1900. Photographer: Unknown**

The mainstay of the shipbuilding industry was the repair and maintenance work done to the deep-sea and coastal shipping fleet. Shown here, blocked up on the marine railway at the Victoria Machinery Depot, is the sailing ship *Reuce*. A docking cradle would be lowered into the water and the ship floated onto it. Then, the huge gears and chains that can be seen in the foreground were used to haul the entire unit onto dry land. Masters of sailing ships were not always inclined to make use of docking facilities because of their high cost, but some repair and maintenance was unavoidable. The rapid growth of weed and barnacles on large iron hulls that significantly reduced the sailing qualities of a ship were kept at bay by painting the hulls with toxic antifouling paints. Wooden hulls were covered with copper for the same reason, but these bottoms had to be checked occasionally to make sure the copper plates had not come loose, thereby exposing the wooden hull to worms and growth and causing drag. VANCOUVER PUBLIC LIBRARY 13437

*(Facing page)* **Auxiliary schooner *Cap Palos*, Vancouver, December 16, 1918. Photographer: Dominion Photo Company**

The five-masted gaff-rigged schooner *Cap Palos* undergoes sea trials in the Strait of Georgia. With all her lower sails set, she appears to be making good headway in a light breeze. The ship was one of six 2,500-ton schooners built on speculation by the Lyall Shipyard of Vancouver. Initially purchased by a Belgian businessman, these ships were refused by the buyer when they arrived in Europe. Lyall operated one of them and sold the rest to other European interests. The *Cap Palos* did not fare well, running aground off the Yorkshire coast of England on October 24, 1920. The vessel was patched and taken in tow but broke adrift in foul weather with seventeen men on board. The Whitby lifeboat was sent to the rescue and, after a seven-hour search, found the ship and took off the men. The *Cap Palos* broke in half and sank almost immediately. VANCOUVER PUBLIC LIBRARY 20626

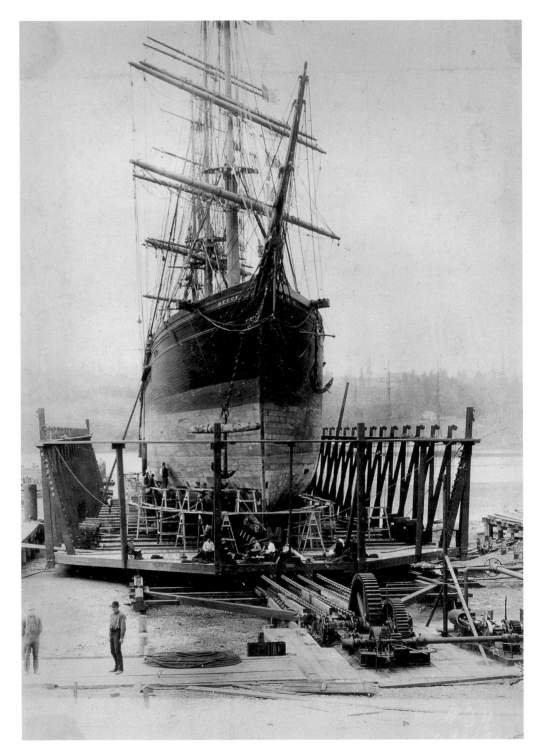

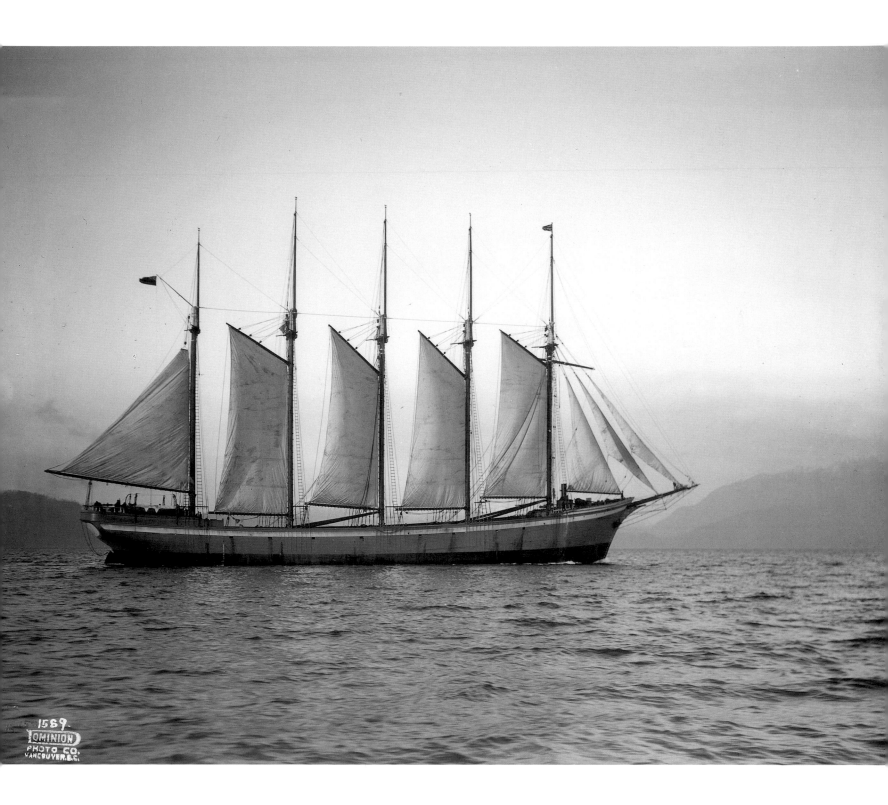

51

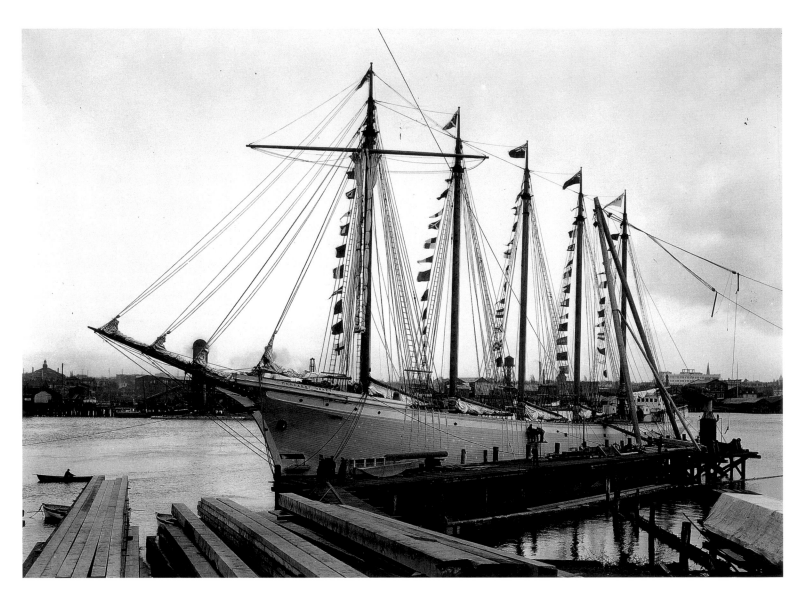

**Schooner *Margaret Haney*, Victoria, 1917.**
**Photographer: Edgar Fleming**

Freshly fitted with new spars, rigging and sails, the
*Margaret Haney* lies alongside the fitting-out berth at
the Cameron-Genoa Mills Shipyard in Victoria's
inner harbour. Her loading ports on the bow are
open, ready to accept her first consignment of lum-
ber for export to Australia. Launched on February 3,
1917, *Margaret Haney* was the first of six vessels to be
built at the new shipyard. These five-masted auxiliary
schooners were constructed to save the British
Columbia lumber industry from collapse, as wartime
shipping losses meant that there were few deep-sea
ships available for timber export. The British
Columbia Shipping Assistance Act of 1916 helped to
finance the construction of a deep-sea fleet to aid
the desperate industry. BRITISH COLUMBIA
ARCHIVES F-04539

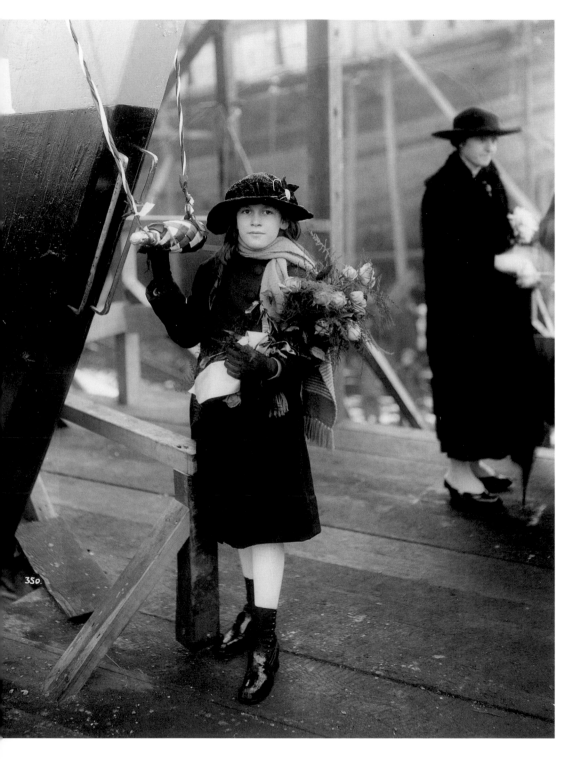

**Schooner *Mabel Brown*, North Vancouver, January 27, 1917. Photographer: Dominion Photo Company**
The young girl in the photograph is Miss Betty Brown, the daughter of the sponsor for whom the ship was named. She poses for the camera in her best clothes, with a bouquet of roses and the christening bottle of champagne in hand. Launchings were important events in the community, but this one, in particular, marked the beginning of the first major shipbuilding boom in British Columbia's history. The *Mabel Brown* was the first of twelve five-masted schooners constructed in Victoria and Vancouver, followed by a larger number of cargo steamers built for the British and French governments. Unfortunately, during this launching, the vessel refused to budge, as the grease on the skidway had become too hard. A second, more successful launching took place one week later. VANCOUVER PUBLIC LIBRARY 20099

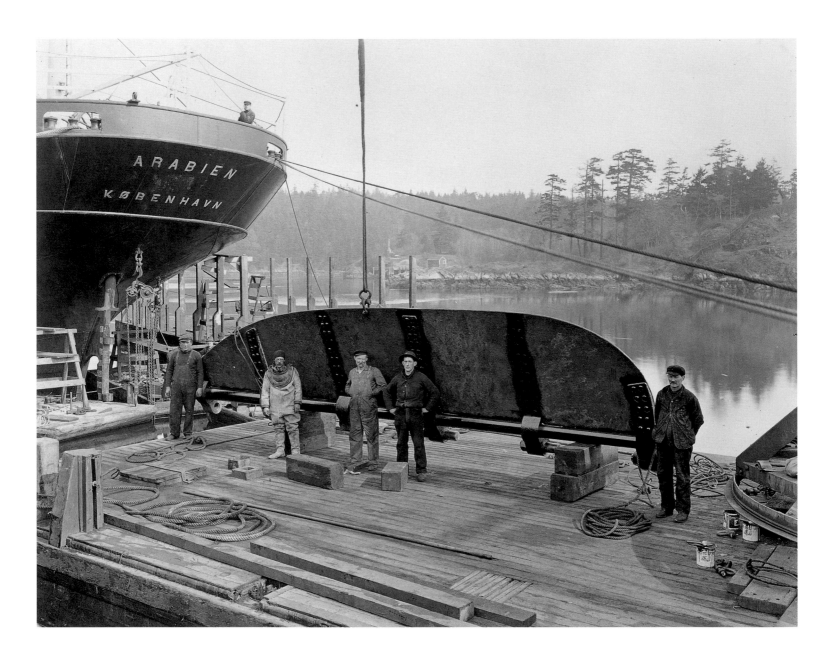

**Steamship *Arabien*, Esquimalt, 1912. Photographer: Harold Fleming**

The steamship *Arabien* belonged to the East Asiatic Company, a premier Danish shipping company which had long traded with Southeast Asia. In 1912, the company established a regular west coast-European service, positioning itself to take advantage of the trade opportunities that would result from the opening of the Panama Canal. By the time the canal opened two years later, the company's new service was well in place. The *Arabien* was the first of its ships to operate on this new run and is seen here, needing work on her rudder, photographed on Bullens ways in Esquimalt harbour. MARITIME MUSEUM OF BRITISH COLUMBIA 993.017.2206

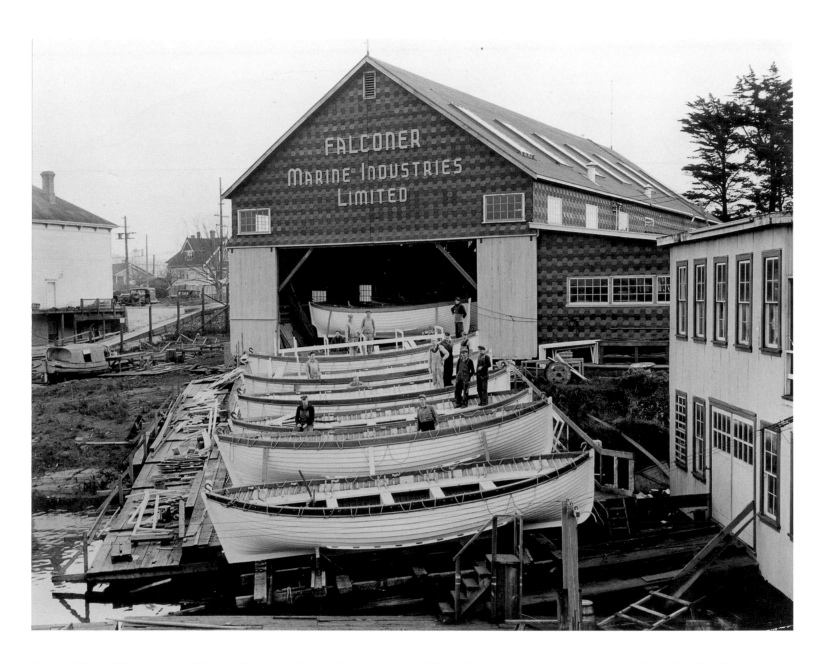

**Falconer Marine, Victoria, c. 1940. Photographer: Duncan MacPhail**

Falconer Marine was a small boatyard that changed overnight to a high-production facility, supplying quality small craft to the Wartime Shipping Commission. Based at the foot of Kingston Street in Victoria, the company made lifeboats for the merchant fleet built by British Columbia shipyards. Throughout the Second World War, hundreds of clinker-built double-ended lifeboats, generally 26 feet in length, were produced. Falconer also made other watercraft, such as patrol boats, captain's gigs and target towing craft for the British and Canadian navies. Despite the dominance of men in the photograph, its workforce was mostly female because of the shortage of male workers that occurred with enlistment. MARITIME MUSEUM OF BRITISH COLUMBIA 990.009.0063

**Wallace Foundry, Vancouver, March 7, 1919.**
**Photographer: Dominion Photo Company**
The immense growth in the shipbuilding industry affected the support industries supplying auxiliary machinery, winches, windlasses, piping and castings, as well as boilers and marine engines. Previous production of these items had existed only on a small scale. In order to meet the demand, the established firms, which until 1916 had been engaged primarily in the making of shell casings for the war, began retooling their shops. This freshly cast manganese bronze propeller, which will be polished before delivery, was one of the many produced for the shipbuilding industry by the Wallace Foundry on Granville Island in Vancouver. VANCOUVER PUBLIC LIBRARY 20654

**Vulcan Boiler Company, Vancouver, March 31, 1921.**
**Photographer: Dominion Photo Company**
Dominating this photograph are two massive steel Scotch boilers, under production-line construction at the Vulcan ironworks on Granville Island in Vancouver. Built of riveted and rolled steel, these were typical of the boilers used to power not only most merchant vessels of the period but the wooden and steel cargo ships built for the Imperial Munitions Board at the end of the First World War. Although the cost of the steel, which had to be transported from the east, was high, it was considered more expedient to have the boilers constructed on the west coast than to import the finished product from England. NORTH VANCOUVER ARCHIVES 27-2696

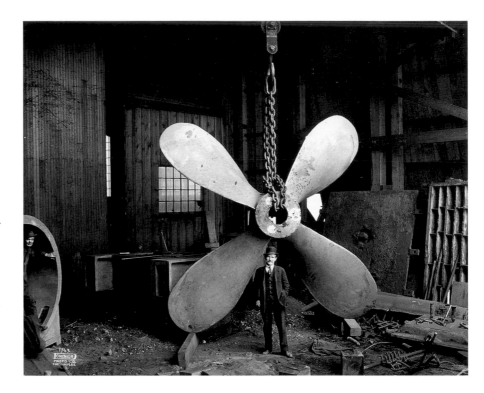

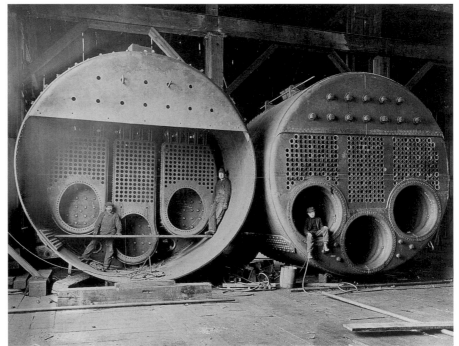

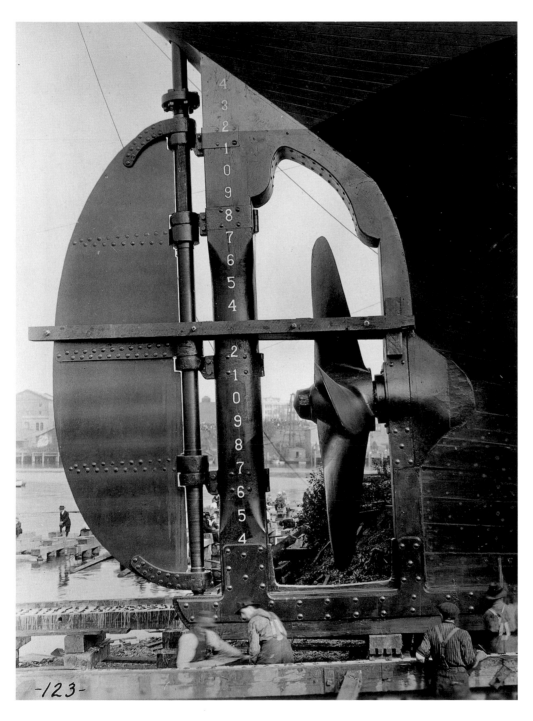

-123-

**Steamship *War Nanoose*, Victoria, 1919.**
**Photographer: Harold Fleming**

The imposing stern arrangement of the 2,800-ton cargo vessel *War Nanoose*, built for the Imperial Munitions Board, dwarfs the two shipyard workers below. The men are spreading a heavy layer of grease on the skidway in preparation for the vessel's launch. A heavy timber strongback has been bolted in place to keep the rudder in a fore-and-aft line during the launch, thus preventing any violent movement that could cause damage to the steering gear. Spectators sit patiently in the background, waiting for the proceedings to begin. Capital Iron and the Hudson's Bay Company store, Victoria landmarks to this day, are visible on the far shore. VANCOUVER MARITIME MUSEUM 5553

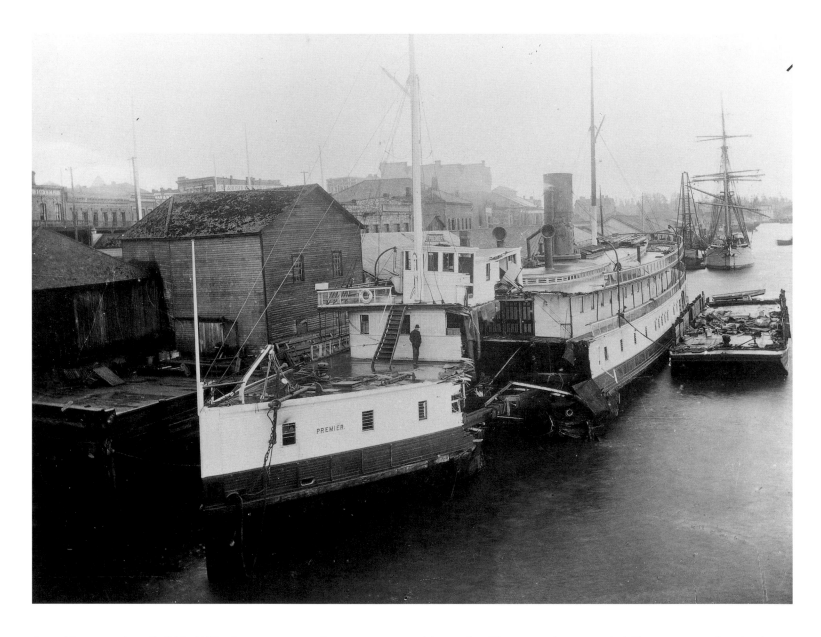

**Steamship *Premier* alongside Rithet's Wharf, Victoria, 1892. Photographer: Unknown**
On October 8, 1892, the Canadian Pacific Navigation Company steamer *Premier* was en route to Seattle from Port Townsend in heavy fog. Preferring to maintain her schedule rather than reduce speed, the captain kept up full engine revolutions. A foghorn was heard on her port side and the

*Premier*'s engines were reversed, but too late. The heavily laden collier *Willamette* appeared suddenly out of the fog, colliding with the *Premier*'s port side and causing heavy damage to the passenger ship. The two vessels remained locked together, and the *Premier* stayed afloat until she was beached at Bush Point on the American shore. Four were killed and twenty-one injured. The masters of both vessels had their

licences revoked. The *Premier* was refloated and towed to Victoria for repairs. To avoid any lawsuits, the ship's registry was changed from American to Canada under the new name of *Charmer*. She continued service until 1935 but never again ventured south of the border. BRITISH COLUMBIA ARCHIVES A-7723

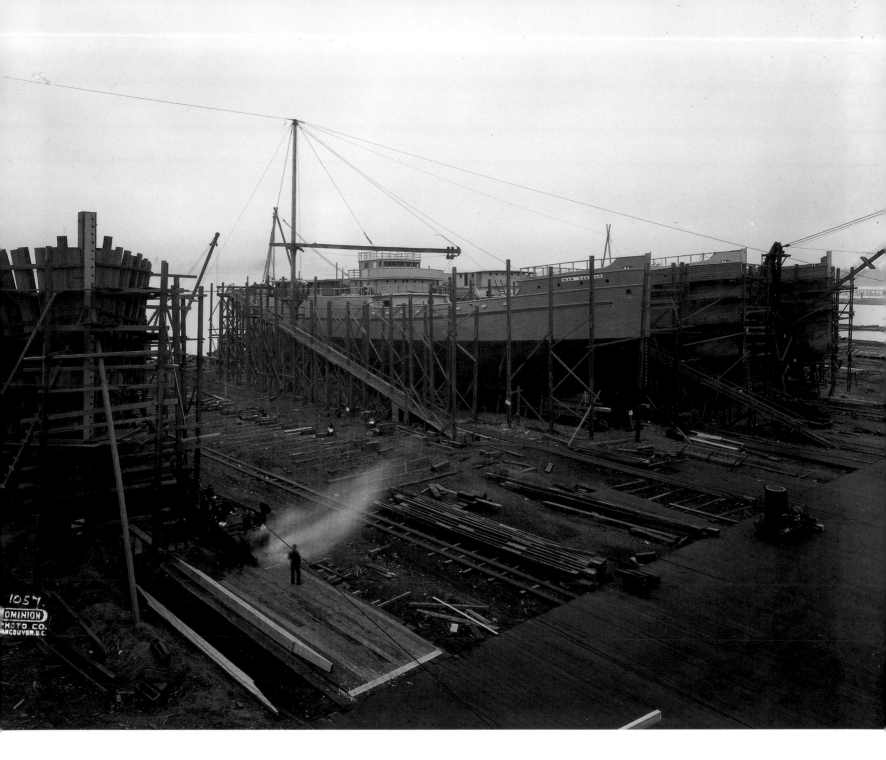

**Lyall Shipbuilding Company, March 15, 1918.**
**Photographer: Dominion Photo Company**
In 1917, William Lyall, president of Lyall
Construction Company, bought Wallace Shipyard's
yard No. 2 and immediately built the six berths
needed to take on the wartime ship construction
awarded by the Imperial Munitions Board. Lyall
Shipbuilding Company Ltd. built six of the

twenty-seven 2,800-ton wooden steamers produced
by half a dozen west coast shipyards. The other
firms involved were Cameron-Genoa Mills Shipyard
of Victoria, Western Canada Shipyards of Vancouver,
New Westminster Construction, Pacific Construc-
tion Company of Coquitlam and Foundation
Company, also of Victoria. Contracts for another
forty wooden ships were cancelled when the First

World War came to a close. VANCOUVER PUBLIC
LIBRARY 20467

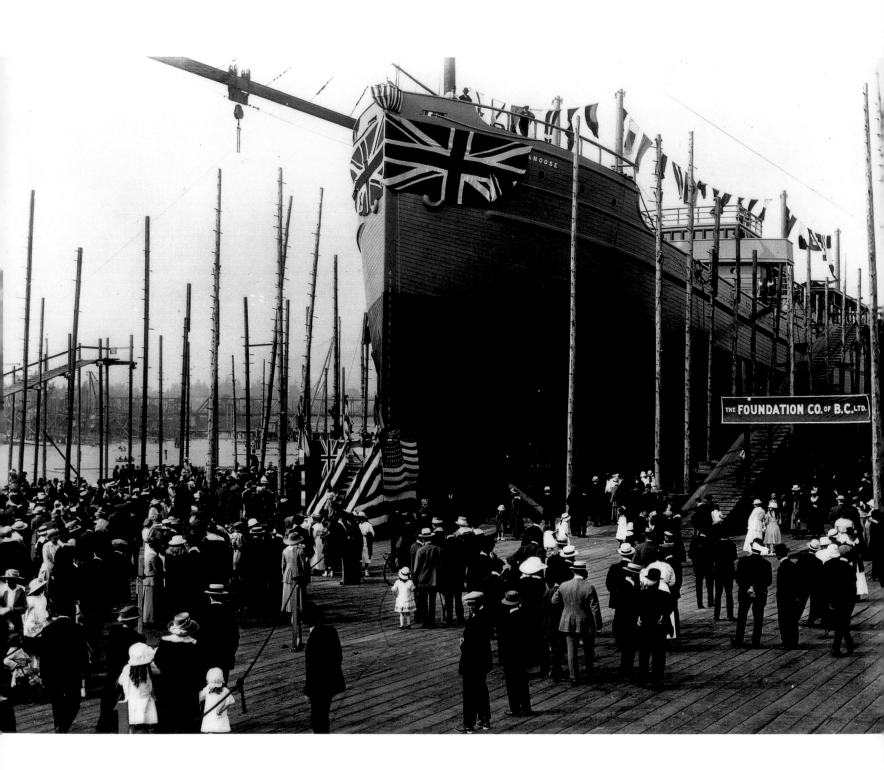

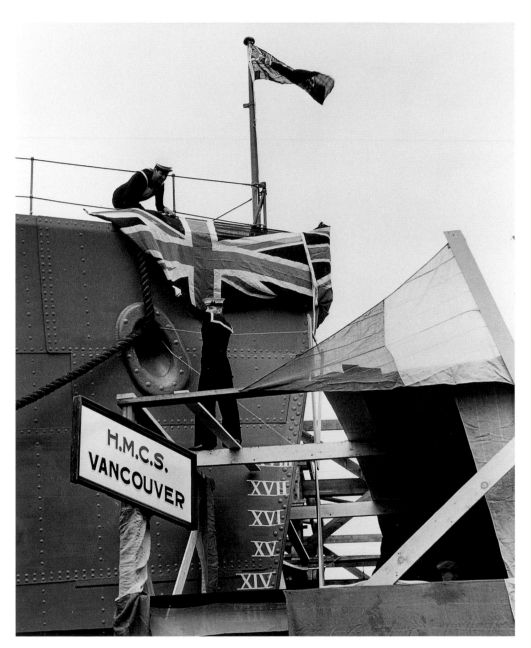

(*Facing page*) **Steamship *War Nanoose*, Victoria, 1918.**
**Photographer: Unknown**
Built for the Imperial Munitions Board, *War Nanoose* was one of twenty-seven wooden cargo steamers produced in British Columbia during the First World War. With Union Jacks on her bow and bunting flying from stem to stern, the vessel awaits launching before a crowd of 20,000 spectators in 1918. These 2,800-ton ships were 260 feet in length and were powered with triple-expansion steam engines. During this period, the foreshore of Victoria's inner harbour was alive with industry. The shipbuilding boom produced by the First World War also brought more contracts for merchant ships of similar size to be built for the French government. However, after those contracts were completed, the industry fell into a slump in the 1920s and did not recover until the next war. BRITISH COLUMBIA ARCHIVES F-04535

HMCS *Vancouver*, Esquimalt, August 26, 1941.
**Photographer: Department of National Defence**
Built as part of the 1940–41 Flower Class corvette program during the Second World War, HMCS *Vancouver* is seen here being dressed for launching in August 1941. She was one of five corvettes and seventeen frigates built by Yarrows Shipyard in Esquimalt. Corvettes were a popular ship for the Canadian navy as they were relatively inexpensive, easy to build and required only a small crew. While most of these warships were dispatched to the east for convoy duty, HMCS *Vancouver* joined the Esquimalt group and provided close support and escort service to the Americans during the Aleutian campaign. In 1943, she was reassigned to the east coast for escort duty but, before leaving, had her fo'c'sle extended, improving her design and making her a much drier ship. The early versions of these corvettes were so low in the waist and took on so much water during rough weather that crews commented that they should be receiving submarine pay! MARITIME MUSEUM OF BRITISH COLUMBIA 993.017.4364

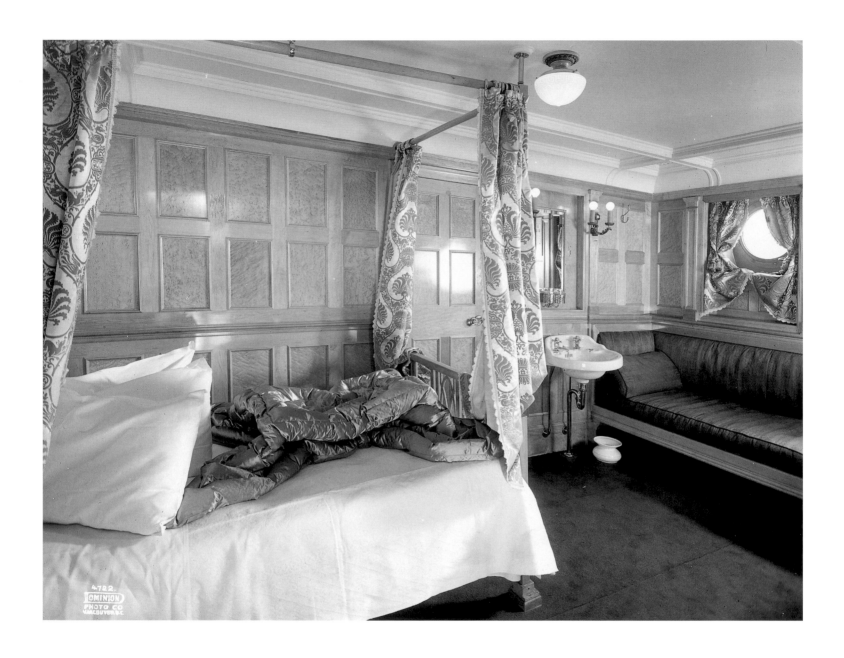

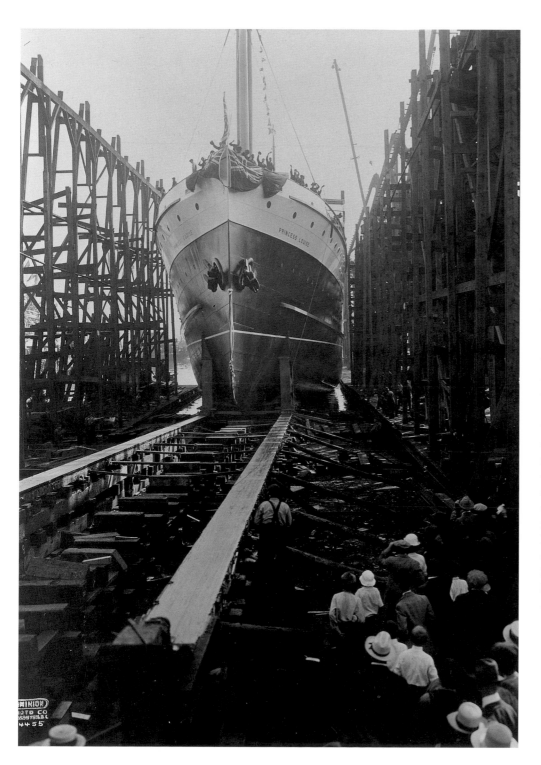

(*Facing page*) Interior view, *Princess Louise*, Vancouver, 1921. Photographer: Dominion Photo Company

This interior view of the CPR's *Princess Louise* shows the fine craftsmanship of the workers at Wallace Shipyard in North Vancouver. The quality was certainly comparable to the work done in Britain for the other Princess ships and proved that B.C. shipyards could compete with their British cousins in the building of first-class passenger liners. As the rich panelling and luxurious furnishings were all manufactured by local firms, the ship was a source of great pride to the public. The *Princess Louise* served the CPR reliably for the next forty years. VANCOUVER PUBLIC LIBRARY 21251

Steamship *Princess Louise*, North Vancouver, 1921. Photographer: Dominion Photo Company

Launching day is August 29, 1921, and the newest CPR vessel, *Princess Louise*, slides into the waters of Vancouver harbour. The CPR had sorely needed a vessel to replace the *Princess Sophia*, which had sunk in the Lynn Canal in 1918. Normally, the company had its vessels built in British shipyards, but, because of the backlog of building contracts in Britain and the resulting inability to give a firm delivery date, it was forced to look elsewhere. To the delight of the west coast industry, the CPR decided to build locally and awarded the contract to Wallace Shipyard. The luxury 4,000-ton steamer was launched with great fanfare, in anticipation of more orders to come. However, this was not to be: the *Princess Louise* was an aberration. As most of the CPR's stockholders were British, future ships were once again christened in English and Scottish shipyards. NORTH VANCOUVER ARCHIVES 27-2505

**Steamship *Fort Camosun*, Esquimalt, June 1942.**
**Photographer: Unknown**

This photograph shows the extensive torpedo damage done to the hull of the North Sands Class freighter *Fort Camosun*. She was built by the Victoria Machinery Depot in 1942 for the United States War Shipping Administration and, after completing her sea trials in June, departed Victoria loaded with plywood on a bare-boat charter for the British Ministry of War Transport. Seventy miles northeast of Cape Flattery, the vessel was attacked by submarine *I-25* of the Imperial Japanese Navy. She was torpedoed and shelled but remained afloat because her cargo of wood gave her positive buoyancy. The *Fort Camosun* was towed into Neah Bay on the American side of Juan de Fuca Strait and then across to Esquimalt to be dry-docked. The hull was repaired and the ship returned to service. After surviving the war, the *Fort Camosun* was finally scrapped in 1960. MARITIME MUSEUM OF BRITISH COLUMBIA 993.017.3089

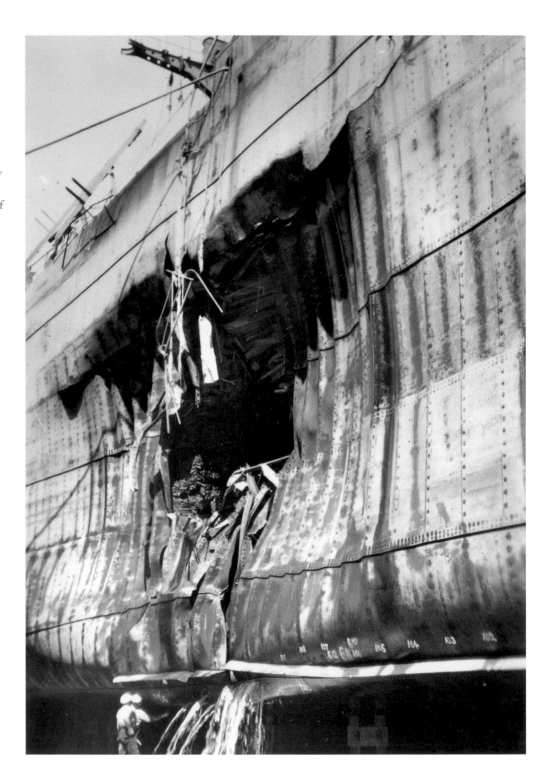

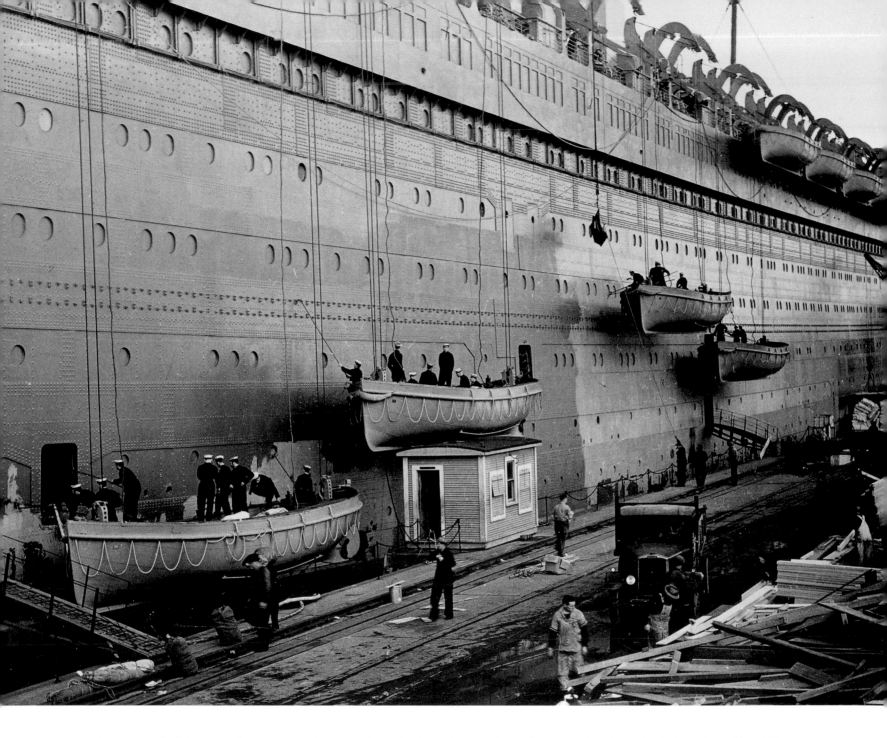

**Passenger liner *Queen Elizabeth*, Esquimalt, 1942.
Photographer: Department of National Defence**
In 1942, the Cunard passenger liner *Queen Elizabeth* was dry-docked in Esquimalt for wartime conversion to a troop carrier. The work was done in just thirteen days under a cloak of secrecy which is hard to imagine, considering that the 85,000-ton liner must have towered over the dockyard. Over a thousand workers laboured day and night to complete the refit, including three hundred naval ratings who applied 10 tons of paint to the ship and sixty high school students who were employed to clean boilers. Three thousand berths were added to the accommodation, and the galley arrangements were enlarged. Few dry-docks in the world could have accommodated the 1,035-foot vessel, which slid into the 1,050-foot Esquimalt dock leaving only 12 inches clearance over the keel blocks. MARITIME MUSEUM OF BRITISH COLUMBIA PQ-5

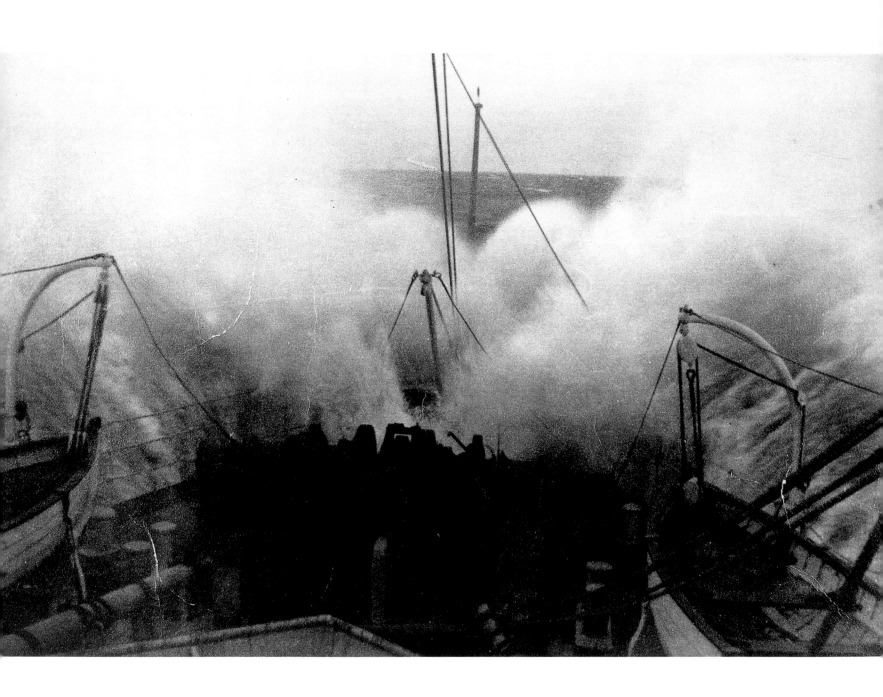

# *Coastal Trade* <span style="float:right">CHAPTER THREE</span>

THE INTRODUCTION OF steam-powered vessels in the mid-nineteenth century made regular travel up and down the coast easier but did not eliminate the dangers. The thousands of miles of rugged coastline and the unpredictable weather could be hazardous to early mariners. Navigators would make passage into "the jungles," as any destination north of Vancouver was known, with little more than a compass, a ship's whistle, a timepiece and a lead line. Practical seamanship and meticulous record-keeping were essential elements in the preservation of ship and crew. Even the most experienced of master mariners, when first subjected to the trial of blind pilotage up the coast in dense fog, were often left humbled. The more prudent would demand time as mate before assuming command of a coastal ship.

In spite of these hazards, steamships became the routine mode of travel and opened up opportunities to expand settlement. The Fraser River gold rush brought huge commercial opportunity to the lower mainland and Vancouver Island. Steamship companies and individuals competed for their share in the transport of thousands of miners and equipment to the gold fields. After the collapse of the gold rush in the mid-1860s, many ships were laid up or scrapped. However, a few companies survived and, in 1883, the first major shipping alliance was formed. The Hudson's Bay Company, whose vessel the *Beaver* had been the first steam-powered ship on the coast in 1836, joined with the East Coast Mail Line and the Pioneer Line to form the Canadian Pacific Navigation Company. With a fleet of freighters and passenger ships, the CPN served the coast for nearly twenty years.

The next to establish itself was the Union Steamship Company of B.C. in 1889. Until this time, coastal service had been a hit-and-miss affair, with little in the way of scheduling. Union soon found that offering a reliable schedule led to capacity bookings and, over the years, a solid reputation. With the regular service provided by the

**Canadian Survey Ship *Wm. J. Stewart*, c. 1935. Photographer: Unknown**
Pounding into heavy seas, the hydrographic vessel *Wm. J. Stewart* makes her way up the west coast of Vancouver Island on a survey trip to Barkley Sound in the late 1930s. Built in 1932 at the Collingwood Shipyard on the Great Lakes, the *Wm. J. Stewart* was a coal-burning vessel of steel and riveted construction, powered by twin triple-expansion steam engines. The *Stewart* was used to replace the ageing survey vessel *Lillooet*, which, along with Royal Navy ships, had been employed in pioneering hydrographic survey work on the B.C. coast. The *Wm. J. Stewart* continued the work of the *Lillooet* by charting much of the province's coastal waterways until she was retired forty-four years later in 1976. BRITISH COLUMBIA ARCHIVES B-06199

steamships, logging, mining and cannery operators found themselves able to set up camps in some of the most remote areas. To meet the increased demand, Union built up its fleet and expanded its shipping routes. The distinctive red-and-black funnels of Union ships and their signature whistle came to stand for reliability to those who depended on them. Until 1959, Union Steamship was part of the fabric of life on the coast and was sadly missed when it closed down.

In 1901, the Canadian Pacific Railway saw the possibilities of expanding its transportation network from land to sea and acquired controlling interest in the Canadian Pacific Navigation Company's ageing fleet of fourteen vessels. The CPR then began a shipbuilding program of modern luxury passenger vessels, the famous Princess ships built to serve the major communities of Puget Sound, the British Columbia coast and southern Alaska. While the company maintained a high public profile with its Triangle Run between Seattle, Victoria and Vancouver, it also maintained a fleet of vessels to serve smaller communities. As competitive as they were, Union Steamship and the CPR carved out their own niches in coastal trade and seldom found themselves in conflict.

The Grand Trunk Pacific Railway, with its new terminus in Prince Rupert, appreciated the advantage the CPR had in combining a shipping fleet and a rail line, and in 1910 entered the arena with its own ships. Like the CPR, its vessels were luxurious and modern, providing weekly service between Prince Rupert, the lower mainland ports and the Queen Charlotte Islands. Grand Trunk was forced into bankruptcy in 1920, and its fleet was absorbed by the Canadian National Railway, which ventured into direct competition with the CPR in the Triangle Run. Unable to compete with the well-established CPR fleet, however, Canadian National suspended the service in the 1930s.

Passenger service fell into decline in the early 1950s. Vessels were very expensive to maintain and the public lost its taste for the luxury and leisure of a sea voyage, preferring the quicker, more accessible and cheaper modes of travel provided by the growing highway system and air transport. Tugs and barges continued to haul supplies, but the docks, once routinely enlivened by excited crowds of passengers, grew quiet, and the ships that had served them for so many years were sold for scrap.

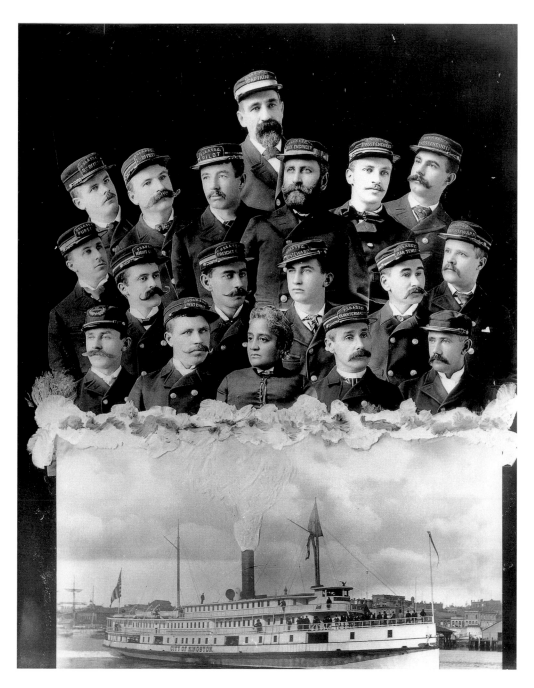

**Steamship *City of Kingston*, Victoria, c. 1890.**
**Photographer: Hannah Maynard**

Hannah Maynard assembled, in this collage, a unique and intriguing group portrait of the *City of Kingston*'s crew. Her darkroom skills allowed her to create many innovative photomontages that won awards from eastern photographic salons. The crew of the *City of Kingston* probably felt as much at home in Victoria as they did in their home port of Seattle, since the ship maintained regular service between the two cities. In 1899, while the *City of Kingston* was entering the port of Tacoma, she was rammed by the Northern Pacific steamer *Glenogle* and was cut in two. Fortunately, the upper works, where the staterooms were located, remained afloat until all the passengers, who had been sleeping when the incident took place, could be rescued. No lives were lost. BRITISH COLUMBIA ARCHIVES G-04392

69

(*Facing page*) **Steamship *Prince Rupert*, Genn Island, March 23, 1917. Photographer: W. W. Westhall**
Navigation on the British Columbia coast could be hazardous, especially when attempting to maintain schedules during the unruly winter weather. The Grand Trunk Pacific's coastal steamer *Prince Rupert* suffered a series of mishaps, beginning in March 1917 while en route to Victoria from Prince Rupert. Within two hours of her midnight departure, in thick weather and poor visibility, the vessel piled up on the west side of Genn Island and was left high and dry. Fortunately, there were no injuries, and the passengers were able to walk ashore to the forest, a mere 30 feet away. The rock pinnacles that had pierced her double bottom had to be blasted away before the vessel could be refloated many weeks later. The ship continued service on the coast until 1956, her career plagued by strandings, collisions and a sinking. VANCOUVER MARITIME MUSEUM

**Steamship *Beaver*, Prospect Point, Vancouver, c. 1889. Photographer: Unknown**
On April 10, 1836, the *Beaver* arrived at Fort Vancouver at the mouth of the Columbia River after a 225-day voyage from England. She was the first steamship to work on the west coast of North America. Originally built for the Hudson's Bay Company as a fur-trading vessel for the North Pacific coast, she was chartered by the Royal Navy for use as a survey ship from 1862 until 1870. In 1874, the *Beaver* was sold to private interests in Victoria and worked as a towboat until she ran aground in 1888 at Prospect Point. For four years, the wreck of the *Beaver*, sitting prominently at the entrance to Vancouver harbour, was a popular subject for photographers, until the wake from a passing steamer, *Yosemite*, dislodged her, and she finally slipped beneath the surface. CITY OF VANCOUVER ARCHIVES BO.P.I.N.3

**New Westminster, c. 1895. Photographer: S.J. Thompson**

The city of New Westminster of the mid-1890s enjoyed lively economic activity. The railway across Canada reached it in 1887, and the establishment of that branch line, together with the city's capacity as a shipping port, well situated it for the export and import of products from all over the world. Plans were made by the city to hold a large industrial and agricultural exposition in the fall of 1898. However, in the late evening of September 10, a fire, started in a hay-filled warehouse on Front Street, spread rapidly up the hill and out in all directions, ending any thoughts of an exposition. By morning, a huge portion of New Westminster lay in ruins. Almost all the major buildings including the city hall, courthouse, public library, two fire halls, opera house, banks, post office and two canneries had been destroyed, as well as most of the major hotels and many residences. Reconstruction commenced immediately, and, within a year, most of the downtown core was rebuilt. In spite of its continued commercial success, however, New Westminster never lived up to expectations that it would become a serious rival to Victoria or Vancouver in economic and political spheres. BRITISH COLUMBIA ARCHIVES A-01834

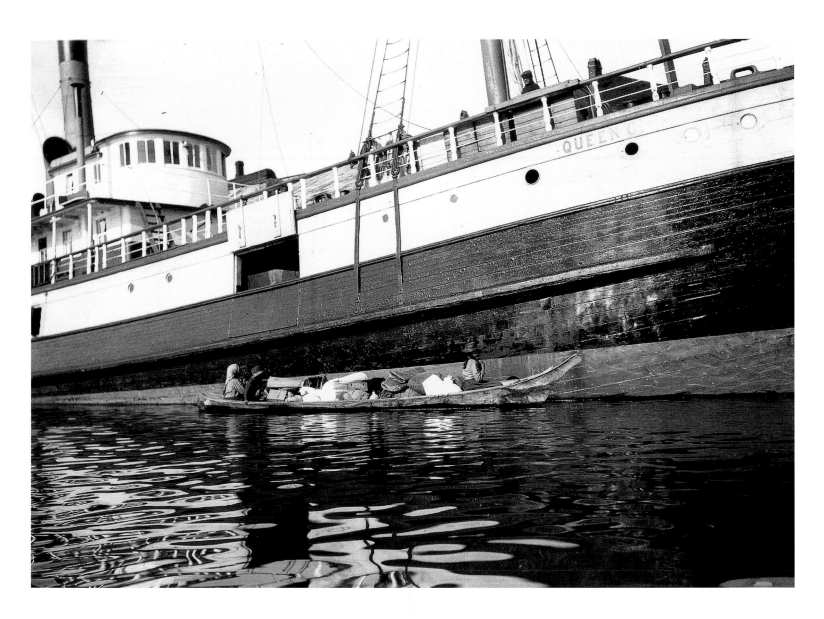

**Steamship *Queen City*, Barkley Sound, Vancouver Island, c. 1900. Photographer: Unknown**

The small steamer *Queen City* was typical of the vessels that served the coast around the turn of the century. Originally built as a three-masted schooner, she was bought by the Canadian Pacific Navigation Company in 1897 and converted into a steamship. At 116 feet in length and travelling at a sedate 8½ knots, she was licensed to carry only 150 passengers. To the remote communities she served, the little ship represented the only link to the outside world, and her routine arrivals were social events of importance. As well as mail and other supplies, the *Queen City* provided a pipeline for news and gossip. Some places on the coast were so small that they had no docks or facilities at which the steamer could tie up, so that supplies had to be transferred ashore in boats or dugout canoes while she stood by. BRITISH COLUMBIA ARCHIVES A-06438

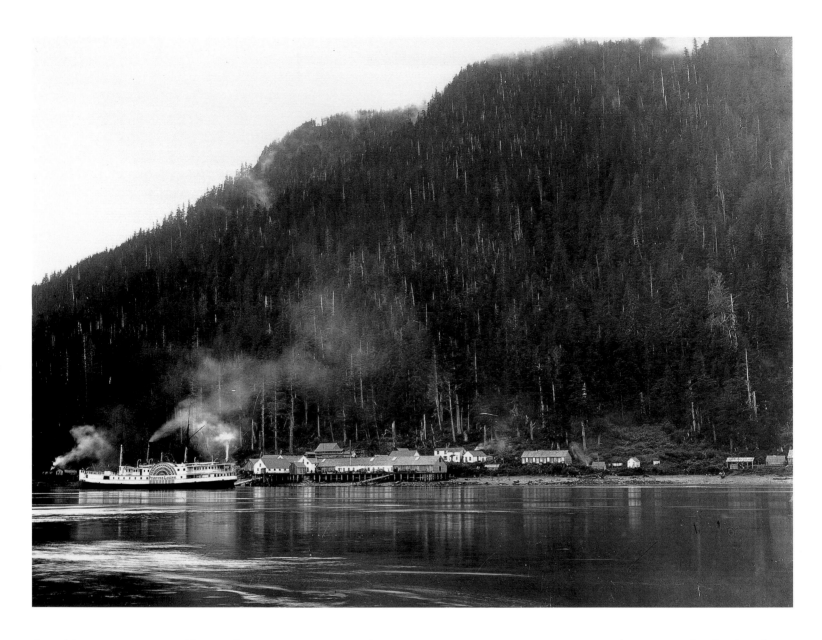

**Steamship *Princess Louise*, c. 1900. Photographer: Unknown**

The *Princess Louise* lies alongside a salmon cannery in a remote inlet on the coast. Improved canning techniques and the establishment of coastal shipping lines made it possible for the fishing industry to expand into unpopulated areas, but, in the early years, service to these communities was scant. Without reliable schedules, some canneries could wait months for a steamer to arrive. The infrequent communication to the outside world made life very hard for cannery workers. During the Alaska gold rush of the late 1890s, ships such as the *Princess Louise* would make passage north to the gold fields, carrying miners and equipment on board, and, on the return trip, stop by these small settlements to pick up cargo and southbound passengers. Bought by the CPR in 1901, the *Princess Louise* was the first in the company's fleet of Princess ships. BRITISH COLUMBIA ARCHIVES G-04908

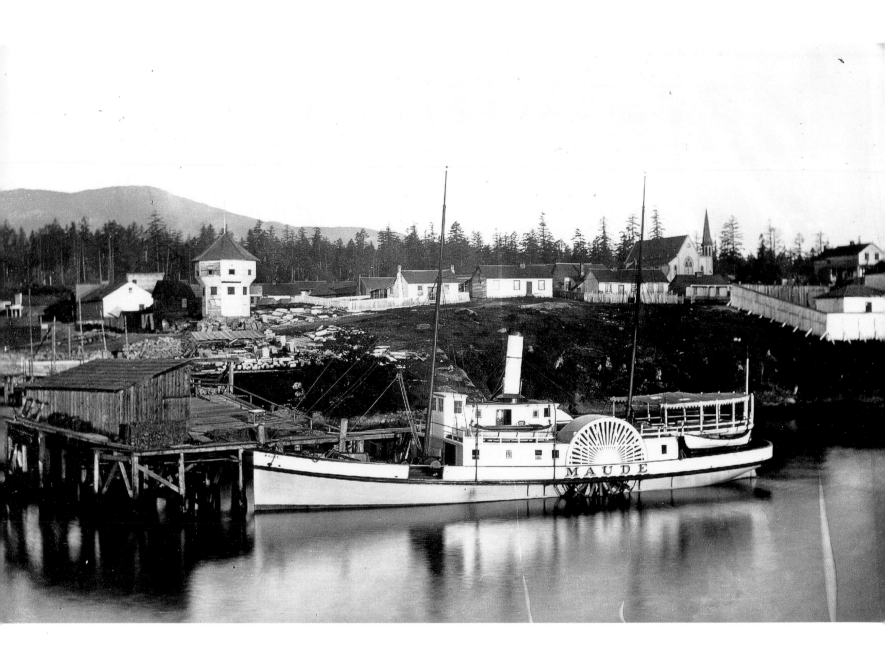

**Steamship *Maude*, Nanaimo, c. 1883. Photographer: Unknown**

The little side-wheel steamer *Maude*, owned by Joseph Spratt's East Coast Mail Line of Victoria, operated mostly on the east coast of Vancouver Island and on the Fraser River. The *Maude* was launched in 1872 on San Juan Island, which, because of a boundary dispute at the time, was under joint British and American jurisdiction. Spratt named his little ship after the daughter of a captain in the British garrison. The vessel was towed to Victoria, where a 150-horsepower engine was installed at Albion Iron Works, also owned by Spratt. In 1883, the newly formed Canadian Pacific Navigation Company purchased the East Coast Mail Line's small fleet, creating a virtual monopoly on shipping in the colony. *Maude* was bought by British Columbia Salvage Company in 1903 and was finally scrapped in 1914. BRITISH COLUMBIA ARCHIVES F-02488

**Victoria harbour, 1898. Photographer: Bert Howell**
The photograph shows two ships tied up to the
Wharf Street docks in Victoria in 1898. The vessel in
the foreground is the *R. P. Rithet*, one of the first in
the Canadian Pacific Navigation Company fleet,
which provided mail and passenger service to
Nanaimo and New Westminster. The other ship, the
*City of Kingston*, belonged to the Puget Sound and
Alaska Steamship Company, and ran between
Seattle, Tacoma and Victoria. In 1897, gold had been
discovered on the Klondike River in the Yukon
Territory, so, by 1898, almost every vessel on the
coast was carrying men and supplies north to
Alaska. Along with many shipping companies on the
coast, the CPN saw the potential in the gold rush and
took the opportunity to expand its fleet. Merchants
in Victoria and Vancouver mounted aggressive cam-
paigns to attract Klondikers to their cities to sell
them supplies and services before they headed north.
The customs house, the first tall building on the
right, still sits prominently on Victoria's waterfront.
B. LARSEN COLLECTION

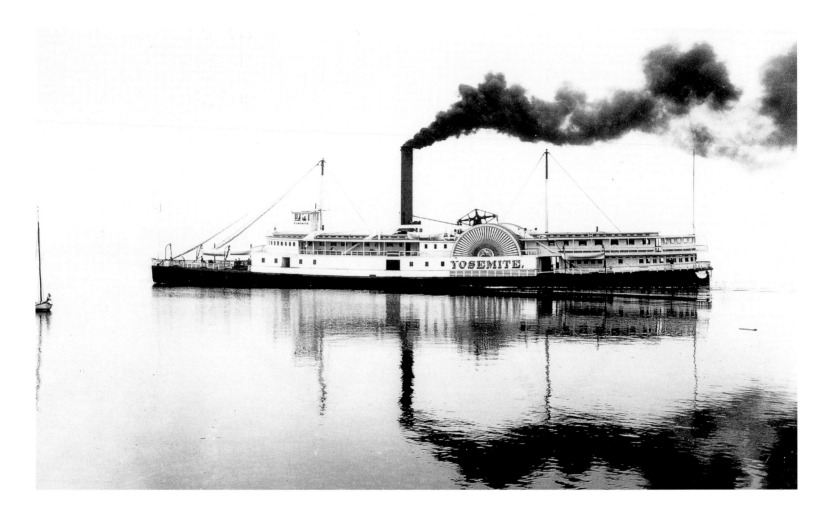

**Steamship *Yosemite*, Vancouver, 1887. Photographer: William McFarlane Notman**

In 1883, the newly formed Canadian Pacific Navigation Company purchased the steamer *Yosemite* in California. At 282 feet in length, the twenty-one-year-old *Yosemite* was the largest as well as the oldest vessel in the company's fleet. In spite of her age, however, she was fast, spacious and comfortable, and proved a valuable asset in the transport of cargo and passengers between Victoria, Vancouver and New Westminster. With speeds up to 17 knots, she could make the trip in four hours and twenty minutes. Apparently, the British Columbia public refused to pronounce her name in the American manner, preferring to call her "Yo-see-mite." The ship served the CPN and later the CPR until 1906. BRITISH COLUMBIA ARCHIVES A-00299

**Union Steamship Wharves, Vancouver, June 6, 1919.
Photographer: Dominion Photo Company**

The Union Steamship Company of B.C. was the
first major coastal passenger and freight company to
operate from Vancouver. It began modestly in July
1889 with the acquisition of three small ships and
grew to become a west coast institution. Union
ships faithfully served the fishing, mining and log-
ging camps up the coast as far as Alaska, and their

signature whistle of one long-two short-one long
and their red-and-white funnels were welcome sights
and sounds. Union ships not only offered regular
service but a sense of community to even the
smallest settlements by providing a direct link with
major centres. During the company's seventy years of
operation, more than fifty ships flew the Union flag.

**Ship unknown, Vancouver Island, 1898.**
**Photographer: S. J. Thompson**

S. J. Thompson was a portrait and landscape pho-
tographer who contributed much to the visual her-
itage of British Columbia. In 1898, he accompanied
federal cabinet ministers on a tour aboard the Coast
Guard steamer *Quadra* to inspect the northern water-
ways at the height of the Klondike gold rush. While
on a coaling stop on Vancouver Island, probably at
Departure Bay, Thompson captured a typical gold-
rush scene aboard this unidentified ship carrying the
would-be miners north. The mounted police in the
foreground are likely checking passengers for cus-
toms and immigration as they enter their first
Canadian port after leaving the United States. The
crowd of men and a few women appear ill-prepared
for the rigours of the Yukon climate and the adven-
tures that lie ahead. CITY OF VANCOUVER ARCHIVES
CVA 137-95

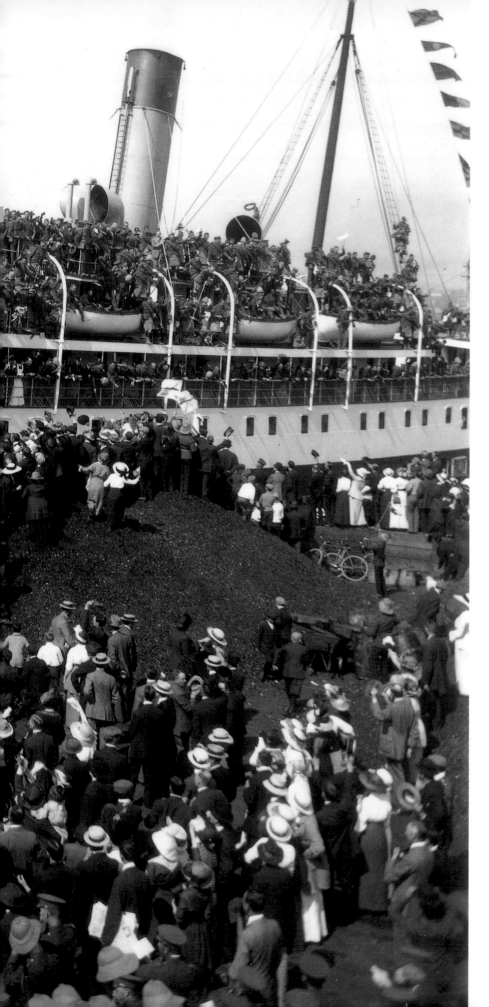

**Steamship *Princess Sophia*, Victoria, c. 1915.**
**Photographer: E. W. A. Crocker**

The *Princess Sophia* loads troops bound for the killing fields in Europe. Sadly, the ship herself did not last until the war's end, as she was involved in the most tragic marine disaster on the west coast. Filled to capacity for her last run of the season, the *Princess Sophia* departed from Skagway, Alaska, on October 23, 1918, bound for Vancouver. While she was transiting Lynn Canal, a storm blew up in the early hours of the morning, and she ran aground in near-zero visibility on Vanderbilt Reef. A fleet of vessels rushed to her aid but were forced to look on helplessly. Because the storm was raging on and the ship was firmly stuck on the reef, it was felt safer for passengers to remain in the relative safety on board the *Princess Sophia* than risk the dangerous transfer to rescue vessels. The ship remained in this state for over a day, waiting, along with those ready to help her, for a break in the weather. Unfortunately, the storm only increased in ferocity and, at five in the morning of the 24th, the radio officer on the *Princess Sophia* sent out a call that the ship was foundering. Unable to navigate in the severe weather, the rescue vessels could not reach her until morning, when they found only the top portion of her mast and not one survivor of the 353 passengers and crew. BRITISH COLUMBIA ARCHIVES I-51630

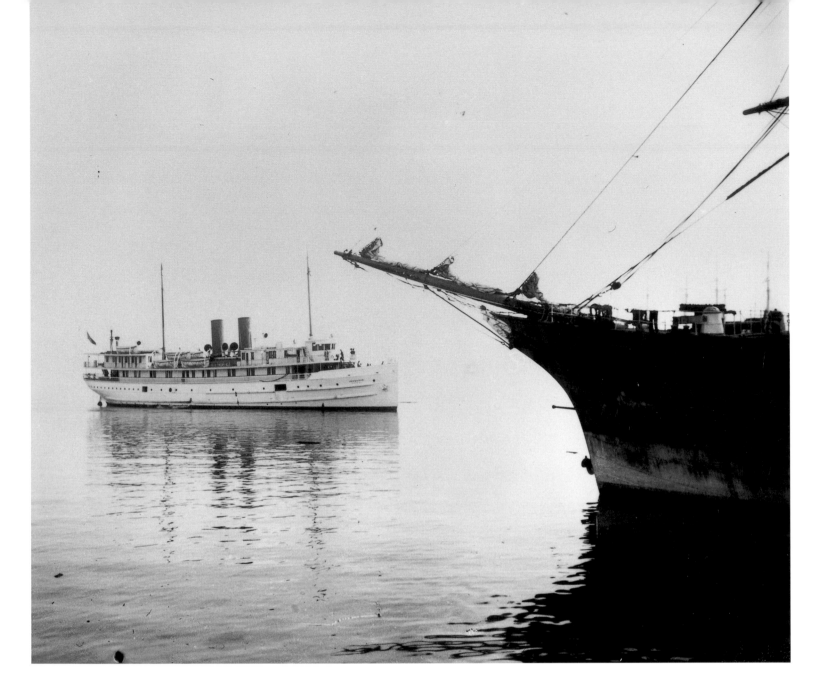

**Steamship *Iroquois*, Vancouver, c. 1907.**
**Photographer: Philip Timms**
Irked by the dominance of the Canadian Pacific
Railway in the Seattle-Victoria run, Joshua Green,
the manager of the Puget Sound Navigation
Company, bought two steel steamers, the *Chippewa*
and *Iroquois*. Green placed the *Chippewa* in direct
competition to the CPR's *Princess Beatrice* and *Princess
Victoria* on the Seattle-Victoria route. He sent the
*Iroquois* to Vancouver, at the time unserved directly
by the CPR. Captain Troop of the CPR countered by

replacing the ageing *Princess Beatrice* with the newer
*Princess Royal* and introducing the Triangle Run that
connected Victoria, Vancouver and Seattle. The
public not only benefited from the rivalry and lower
rates but often wagered on races between the two
passenger lines. VANCOUVER PUBLIC LIBRARY 2961

*(Facing page)* **Canadian Pacific Railway, Pier D,
Vancouver, July 27, 1938. Photographer: Stan
Williams**
On the summer afternoon of July 27, 1938, the

Canadian Pacific Railway's Pier D caught fire.
Within fifteen minutes, the entire creosoted pier was
engulfed in flames. Two ships, the *Princess Adelaide* and
*Princess Charlotte*, were saved by the prompt actions of
their crews. All available fire-fighting equipment, as
well as the fire monitors from two tugs, were put to
use. The pier, home to the Princess ships since 1914,
was completely destroyed, and the fleet was moved
to Pier B-C. No lives were lost but about 30 tons of
cargo, including 4 tons of fireworks, were burned.
BRITISH COLUMBIA ARCHIVES D-05648

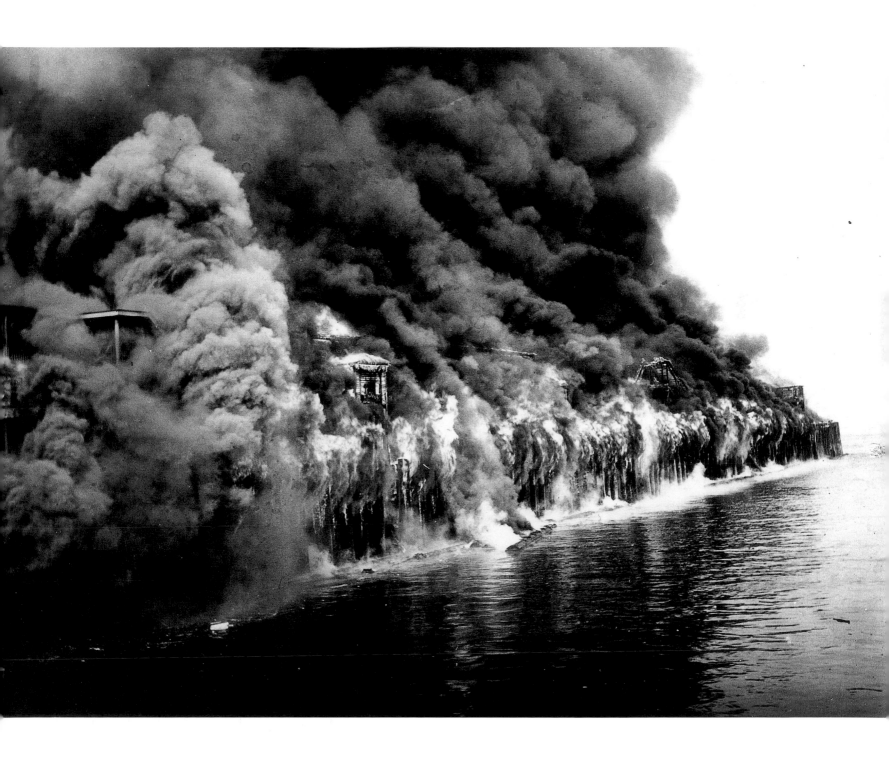

**Steamship *Prince Rupert* at Prospect Point, Vancouver, 1923. Photographer: Leonard Frank**

The Prospect Point signal station opened in 1910 to provide up-to-the-minute marine traffic information on ships entering or leaving Vancouver harbour. The station sat on a bluff 150 feet above Prospect Light. The First Narrows leading into the harbour had become extremely busy as shipping increased, and mariners, who had no way of seeing what lay head, risked collision when rounding the corner at Prospect Point. Through a series of shapes in day-time and lights at night, traffic information was passed on to vessels about to transit the narrows. Black balls indicated inbound ships, and red cones signified vessels departing the harbour. Code flags were used to communicate information such as berth assignments, anchorages or requirements for tugs. At night, signal lamps using Morse code replaced the code flags. The signal station remained in service until the construction of the Lions Gate bridge in 1938, when it was moved to the centre of the span.

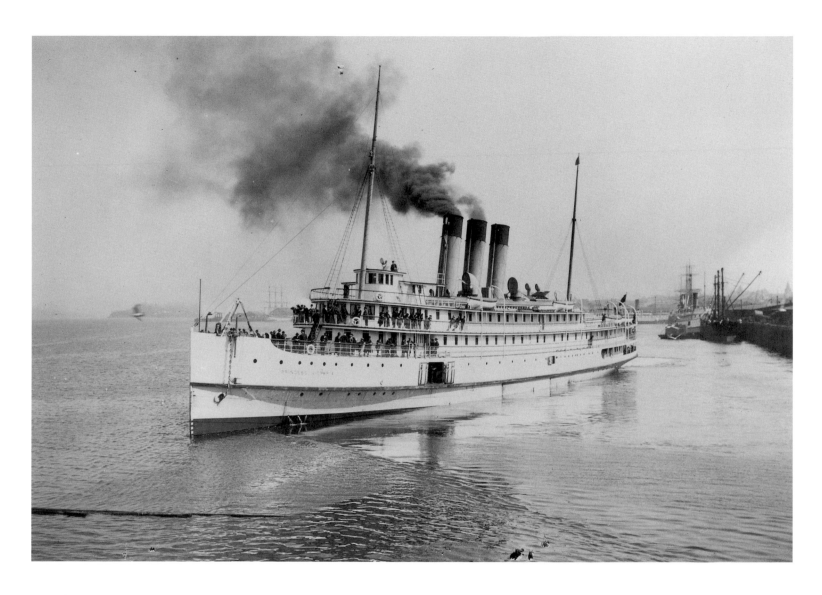

**Steamship *Princess Victoria*, 1937. Photographer: Philip Timms**

Construction of this CPR coastal liner began in 1902 at the Swan and Hunter Shipyard in Newcastle, England, but because of the threat of a shipworkers' strike, was finished in British Columbia. The *Princess Victoria* arrived in Vancouver looking more like a British gunboat than a luxury coastal liner, her three funnels sprouting from an engine room casing and a canvas dodger acting as a bridge. Her elaborate wooden upperworks were completed in Vancouver, and, by the summer of 1903, the latest Princess vessel was ready for service. The *Princess Victoria* set a new standard as the fastest and most elegant steamer on the coast. With her service speed of 19 knots, she could make the Victoria-Vancouver run in just over three hours, and, on the route to Seattle, left all competition in her wake. VANCOUVER PUBLIC LIBRARY 2917

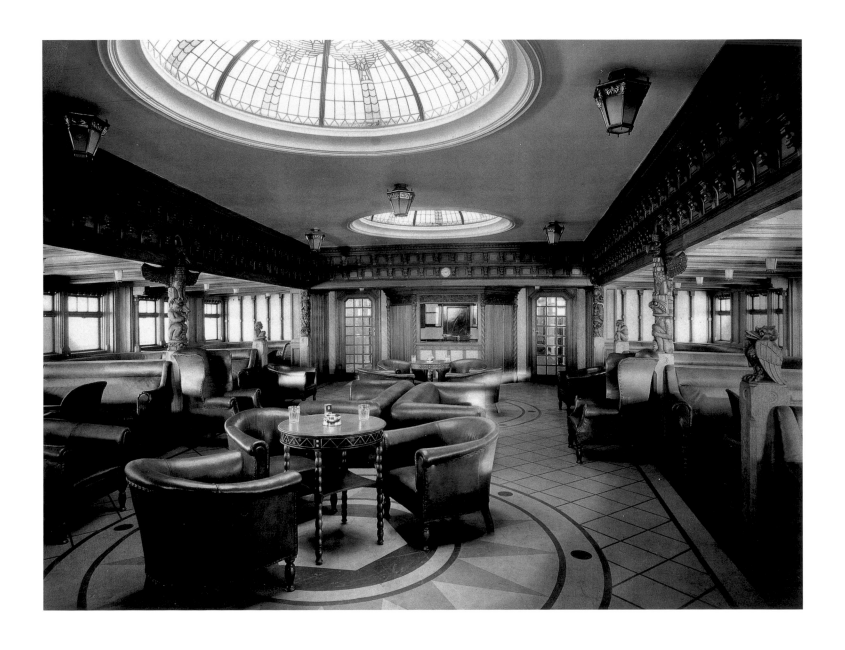

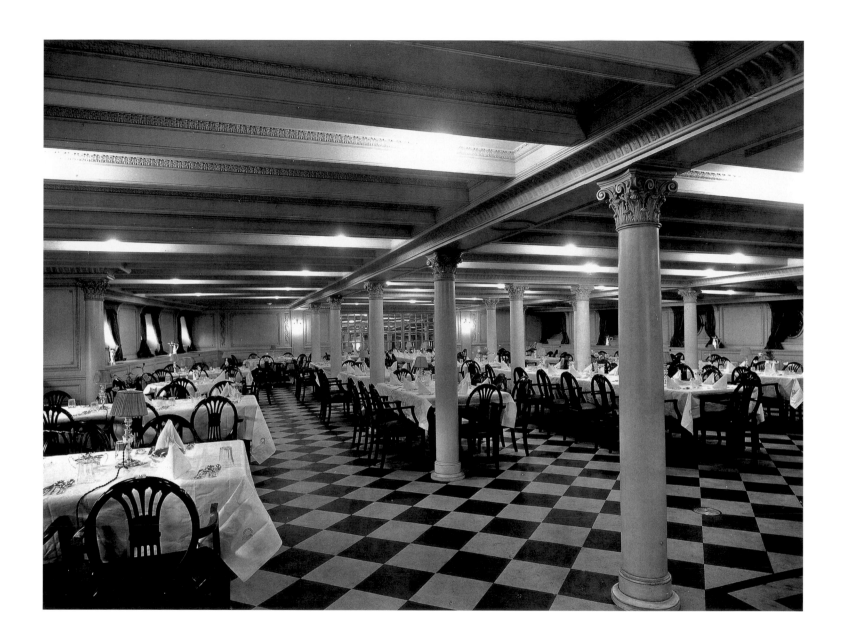

**Steamship *Princess Kathleen*, 1925. Photographer: Unknown**
Elegant and luxurious accommodations were standard requirements of the Canadian Pacific Railway coastal fleet. These two interior views of the *Princess Kathleen (facing page and above)* were typical of the period. Built together in 1925, she and her sister, the *Princess Marguerite*, were 5,875-ton ships, licensed to carry 1,500 passengers and capable of speeds up to 22 knots. They soon dominated the popular Triangle Run between Victoria, Vancouver and Seattle. In 1952, while on a southbound run from Juneau to Skagway, the *Princess Kathleen* accidentally grounded on Lena Point, Alaska. She was held fast and a rising tide began to fill her from the stern. The horrified passengers and crew, who had escaped to shore, watched as the ship filled, was dragged clear of the rocks and sank in the channel. BRITISH COLUMBIA ARCHIVES A-06272 (PAGE 86) and A-06273 (PAGE 87)

**Steamship *Cheslakee*, n.d. Photographer: Unknown**
In 1910, the Union Steamship Company of B.C. planned to upgrade its northern run with the addition of a large coastal steamer, but after the Grand Trunk Pacific announced its intention to enter passenger service on the coast with two large liners, Union settled on a smaller vessel, the *Cheslakee*. Her hull and machinery were built in Ireland, and her superstructure was added in Vancouver by Wallace

Shipyard. While the vessel performed well in the rough seas of her trip from Britain, the addition of the superstructure and topside fittings altered her stability, causing her to behave poorly in wind and current. On a voyage in heavy weather to the north end of Texada Island on January 6, 1913, the *Cheslakee* took on a 25-degree list. The ship managed to limp back to Van Anda on Texada, but just as she was nearing the dock, she rolled over and settled on the

bottom. Eighty-five passengers and crew escaped, but the seven trapped inside the vessel perished. The *Cheslakee* was refloated, dry-docked, cut in half, reassembled and lengthened by 20 feet. With the changes, she proved much more stable and, under a new name, *Cheakamus*, continued to sail for Union until she was sold in 1941. BRITISH COLUMBIA ARCHIVES B-00453

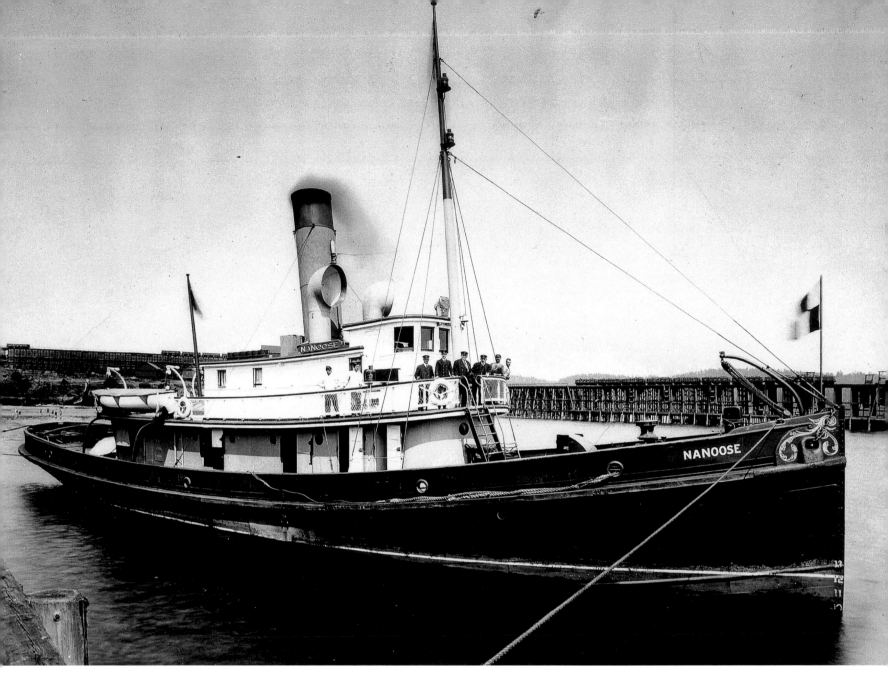

**Steamship *Nanoose*, Ladysmith, n.d. Photographer: K. Broadbridge**

The tug *Nanoose* sits alongside the transfer wharf at Ladysmith on Vancouver Island. Her lines have been slackened and the vessel allowed to drift out so that the photographer could capture this portrait of the ship and crew. The captain, mate, chief engineer, second engineer, two firemen and two Chinese stewards pose on the bridge deck. The tug belonged to the CPR and was built in 1908 at the B.C. Marine Railway Company in Esquimalt. She was used to tow railway barges from Vancouver to Ladysmith, under an agreement with the Esquimalt and Nanaimo Railway. The vessel served the CPR until 1946 and now lies as part of a breakwater for a booming ground at Royston on Vancouver Island.
BRITISH COLUMBIA ARCHIVES A-06322

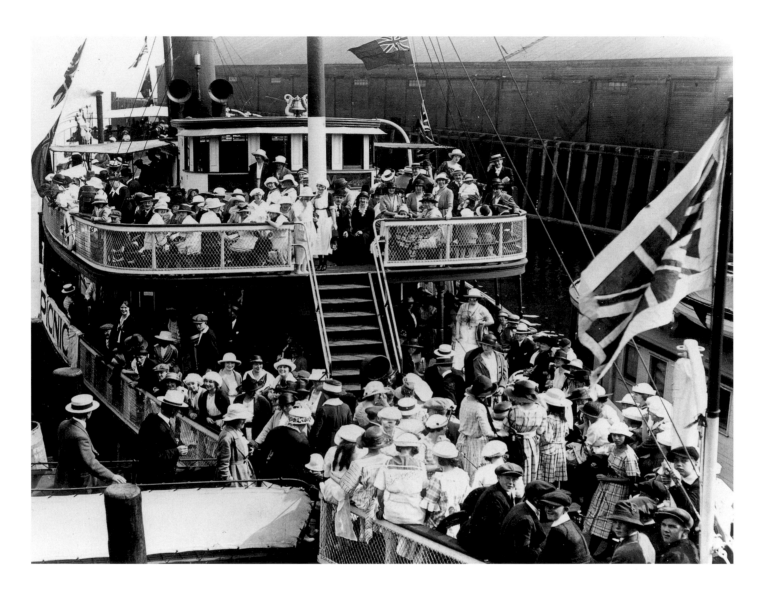

**Steamship *Cheam*, Vancouver, August 1921.**
**Photographer: Unknown**

In 1920, the Union Steamship Company of B.C. saw possibilities in tourism and bought a large property on Bowen Island to transform into a holiday resort. Only an hour's steam away from Vancouver harbour, Bowen quickly became a favourite holiday destination. Company picnics on the island were popular events during this period. Here, the decks of the *Cheam* are crowded with employees and their families on a Hudson's Bay Company outing. As a rule, the crowd that boarded the ship in Vancouver was much more sedate and dignified than the one that returned from Bowen Island. The *Cheam* was the first Union vessel to be dedicated to the excursion trade, and she worked it until her retirement in 1923. The excursion business was so popular that the company introduced four more vessels, called the "Lady" boats, during the next few years. CITY OF VANCOUVER ARCHIVES BO.P.420.N.427

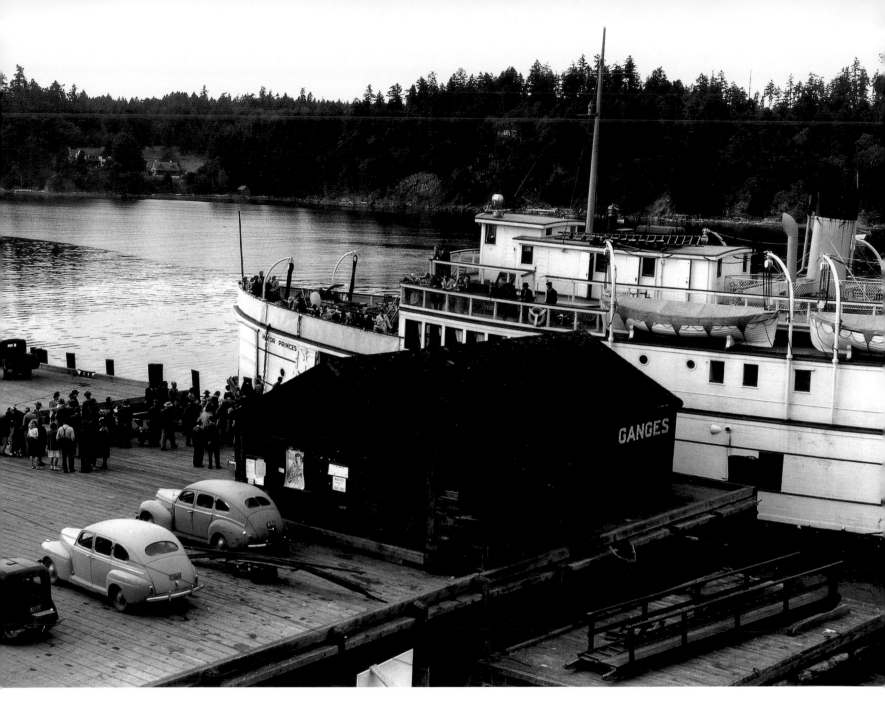

**Steamship *Motor Princess*, Ganges, Saltspring Island, c. 1925. Photographer: Unknown**

Following the new trend in marine transportation, the CPR ordered the first car-carrying ferry to be built at Yarrows Shipyard in Esquimalt. The keel of the *Motor Princess* was laid on January 10, 1923, and the vessel launched ninety-seven days later. Built entirely of Douglas fir and spruce, she was 153 feet in length and had a service speed of 14 knots. Initially, she was designed to carry 45 autos and 250 passen-gers, but this number decreased as automobiles increased in size. The *Motor Princess* was the last vessel built in British Columbia by the CPR for the next forty years. In 1955, she was sold to the Gulf Island Ferry Company for use on the run between Swartz Bay on Vancouver Island and Fulford Harbour on Salt Spring Island, and remained in service when the B.C. Ferry Authority took over control in 1961. Twenty years later, she was retired. BRITISH COLUM-BIA ARCHIVES I-26713

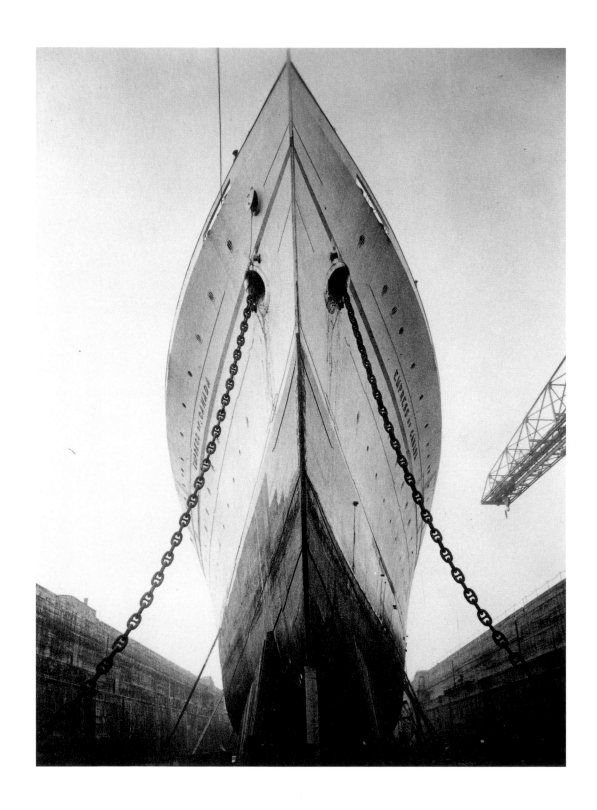

# *Across the Pacific*

O<small>N</small> J<small>ULY</small> 27, 1886, the three-masted barque *W.B. Flint* arrived at Port Moody, the first western terminus of the newly completed transcontinental railway. This small ship, chartered by the Canadian Pacific Railway to link it to the Orient, had crossed the Pacific in thirty-five days, carrying 564 tonnes of tea from China to Port Moody, where the cargo was transferred to thirty boxcars and rushed to Montreal. The new railway had officially opened only weeks before, and this was its first trans-Pacific cargo. The *W. B. Flint* and six more chartered sailing ships used to import tea and export lumber served the route for a year until more reliable carriers could be found.

The link that the CPR developed with the Orient became a major economic force in North Pacific trade. The transcontinental rail line effectively replaced the need for a Northwest Passage through Canada to join Asia and Europe. Products could now be shipped by one company 4,000 miles across the Pacific and a further 3,600 miles by rail across Canada to Saint John, New Brunswick, and from there by other companies across the Atlantic to England or Europe. The insurance rates for moving goods from Asia to Europe using the new and quicker sea-rail route were significantly lower than those charged for the far longer ocean passages around Cape Horn or through the Suez Canal, making it even more attractive. In 1903, the CPR entered the North Atlantic steamship trade, which further consolidated its position and allowed for still more efficiency in transport between the Orient and Britain.

Vancouver soon replaced Port Moody as the terminus for the CPR. The location of the city, the most westerly in continental North America, provided ships with the shortest route to China across the North Pacific. The key to success was to supply efficient, regular and reliable transportation across the Pacific and, to achieve that, the CPR would have to end its use of sail and employ steamships. The CPR initially chartered three steamships, the *Abyssinia, Parthia* and *Batavia*. When lucrative mail subsidies

**Steamship *Empress of Canada*, Esquimalt, 1929. Photographer: Unknown**

The sharp, sleek hull of the *Empress of Canada* soars skyward as she sits out of water in the federal graving dock in Esquimalt harbour. The Canadian Pacific Railway luxury liner had grounded on William Head off Victoria in heavy fog. She was on a return trip from England with new engines and had arrived at the Juan de Fuca Strait on October 13, 1929. Although her speed was low when she struck the rocks, damage to the 21,000-ton ship's bottom was considerable, extending over 145 feet. Twenty plates had to be repaired or replaced. The ship had to be lightened before tugs managed to tow her off the rocks on October 15. The *Empress of Canada* was moved into dry-dock, and Yarrows Ltd. immediately started work repairing the vessel's bottom. Approximately 275 workers completed the job within eighteen days, and the ship sailed for Hong Kong, missing only one scheduled sailing. MARITIME MUSEUM OF BRITISH COLUMBIA P 3368

from the British government were secured and the success of the route was assured, the CPR began building a fleet of steamships specifically for the North Pacific trade.

The first of these new steamships entered service in 1891. Her name, *Empress of India*, symbolized the luxury and prestige that the CPR desired for its liners. She was the first of seven Empress ships built in Britain. Two more liners were bought and refitted to CPR standards. For fifty years, the Empress ships provided unequalled service on the North Pacific, dominating the trade in silk, tea and other products, and transporting thousands of passengers, first class to steerage. The company's reputation was based on elegance, speed and efficiency. The last of its ships to enter Pacific service, the *Empress of Japan* (the second of that name), was the finest of her line and, in the early thirties, set records that remained unbroken for three decades.

The CPR was not without rivals on the route to the Orient. Both Japanese and American interests successfully captured a share in the trade. As early as 1896, the Nippon Yuen Kaisha Company ran ships between Hong Kong, Japan and Seattle, connecting with the Northern Pacific Railway in the United States. In the 1930s, it went into direct competition with the CPR by placing three luxury liners on the run to San Francisco. As well, the American Dollar Line operated its President ships between San Francisco, Seattle and Yokohama. Although these lines were comparable as far as speed and service went, they lacked the advantage the CPR had in its shorter route and more efficient rail service.

Liners crossing the Pacific were not limited to destinations in the Orient. In 1893, the Union Steamship Company of New Zealand ran ships between North America, Australia and New Zealand. Called the All Red Route, it connected British Empire countries around the world. In 1931, the CPR bought a half-interest in the company and established the Canadian Australian Line, operating the *Aorangi* and *Niagara* on the route. It supplied an important commercial trading link and a vital mail service between these countries. The ships were luxurious and comparable to the Empress liners, providing passengers with the high degree of comfort required to meet the CPR's demanding standards.

Passenger service across the Pacific was so severely interrupted by the Second World War that the industry never recovered. All the major liners were requisitioned as military transport, and few survived the war. Of the four CPR Empress ships, only the *Empress of Japan*, renamed *Empress of Scotland*, remained, and she served on the Atlantic routes until 1957. The *Empress of Asia* was bombed and sunk in 1942 off Singapore, the

*Empress of Canada* was torpedoed and sunk in the South Atlantic, and the *Empress of Russia* was destroyed by fire in 1945. The *Niagara* was sunk off New Zealand in 1940, leaving only the *Aorangi* in service on the Pacific. After the war, she returned briefly to her former role, sailing between Canada, Australia and New Zealand. The end of the war brought new travel patterns in which airplanes became the dominant means of travel all over the world. That, combined with the high cost of operation, brought an end to regular passenger transport by sea across the Pacific.

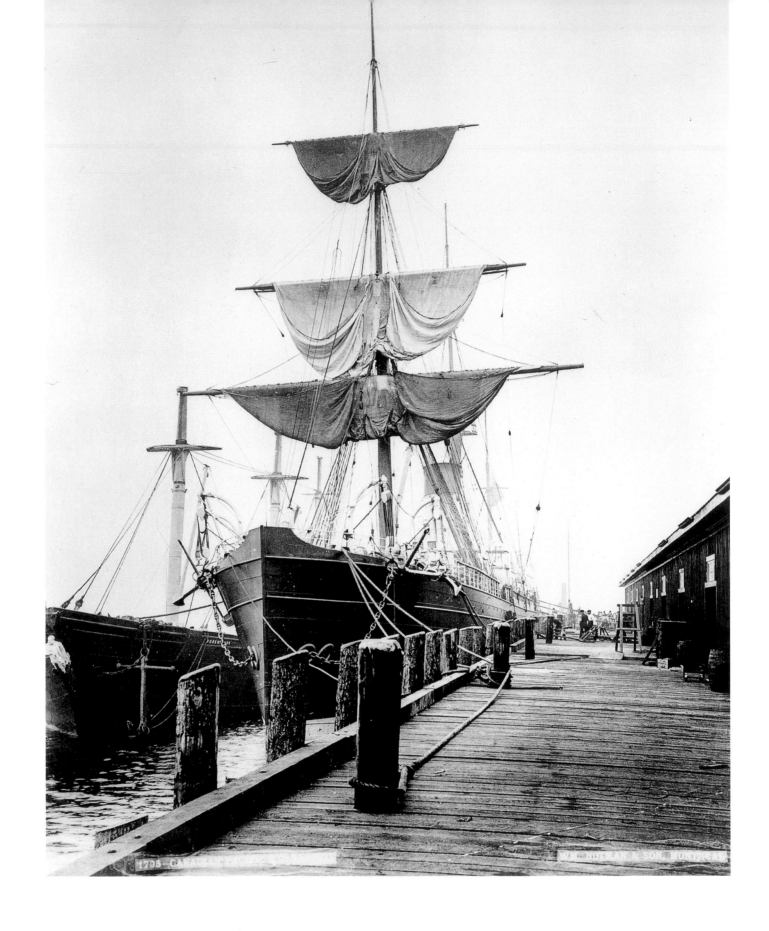

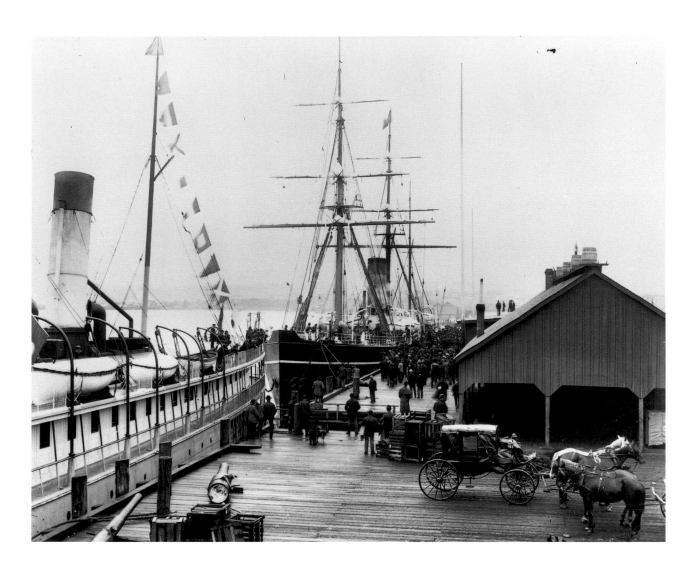

(*Facing page*) **Steamship *Parthia*, Vancouver, 1887.**
**Photographer: William McFarlane Notman**
The *Parthia* lies alongside a wharf in Vancouver in 1887, taking on fuel from the coaling hulk *Robert Kerr*, which is secured to her starboard side. The *Parthia* was one of the steamships chartered by the CPR as an interim measure until the company was able to build its own fleet. The ships were old and still carried sail as auxiliary propulsion, but they provided the CPR with regular routing across the Pacific. One of the longest serving ships on the west coast, the *Parthia* changed ownership several times but continued Pacific service until 1956, when she was towed to Japan for scrap. BRITISH COLUMBIA ARCHIVES A-00303

**Steamship *Abyssinia*, Vancouver, 22 May 1890.**
**Photographer: Bailey & Neelands**
A crowd of well-wishers gathers before the CPR's *Abyssinia* to greet the Duke and Duchess of Connaught, visiting British Columbia on part of a world tour. A carriage waits to take them to accommodations in Vancouver, whence they will catch the train to eastern Canada. In the foreground, dressed with flags, is the steamship *Islander*, which belonged to the Canadian Pacific Navigation Company and ran between Victoria and Vancouver. The two large cannons on the wharf are likely waiting to be shipped to Esquimalt harbour for naval defence. The *Abyssinia* was eventually returned to England and used for service on the Atlantic. On December 13, 1891, the ship caught fire and was destroyed. VANCOUVER PUBLIC LIBRARY 19888

**Steamship *Empress of India*, Vancouver, c. 1895.**
**Photographer: Charles S. Bailey**

This photograph, taken by prominent Vancouver
photographer Charles S. Bailey, shows the interior
view of the rather modest but comfortable living
quarters of the captain of one of the most presti-
gious vessels afloat on the Pacific, *Empress of India*.
The cabin was located adjacent to the wheelhouse,
giving the master immediate access at any time of
the day or night. The room is richly paneled in hard-
wood and compactly furnished with chairs and a
settee, but, apart from a few mementoes on the desk
and perhaps the prints on the bulkhead, reveals little
of the man who commands the ship. BRITISH
COLUMBIA ARCHIVES A-01797

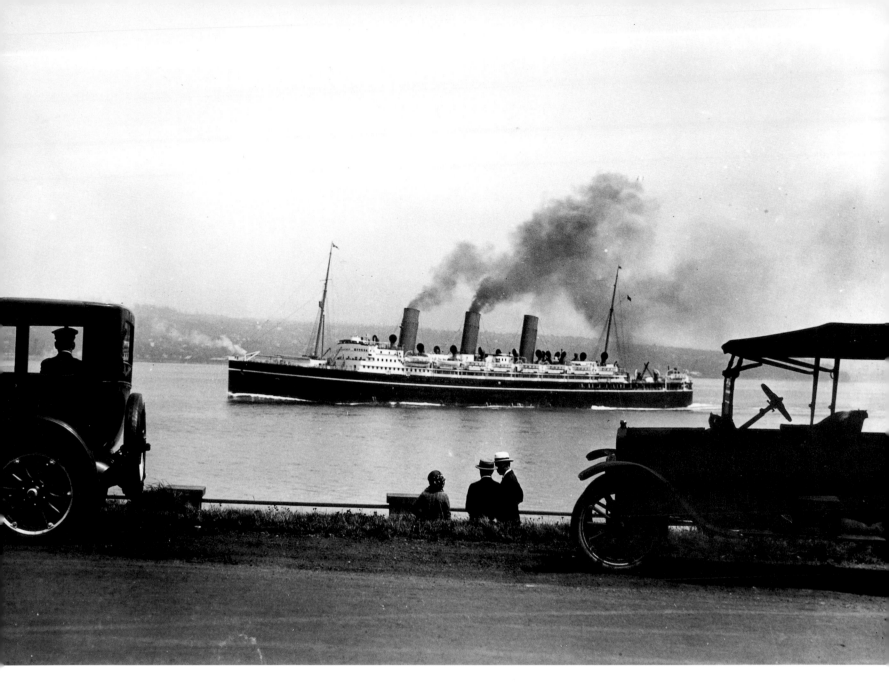

**Steamship *Empress of Asia*, Vancouver, 1924.**
**Photographer: Leonard Frank**

This classic photograph showing the *Empress of Asia* bracketed by two luxury vehicles is a scene typical of the kind used by promoters of the city in the 1920s to advertise the spirit of relaxation and prosperity to be found in Vancouver harbour. The *Empress of Asia* and her sister ship, the *Empress of Russia*, were built in 1913 to replace the three original Empress ships, then past their prime. The CPR had been losing ground on the trans-Pacific run by the turn of the century

and needed a newer fleet incorporating all the latest advances in marine technology. These new vessels also featured the most luxurious and elegant first-class accommodation to be found on the Pacific Ocean. The *Empress of Asia* was requisitioned for military service in both world wars, in the first as an armoured merchant cruiser and in the second as a troop ship. Sadly, she was bombed and sunk by Japanese aircraft in February of 1942 near Singapore.

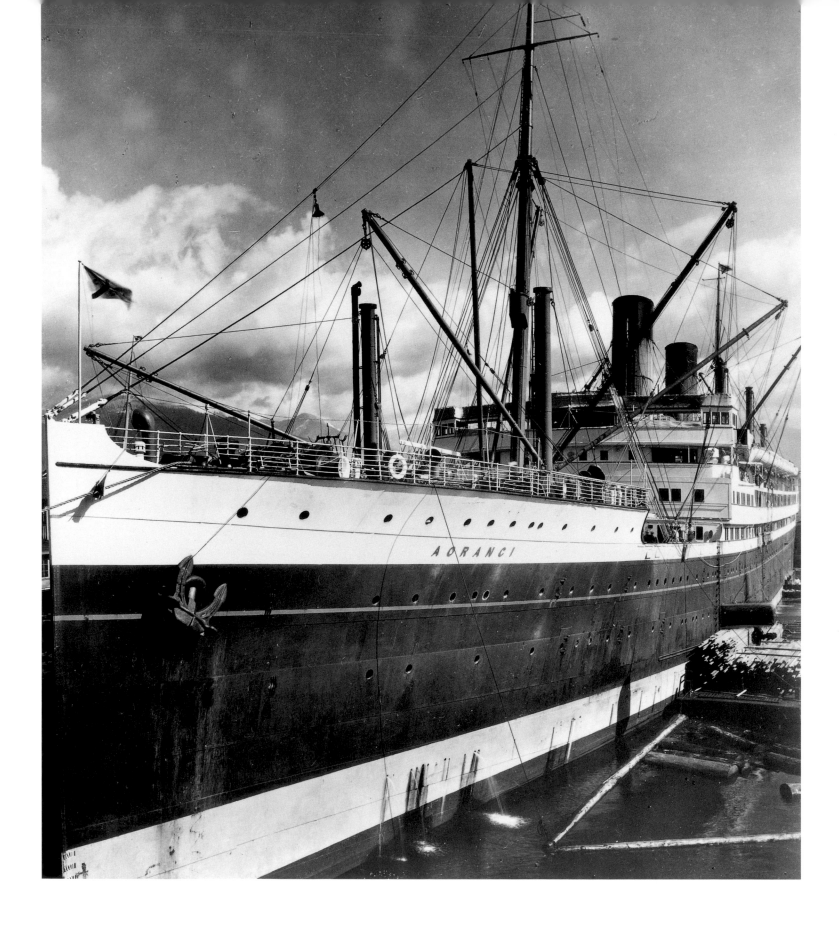

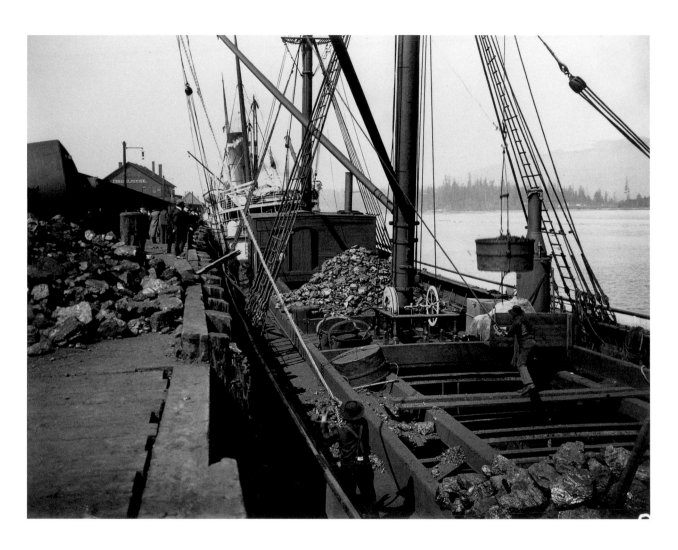

(*Facing page*) **Motorship *Aorangi*, Vancouver, 1929. Photographer: Leonard Frank**
The *Aorangi* was operated by the Union Steamship Company of New Zealand, along with the *Niagara*, between Australia, New Zealand and Canada. Built in 1924, twelve years after the *Niagara*, the *Aorangi* was the largest motorship in the world. Her advanced features included diesel engines, which gave far greater fuel economy than coal-burning ships. Her passenger accommodations were comparable to those of the Empress ships in comfort and elegance. The *Aorangi* remained in service to the line until the Second World War, when it entered the Admiralty

service as an armed merchant cruiser. After the war, the ship returned to Pacific routes until 1953, when she was scrapped. VANCOUVER PUBLIC LIBRARY 2734

**CPR dock, Vancouver, c. 1905. Photographer: Unknown**
A colliery ship unloads a cargo of coal at the CPR dock in Vancouver harbour. A plentiful supply of high-grade coal was available on Vancouver Island and at Nagasaki, Japan. These two fuelling stations were essential for the maintenance of reliable steamship service across the Pacific. The first

Empress ships burned between 1,200 and 1,500 tons of coal on a single crossing. The ready supply on both sides of the ocean doubtless influenced the decision to continue using coal in the next generation of Empress ships, when other companies were converting to oil. The vessel in the background is the *Moana*, which belonged to the Union Steamship Company of New Zealand. The *Moana* replaced the ageing *Warrimoo* in 1901 and served the Canadian route until 1908. VANCOUVER PUBLIC LIBRARY 2930

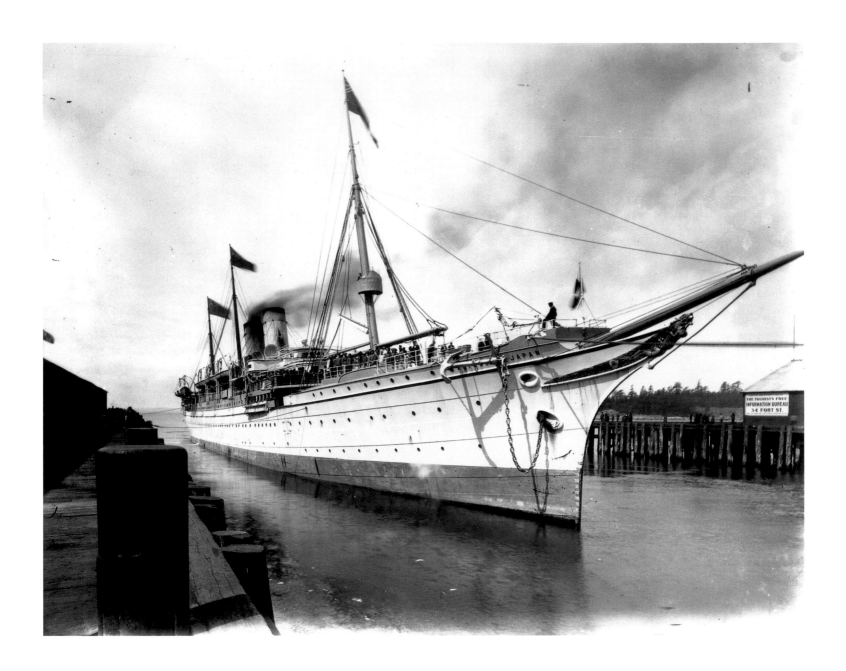

102

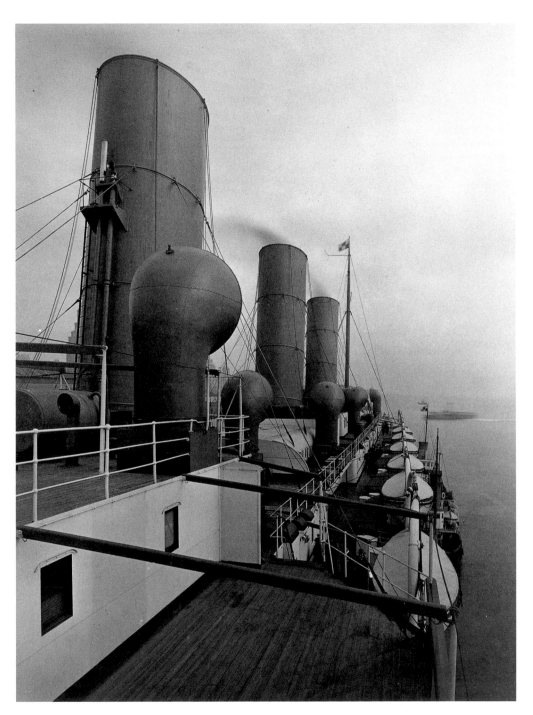

(*Facing page*) **Steamship *Empress of Japan* (I),
Victoria, c. 1895. Photographer: Unknown**

The *Empress of Japan* takes mooring lines as she docks
at the outer wharf at Victoria. She was the second of
three Empresses to enter service on the Pacific in the
early 1890s. With a design that had traditional fine
lines, a clipper bow, a counter stern and a carved
figurehead beneath a lengthy bowsprit, these ships
radiated elegance and speed. They were built by the
CPR specifically for the trans-Pacific route and, at 455
feet in length, were much larger than the ships the
company had previously chartered. Although subsi-
dized for the transport of mail by the British and
Canadian governments, the Empress ships featured
first-class passenger service, as well as carrying a vari-
ety of trade goods such as tea, silk, rice and opium.
Their lovely lines and beautiful appearance were not
altogether an indication of sea kindliness, however,
as they had a tendency to roll and could be uncom-
fortable in heavy seas. Nonetheless, their service
speed of 16 knots made them the fastest regular
transport across the Pacific. The *Empress of Japan* con-
tinued in service until 1922, when she was replaced
by a newer generation of passenger ship. BRITISH
COLUMBIA ARCHIVES G-00917

**Steamship *Empress of Russia*, port side boat deck,
c. 1914. Photographer: Unknown**

The *Empress of Russia* was the first of a new genera-
tion of ships for the CPR on the Pacific. She and her
sister ship, the *Empress of Asia*, outclassed every liner
then on the trans-Pacific routes. These ships were
launched in 1913 at the Fairfield Shipbuilding and
Engineering Company in Govan, Scotland. The
vessels were so well designed and the quality of
construction so high that they withstood the effects
of time and travel, remaining attractive and competi-
tive in the passenger trade on the North Pacific for
the next quarter of a century and more. The follow-
ing two photographs, showing the interior of the
ship, are part of a leather-bound presentation folio
given to the master of the *Empress of Russia*. VANCOU-
VER MARITIME MUSEUM

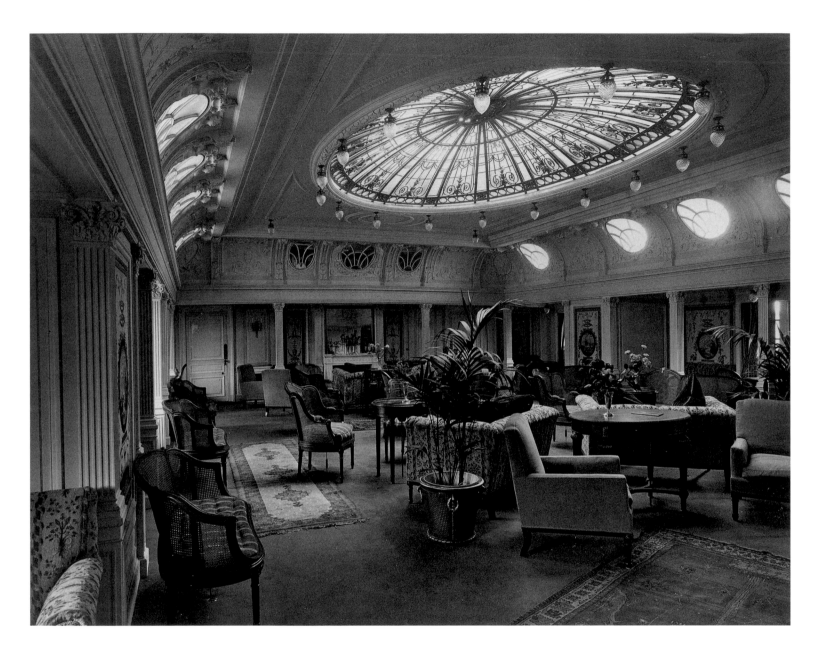

Steamship *Empress of Russia,* first-class lounge
VANCOUVER MARITIME MUSEUM 3533

(*Facing page*) Steamship *Empress of Russia,* first-class
dining salon VANCOUVER MARITIME MUSEUM 3532

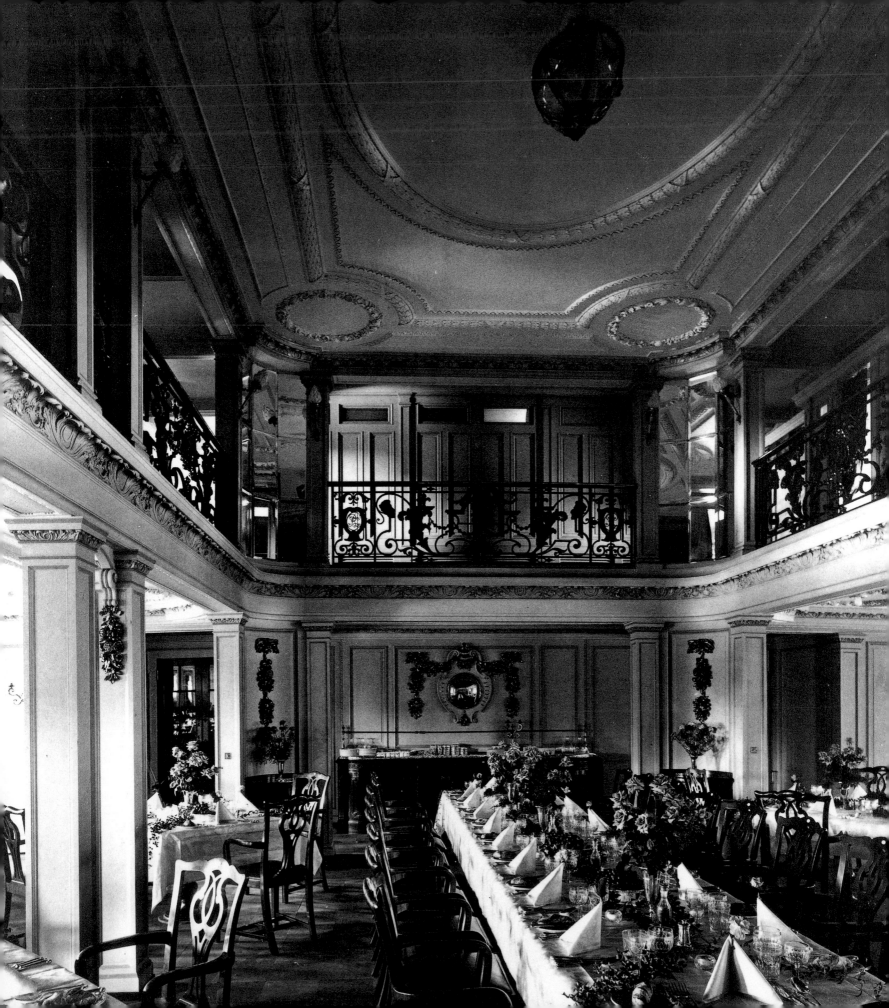

(*Previous page*) **Steamship *Empress of Japan* (II), c. 1935.**
**Photographer: Unknown**

The *Empress of Japan* arrived in Vancouver in the summer of 1930 and was greeted with great enthusiasm. The massive 26,032-ton liner, with a service speed of 21 knots, was the largest and fastest passenger liner ever to provide regular Pacific service. She entered the water in June 1930 at the Fairfield Shipyard in Scotland, where the three previous Empress ships, *Russia, Asia* and *Canada*, had been built. At the time, she was the ultimate Empress ship and set a new standard for excellence. In 1931, under the command of Captain Samuel Robinson, the *Empress of Japan* set a trans-Pacific speed record from Yokohama to Victoria of seven days, twenty hours and sixteen minutes. This record stood for thirty-one years. Sadly, although her construction represented the technological peak of the Empress ships, she was the last liner built for the CPR's Pacific routes. MARITIME MUSEUM OF BRITISH COLUMBIA P.981.17.4

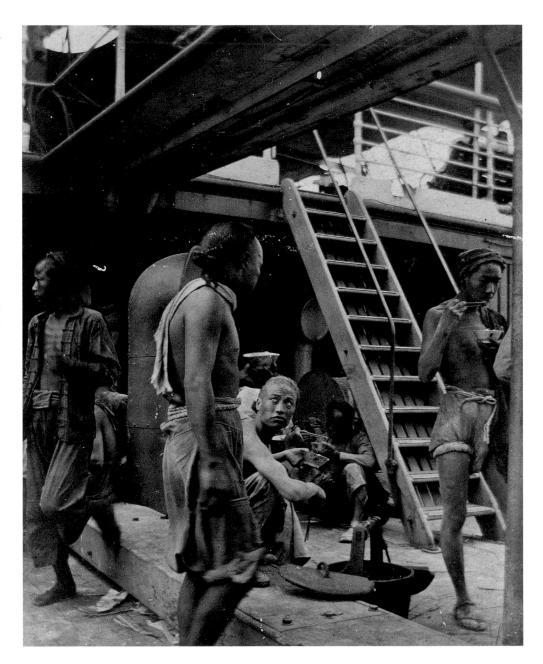

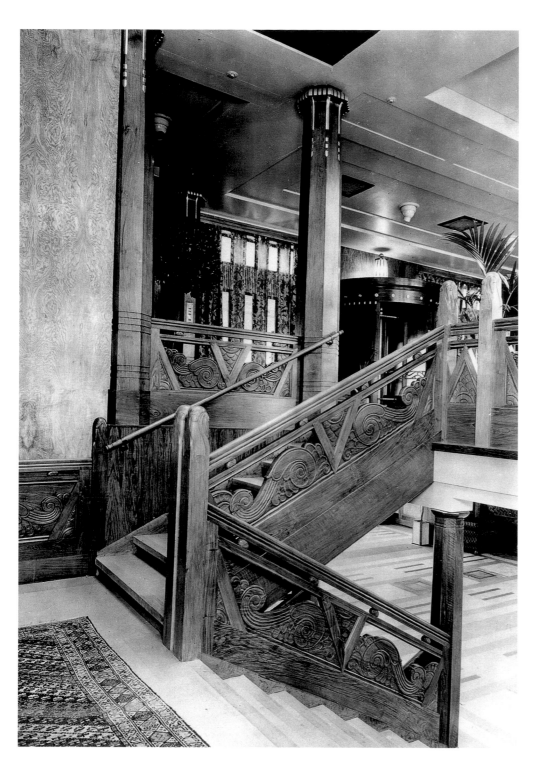

While promotional literature and photographs of the CPR fleet always emphasized the luxury of the ocean liners, many thousands of passengers travelled in steerage. Mostly Asian immigrants, they set out for North America in search of employment. This photograph gives a rare glimpse of living conditions in steerage on a CPR liner. Although an improvement on the squalor that typified life in steerage on earlier immigrant ships, the all-male quarters pictured here were often very crowded and offered no privacy. Very few Asian women were allowed to immigrate, and most men planned to return to China, enriched with Canadian wages. From the mid-1880s, immigration from the Orient supplied cheap labour to railroads, canneries and lumber camps. In an effort to limit the flow, Canada increased the head tax, a sum paid by Chinese immigrants before they were allowed entry into the country, to $500 in 1903, and in 1923, the government enacted legislation that ended immigration from China altogether. VANCOUVER PUBLIC LIBRARY 12866

**Steamship *Empress of Japan* (II), c. 1930. Photographer: Unknown**
Art deco staircase leading to the first-class entrance hall on the promenade deck. BRITISH COLUMBIA ARCHIVES F-00276

**Steamship *Empress of Canada*, bridge wing port side and motor launch port side (*facing page*), c. 1922. Photographer: Stewart Bale**
Some of the images that were frequently used in advertising and publicity for the Empress line came with the ships from Britain. The CPR hired the Stewart Bale Company of Liverpool to take a photo- graphic portfolio of the *Empress of Canada* after she had been completed in Scotland. The exquisitely detailed, large-format pictures of the ship in its pris- tine state, taken by those talented photographers, now form an essential element in the visual heritage of the CPR's Empress liners. MARITIME MUSEUM OF BRITISH COLUMBIA P99.66 (PAGE 110) AND P99.63 (PAGE 111)

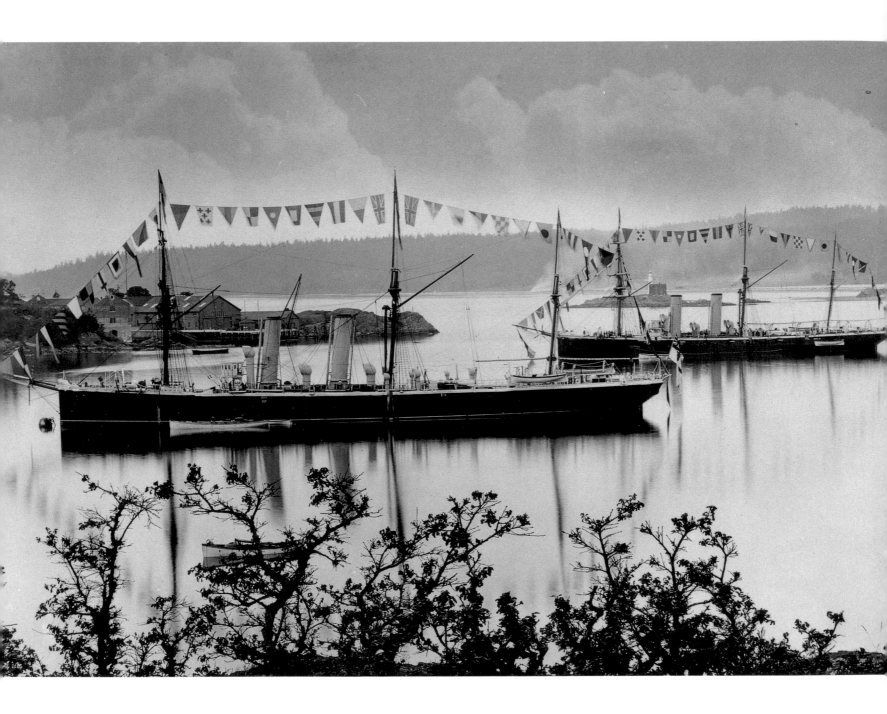

# *The Naval Presence*

ON NOVEMBER 9, 1910, the British government formally transferred its base at Esquimalt to Canada, ending the Royal Navy's protective role on the Pacific coast. The base had been virtually shut down in 1905, when Britain concentrated its Far Eastern Fleet in Hong Kong. Superior communications and faster ships meant that, as far as Britain was concerned, the Pacific region could be better and more economically served from afar. Reactionary forces could be quickly summoned to shore up defence when and where necessary.

The British fleet had been operating from its northern base in Esquimalt harbour since the mid-1850s. Royal Navy ships patrolled a huge area, designated as the Pacific Station: it was bounded on the east by the west coast of both Americas, on the south by Chile, on the north by the Bering Sea and on the west by the International Dateline on the mid-Pacific Ocean. The Royal Navy's presence protected British interests and maintained sovereignty during the period when colonies were establishing themselves on Vancouver Island in 1849 and on the mainland in 1858. In 1866, the British government encouraged the two colonies to join in forming British Columbia and, in a move designed to prevent American encroachment on the area as well as to reinforce colonial defence, officially relocated the Pacific Fleet to Esquimalt harbour from Valparaiso, Chile.

The Royal Navy ensured the enforcement of British law, especially when thousands of miners, mostly American, descended on the lower mainland during the Fraser River gold rush of 1858. The navy was called on to support colonial authority by maintaining gunships at the entrance of the Fraser River and by registering the human tide of prospectors. It also acted as a deterrent to American desires to annex lands north of the border and ensured that British and colonial voices would be heard in the boundary negotiations over the San Juan Islands. The Royal Navy protected settlers in the

**Naval ships at anchor, Esquimalt harbour, c. 1897. Photographer: Unknown**
HMS *Amphion* and *Leander*, two Royal Navy ships, sit at mooring buoys inside Duntze Head in Esquimalt harbour. They were two of the four ships of this class, the others being HMS *Arethusa* and *Phaeton*, which also served on Pacific Station. All were of similar design. The 4,300-ton ships were 300 feet long, and carried ten six-inch guns and four torpedo tubes. On this occasion, in true Royal Navy fashion, the ships have been scrubbed, polished, painted and dressed with flags and bunting to celebrate what is possibly Queen Victoria's Diamond Jubilee. CITY OF VICTORIA ARCHIVES 98603-07-1426

remote trading posts of the Hudson's Bay Company from attack by Native people and acted to prevent the illicit trade in alcohol, particularly from Americans, to the Natives. The presence of British warships on the coast was a comfort to the new colony, especially at times of crisis, such as occurred with the threat of invasion from Russia during the Crimean War. After Confederation in 1867, the government of Canada was not prepared to undertake the new nation's defence and relied on the Royal Navy to continue in that role. It took over forty years for Canada to enact a naval defence policy for the protection of its own coastline.

The new Royal Canadian Navy formed by that policy in 1910 had, as its nucleus, two elderly warships purchased from the British: HMCS *Niobe* assigned to Halifax and HMCS *Rainbow* assigned to the west coast. These two ships were used for training and were served by Royal Navy officers on loan from Britain. Although the formation of a Canadian navy was heralded during the transfer ceremonies, the general public had little enthusiasm for it and regarded a new armed service as largely unnecessary. Thus, Canada entered the First World War with no more than these two ageing cruisers and a handful of auxiliary vessels. Most of the six thousand Canadians who enlisted served in the Royal Navy due to the lack of Canadian vessels. The *Niobe* and *Rainbow* were scrapped in 1920, replaced with two destroyers and one cruiser provided by Britain, but the government remained unenthusiastic about maintaining a naval fleet. During the 1920s, the Royal Canadian Navy shrank to fewer than five hundred officers and men. The status quo was more or less maintained when, in 1922, the cruiser *Aurora* was retired and, in 1928, the two old destroyers *Patrician* and *Patriot* were replaced by two ships, the *Vancouver* and *Champlain*. However, in 1931, changes in government and changes in attitude brought about the acquisition of two brand-new destroyers built by British shipyards, HMCS *Skeena* and *Saguenay*. These two ships were the first to be designed and built specifically for the Royal Canadian Navy.

When war was declared on Germany in 1939, Canada entered the conflict with six destroyers, four minesweepers, one training schooner, a training ship, a trawler and an enlistment of fewer than two thousand officers and ratings. During the course of the Second World War, over 106,000 men and women joined up, and a massive Canadian shipbuilding program of unprecedented scale supplied ships to both the Royal Navy and the Royal Canadian Navy. In six years, Canada's fleet grew to 250 ships: destroyers, frigates and corvettes with an auxiliary fleet of minesweepers, patrol vessels and support craft. With Royal Navy traditions and training, the Royal Canadian Navy

developed into a formidable and disciplined body. Most of the fleet was employed in the defence of the Atlantic convoys to Britain. Forces on the British Columbia coast saw little action, even after the entry of Japan into the war. The west coast yards and naval base supported the conflict in the Atlantic theatre by supplying it with men and ships. Few ships were left in the Pacific, and duties for patrolling the coast were relegated to the Fishermen's Reserve, which operated the over fifty fish boats requisitioned for naval service during the war.

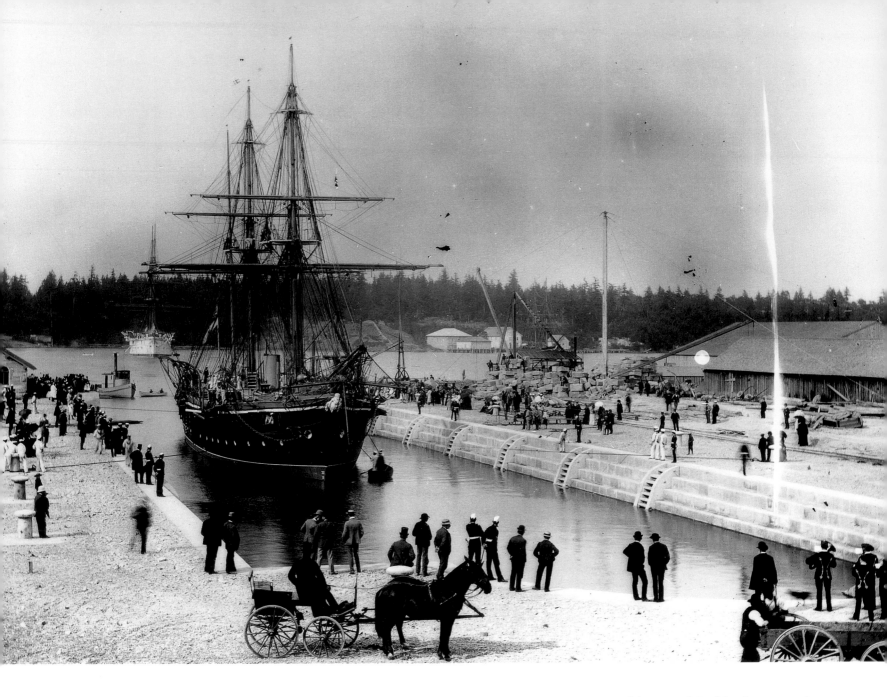

**HMS *Cormorant*, Esquimalt, July 20, 1887.**
**Photographer: Richard Maynard**

This photograph commemorates the opening-day ceremony of the new graving dock in Esquimalt harbour. HMS *Cormorant* had the honour of being the first ship to use the facility. HMS *Triumph*, the flagship of the Pacific Fleet, sits at anchor in the background. The dry-dock had long been needed by British warships, since the nearest alternative had been a floating dock with limited load capacity in San Francisco. The new dock, built to fulfil the require-ments of the terms of Confederation, was 400 feet long and could accommodate vessels up to 7,300 tons. It proved a valuable asset for the Royal Navy and, as well, was an important factor in attracting merchant trade to the Pacific Northwest. In only its first seven years of operation, the dry-dock serviced seventy British warships and twenty-four merchant ships. BRITISH COLUMBIA ARCHIVES A-04645

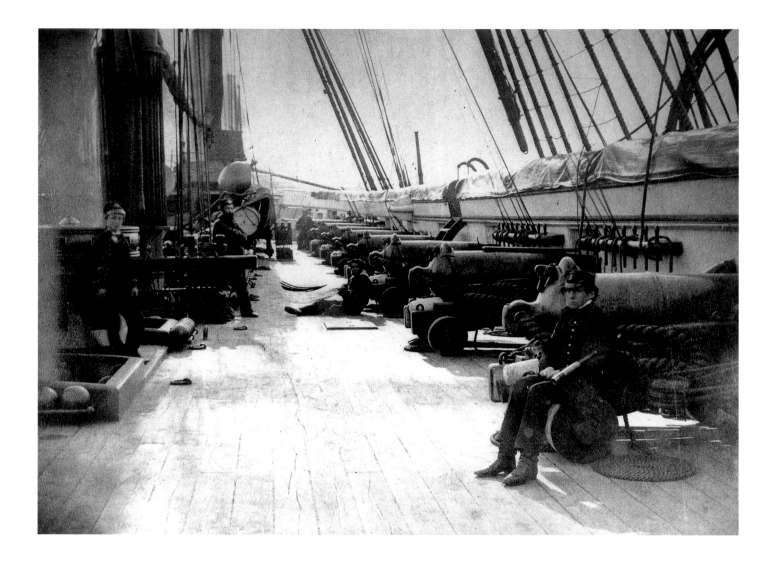

**Gunboat** HMS *Satellite*, **main deck, c. 1858.**
**Photographer: Lieutenant Richard Roche**
One of the earliest photographs taken on the B.C. coast came from the camera of a young lieutenant in the Royal Navy on board the Pearl Class screw corvette HMS *Satellite*. Not always as tranquil as the photograph suggests, the *Satellite*'s role in the defence of the colony was an important one. By June 1858, approximately ten thousand prospectors had descended upon the lower mainland in search of gold on the Fraser River. Foreseeing the lawlessness that could ensue should the situation remain unpoliced, Governor James Douglas ordered the twenty-one gun *Satellite* to patrol the mouth of the Fraser and gave her the job of issuing licences to the hordes of American miners arriving daily from San Francisco. He also dispatched a party of marines from the *Satellite* to Fort Langley to assist the overwhelmed customs office. The desire for gold riches proved too strong for some of the crew and twenty sailors later deserted the ship in search of their fortune. BRITISH COLUMBIA ARCHIVES A-00259

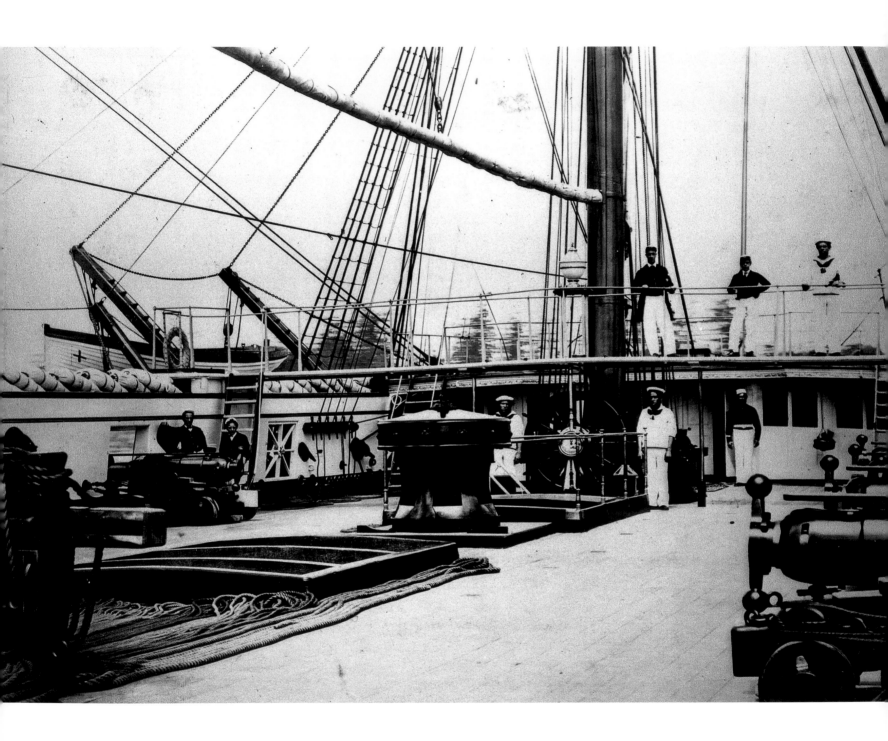

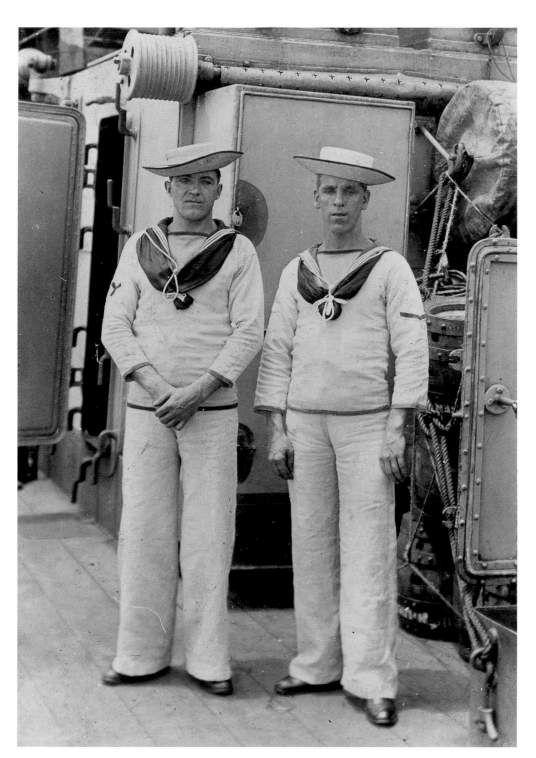

(*Facing page*) HMS *Sutlej*, c. 1865. Photographer: Frederick Dally

HMS *Sutlej* arrived in Esquimalt on June 12, 1863. She was a screw frigate of 3,005 tons, carried thirty-five guns and was manned by a crew of 510. The *Sutlej* was one of the few vessels of the Royal Navy to engage in military action on the British Columbia coast. In August 1864, the trading sloop *Kingfisher* was attacked at Matilada Creek in Clayquot Sound and its crew murdered by a group of ten Ahousat Indians. HMS *Sutlej* and *Devastation* were dispatched to the sound to apprehend the suspects. The Ahousat band put up a determined resistance to the capture of its chief, Chapchah, and his supporters. Throughout the fall, both sides were engaged in a minor frontier war, the renegade chief being chased from village to village. In the end, nine villages and sixty-four canoes were destroyed by the devastating cannon and rocket fire of the British warships, and at least fifteen Ahousats lost their lives. All attempts to capture the elusive chief, however, proved futile. BRITISH COLUMBIA ARCHIVES E-01354

Seamen on HMS *Newcastle*, Victoria, 1914. Photographer: Unknown

On what must have been a hot day in Victoria, two sailors aboard the light cruiser HMS *Newcastle* are dressed to go ashore in their tropical whites. The propeller on the sleeve of the sailor on the left identifies him as an engine room stoker; the single chevron on the left sleeve of the other sailor indicates that he is an able seaman. Both wear the traditional whites and straw sennit hat of the period, a uniform that dates back to the first Royal Navy dress regulations of 1857 and that continued to be worn until 1921. The three white tapes on a blue collar are often thought to represent the three victories of Admiral Horatio Nelson and the black scarf to mourn his death. The costume was in fact a regulated version of the most popular form of dress for seamen that had evolved from the previous century. MARITIME MUSEUM OF BRITISH COLUMBIA P91C

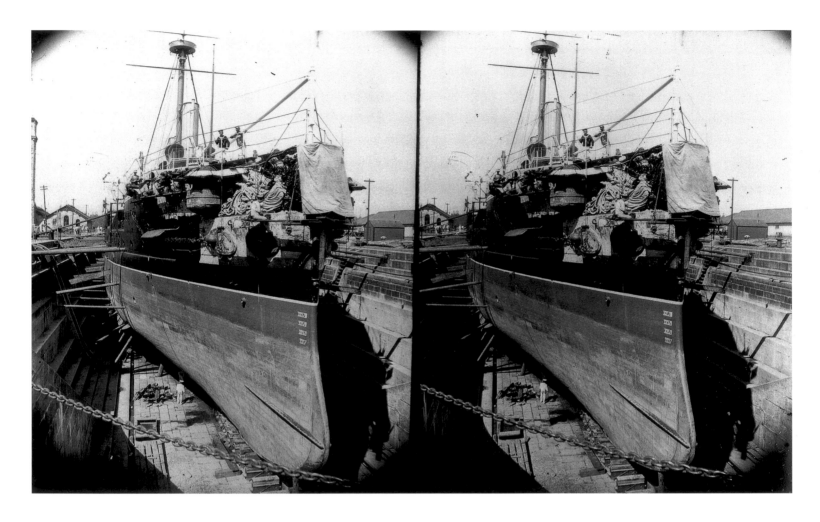

HMS *Warspite*, Esquimalt, c. 1891. Photographer: Richard Maynard

A popular form of photographic presentation was the stereograph, one of the small marvels of the Victorian age. A special stereoscopic camera took a pair of views a few inches apart. After the two photographs were printed, side by side, on a single heavy card, they were then viewed through a stereoscope that merged the two images into a single three-dimensional view. An example is shown here in a photograph taken by Richard Maynard of HMS *Warspite* in the Esquimalt dry-dock. The fourteen-gun Protected cruiser, sister ship to HMS *Imperieuse*, was the flagship of Rear Admiral Charles Hotman from 1890 to 1893. BRITISH COLUMBIA ARCHIVES G-04385

(*Facing page*) HMS *Flora*, Denman Island, December 1903. Photographer: Unknown

On December 3, 1903, HMS *Flora* left Union Bay on Vancouver Island after taking on a cargo of coal. On her return to Esquimalt, she struck Village Point on Denman Island and began taking on water. As the vessel settled on the rock with the falling tide, 40 feet of her bow became exposed and the stern sank. The after section of the ship flooded, but, fortunately, there were no injuries. B.C. Salvage Company was contracted to refloat the *Flora* and made six attempts to pull her off. On the final attempt, one week after the ship was grounded, with the aid of HMS *Grafton*, they succeeded. As the engine room had not taken on water, the *Flora* was able to make dry-dock in Esquimalt under her own power. She remained on station at Esquimalt until 1905. BRITISH COLUMBIA ARCHIVES G-01170

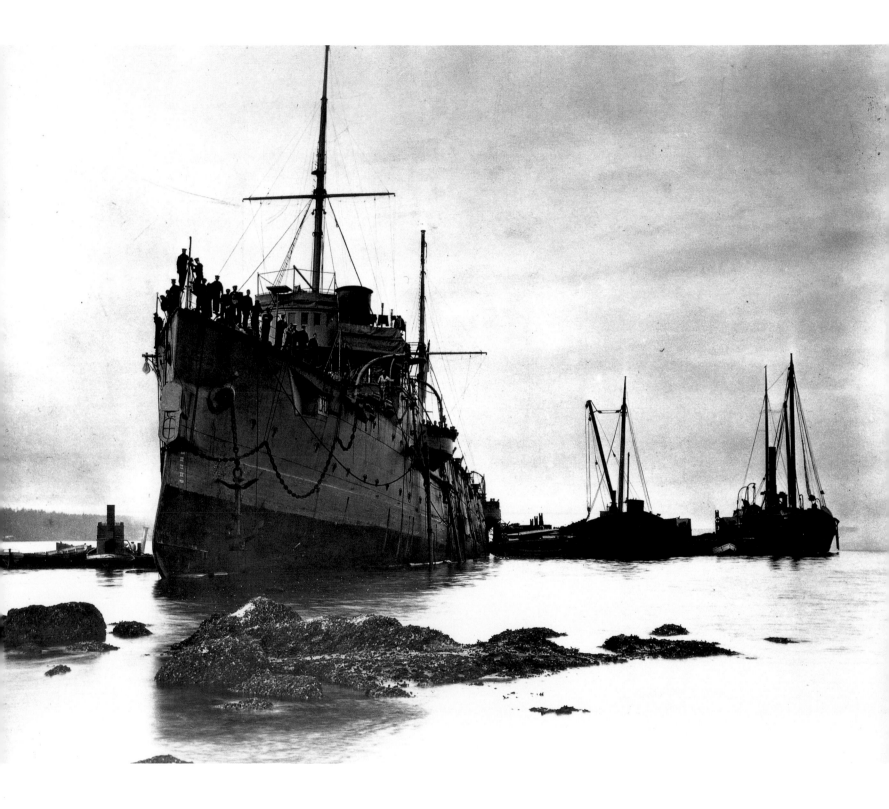

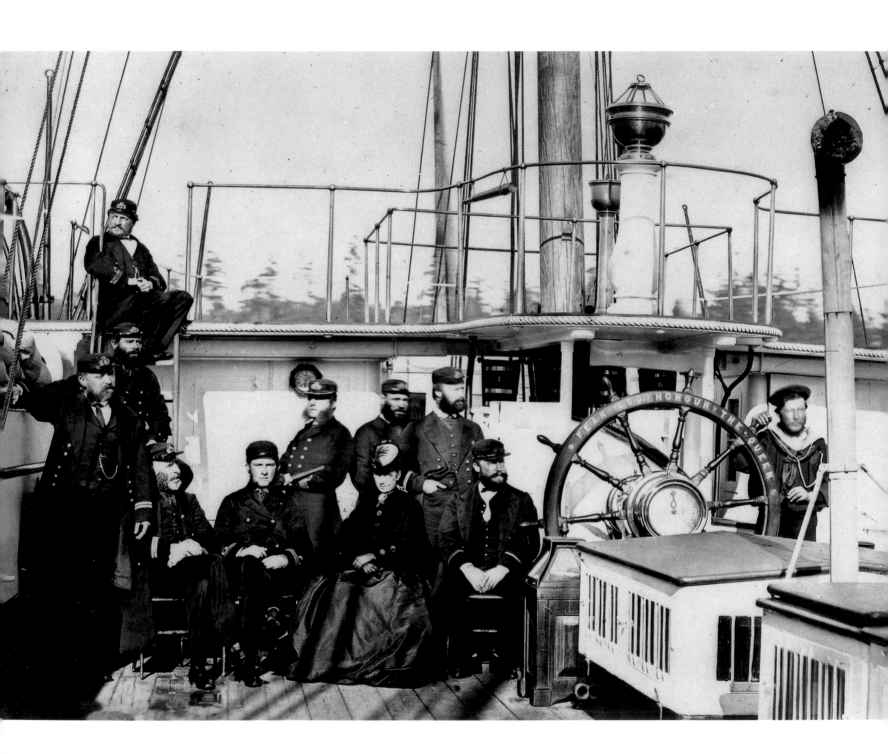

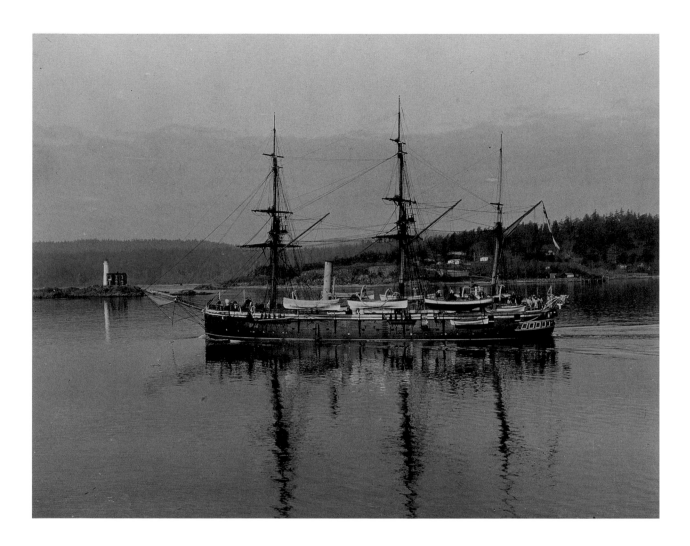

(*Facing page*) HMS *Sparrowhawk*, Esquimalt, c. 1868.
**Photographer: Frederick Dally**
This photograph shows the officers and an
unidentified woman on the deck of the gunship
*Sparrowhawk*, on station in the Pacific from 1866 until
1872. She was small and carried only four guns, but
could be effectively used for inshore police enforce-
ment. Many ships such as this were used to extend
the arm of British law in her colonies. Sometimes,
their commanders needed only to provide a show of
force, firing rockets or guns, to maintain order
among the coastal Native people, but on other occa-
sions, they felt compelled to seize or destroy prop-

erty or take a chief as hostage. BRITISH COLUMBIA
ARCHIVES A-05958

**Survey ship** HMS *Egeria*, Esquimalt, n.d.
**Photographer: Jones Studio**
HMS *Egeria* is departing Esquimalt harbour, with the
oldest lighthouse on the coast, Fisgard Light, behind
her. The steam screw sloop of 940 tons was built in
1873 in Pembroke, Wales, and fitted out specifically
for hydrographic surveying in 1886. She arrived on
the B.C. coast in 1898, under the command of
Captain Morris H. Smythe, with orders to continue
the earlier survey work of Captains Richards and

Pender. The *Egeria* is carrying a large number of
small craft, essential for survey work around the
coast. Rock faces such as those in Bedwell Harbour
on Pender Island and Miners Bay in Active Pass still
bear the ship's name and survey mark deeply incised
in stone. MARITIME MUSEUM OF BRITISH COLUM-
BIA P.983.33.1

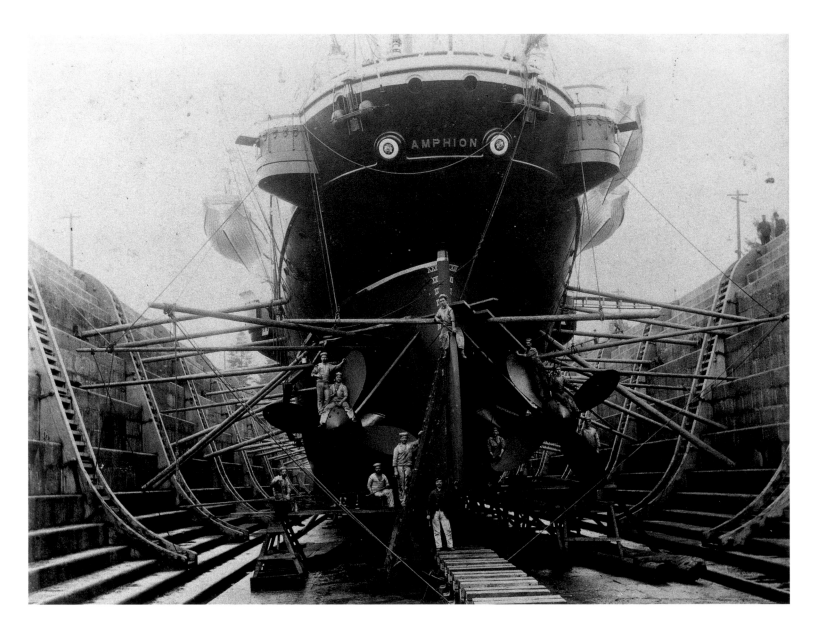

HMS *Amphion*, Esquimalt, 1889. Photographer: Richard Maynard

Richard Maynard enjoyed photographing naval ships and dockyard scenes. He took several images of HMS *Amphion* while the ship was in dry-dock, having repairs made to her hull. In this photograph, the ship seems to be sprouting both timbers and men. The timbers were positioned to hold the vessel in place while the water was pumped out of the dry-dock, as well as to prevent any movement from occurring while work was being done. Maynard has placed the crew of workers, who appear to be naval personnel, strategically around the stern of the vessel. Each of the men is holding a trademark hammer or sledge. BRITISH COLUMBIA ARCHIVES A-208

HMS *Imperieuse,* Esquimalt, c. 1895. Photographer:
Unknown
This photograph shows the main deck of HMS
*Imperieuse,* a large Protected cruiser built in 1881. The
two petty officers are supervising the maintenance of
one of her four 9.2-inch guns. She also carried ten
6-inchers, as well as six torpedo tubes mounted

above the water. The large awning covering the main
deck was normally hung when the ship was at
anchor or in port for extended periods. At 313 feet in
length and weighing 8,500 tons, she could make 16½
knots under forced draught at 10,000 horsepower.
She and her sister ship, HMS *Warspite,* were the last
armoured ships designed to be fitted with sail. The

*Imperieuse* ran her initial sea trials with a brig sailing
rig, but this proved inadequate and was replaced
with a single military observation mast amidships.
With the weight of masts and rigging reduced, the
*Imperieuse* became an efficient cruiser and made an
impressive addition to the Pacific fleet. BRITISH
COLUMBIA ARCHIVES I-51610

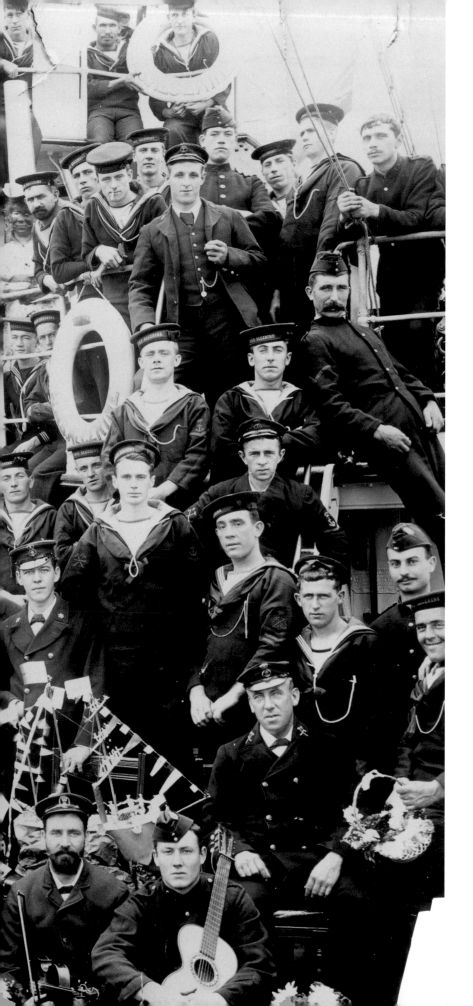

**Crew of** HMS *Algerine*, **Esquimalt, 1902.**
**Photographer: Unknown**

Even in its damaged condition, this photograph is crisp and wonderfully detailed. The obviously happy crew of HMS *Algerine* has been allowed to show off some of its talents and eccentricities for the camera. The second row from the bottom consists of the ship's officers, with the captain and his cat near the centre. The carefree and rakish postures of some of the men and the inclusion of a cardboard cutout of a Victorian lady along the top rail all indicate a lighthearted and jovial mood. Crew members have been encouraged to display their hobbies; a ship model and flower arrangements have been given prominence, and the ship's musicians are seated together on the bottom row. The *Algerine* was one of the three ships left by the British on the Pacific coast after 1908. She was lent to the Royal Canadian Navy as a depot ship and training vessel, and later was sold for use as a salvage ship in 1919. MARITIME MUSEUM OF BRITISH COLUMBIA P3279

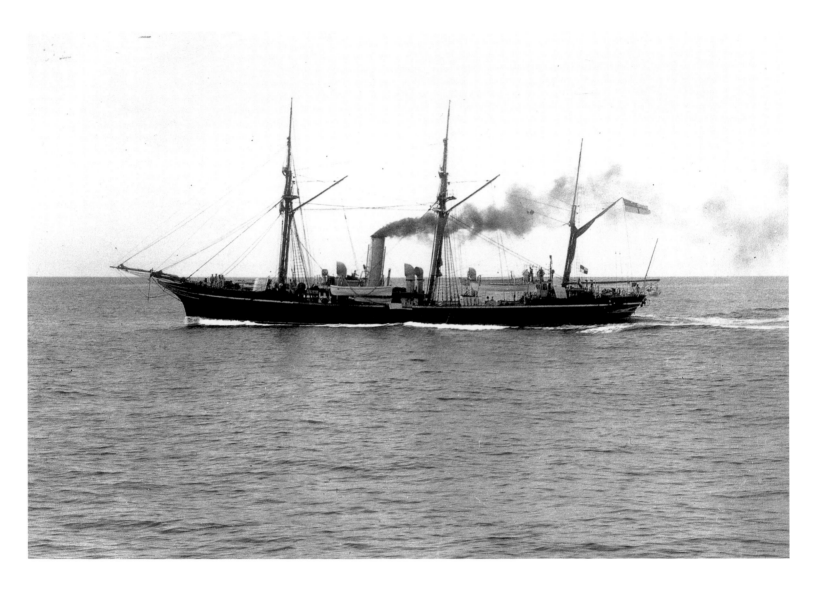

**HMS *Condor*, Victoria, c. 1901. Photographer: Unknown**

HMS *Condor* was commissioned in Britain on November 1, 1900, and sailed for the Pacific two weeks later. During this voyage, the vessel was reported to be very tender, rolling heavily in the slightest swell. Despite this apparent unseaworthiness, she arrived in Esquimalt on April 30, 1901, and took up her duties on Pacific Station. The *Condor* spent time patrolling the Pribilof Islands in the Bering Sea, as part of an international effort to protect the seal population from illegal poaching. In December of that year, she was ordered to depart for Honolulu to visit and make any necessary repairs to the grave of Captain James Cook, then to proceed to Pitcairn Island to collect the annual mail. Heavily laden with coal and supplies for the journey, the *Condor* left Esquimalt on December 2. The ship was never seen again. On January 16, she was reported overdue in Hawaii, sparking a massive search up and down the coast. An empty ship's boat was found off Vancouver Island and a life ring near the Queen Charlotte Islands. The *Condor* was presumed to have foundered in the storm of December 3 and 4, a victim of low freeboard, poor stability and wild seas. BRITISH COLUMBIA ARCHIVES C-03770

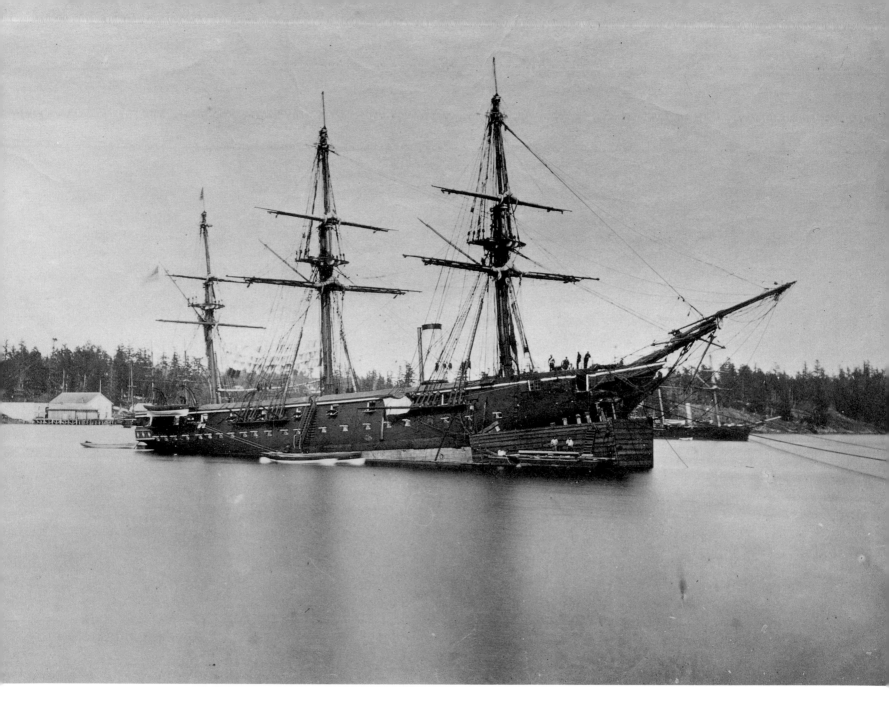

HMS *Charybdis*, Esquimalt harbour, 1870.
Photographer: Frederick Dally

On May 5, 1870, six ships of the Royal Navy's
Flying Squadron entered Esquimalt harbour and
came upon this sight. HMS *Charybdis*, the vessel in the
photograph, had hit a reef and damaged her bow.
Without the benefit of repair facilities, the crew had
been forced to improvise and, under the direction of
First Lieutenant Frederick A. Sargeant, built a

wooden box, called a cofferdam, around the bow.
"They very cleverly constructed a cofferdam for
repairing her, done entirely on board, which reflects
good credit on those concerned," noted the master
of HMS *Liverpool*, the flagship of the Flying
Squadron. On May 28, 1870, the *Charybdis* joined the
squadron and departed for England. In 1881, in an
attempt to form a Canadian Naval Defence Force,
the ageing *Charybdis* was sent to Saint John and

Halifax for use as a training ship for fishermen
recruited into the Naval Reserve. Unfortunately, the
ship was so rotten she was declared unfit for duty
and the project was abandoned. MARITIME MUSEUM
OF BRITISH COLUMBIA P.2483

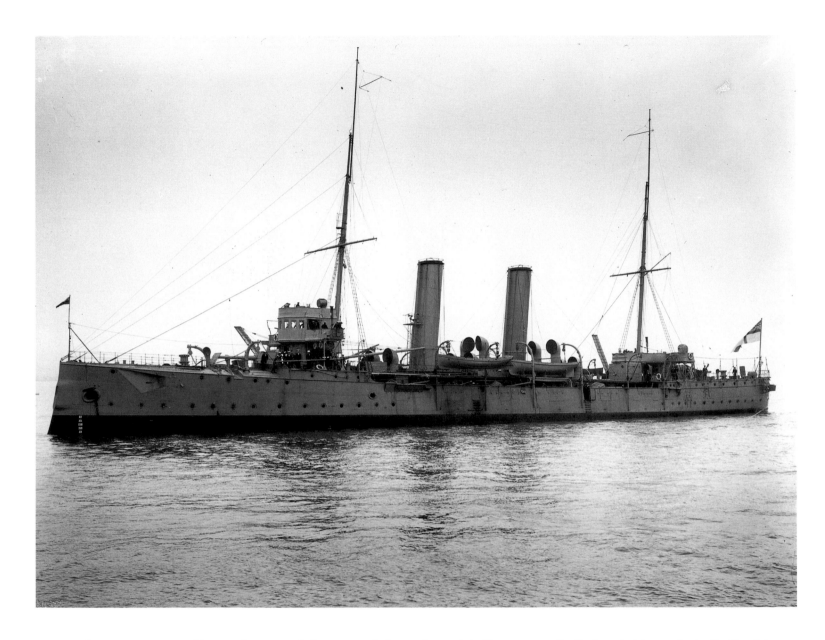

HMCS *Rainbow*, Vancouver, c. 1912. Photographer: Leonard Frank

On November 9, 1910, the naval base at Esquimalt formally passed from British to Canadian hands. Canada had reluctantly accepted responsibility for its own naval defence and formed the Royal Canadian Navy. Apart from the dry-dock and fuelling station, the base at Esquimalt had been virtually shut down in 1905 when the British consolidated the Pacific Command in Hong Kong. Two obsolete warships were bought from Britain to serve as the nucleus of the Royal Canadian Navy. HMCS *Niobe* was sent to Halifax and HMCS *Rainbow* became the first Canadian naval warship to serve in the Pacific. Launched in 1891, the Apollo Class light cruiser *Rainbow* was already seventeen years old when she entered Canadian service. The ship patrolled the west coast until the second year of the First World War, when she was retired from service. VANCOUVER PUBLIC LIBRARY 3132

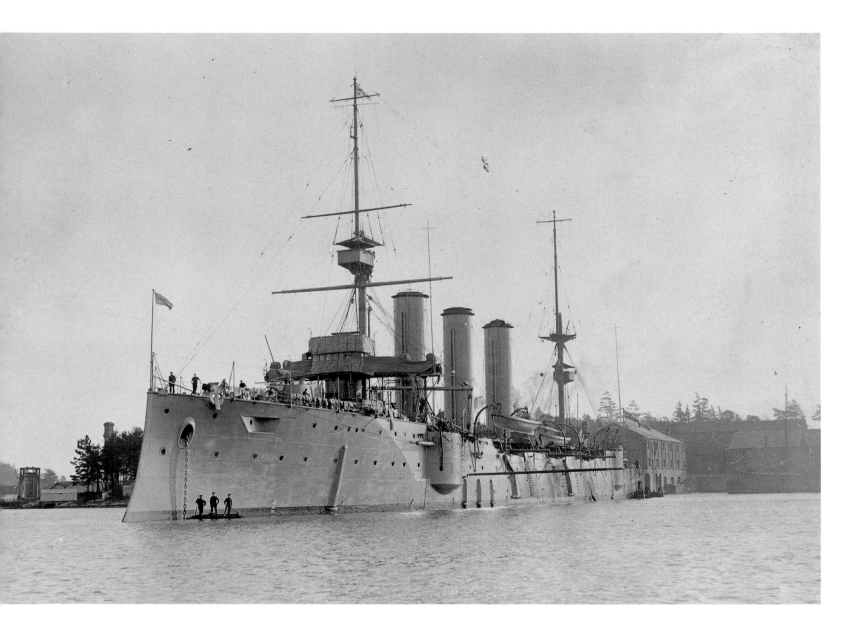

**HMS *Lancaster*, Esquimalt harbour, 1919.**
**Photographer: Unknown**

HMS *Lancaster* lies with her stern to the naval depot at Esquimalt for repairs or replenishing. She was one of ten Monmouth Class cruisers built in 1901 and 1902. These compact and heavily armoured ships, which carried fourteen 6-inch guns and two torpedo tubes, were considered an economical means of protecting Britain's trade routes. The *Lancaster* was 463 feet long, weighed 9,800 tons and had triple-expansion steam engines that produced 22,000 horsepower and moved the vessel at 23 knots. Her sister ship, HMS *Kent*, had been in Esquimalt during the First World War to have repairs made after an engagement off the Falkland Islands in which she sank the German warship *Nurnberg*. VANCOUVER MARITIME MUSEUM

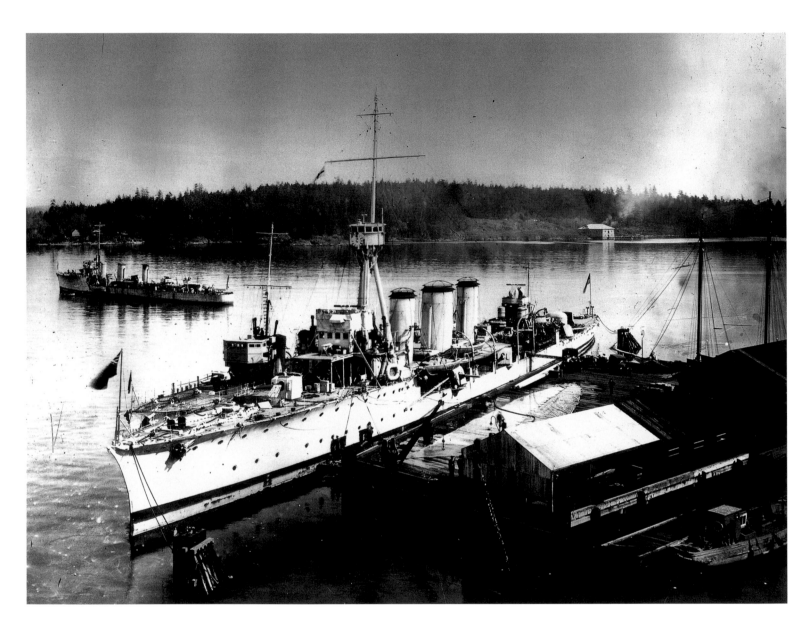

**Royal Canadian Navy, Esquimalt harbour, 1921.**
**Photographer: Unknown**

In 1920, the British government presented Canada with three ships to replace HMCS *Niobe* and *Rainbow*. While the British had hoped Canada would maintain a larger fleet for coastal protection, the Canadian government decided to keep the fleet to the pre-First World War level. The three ships, consisting of the light cruiser *Aurora* and two destroyers, the *Patrician* and *Patriot*, arrived in Halifax in December 1920. Both destroyers were used for training, the *Patrician* on the west coast and the *Patriot* on the east. Budget cuts forced the decommissioning of the *Aurora* in 1922, and the destroyers were sold for scrap in 1929. All three ships are seen here in Esquimalt in 1921 on their first training cruise from the east since arriving in Canadian waters. BRITISH COLUMBIA ARCHIVES I-51629

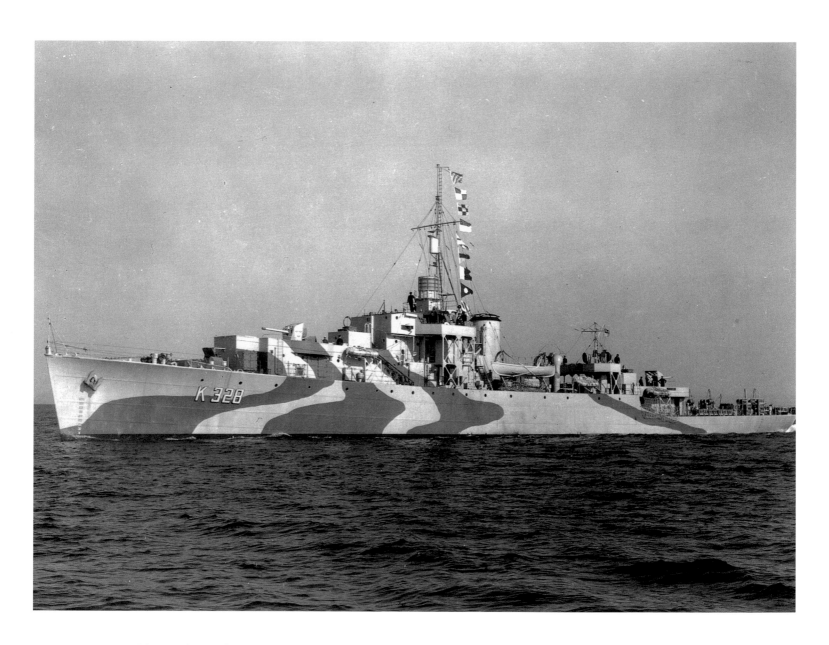

HMCS *Swansea*, c. 1943. Photographer: Unknown

HMCS *Swansea* is seen here dressed in her vivid wartime camouflage, designed to break up the vessel's lines and prevent identification. Built at Yarrows Shipyard in Esquimalt for the Royal Canadian Navy, the *Swansea* was commissioned on October 4, 1943. She was dispatched immediately to the east coast for convoy duty, arriving in Halifax on November 16. Her construction was part of the massive frigate building program begun in 1942. Yarrows built seventeen of a total of seventy River Class frigates, designed to improve upon the corvette. These frigates were longer, faster, carried more firepower and had a much greater steaming range than the corvettes, which, until then, had been the mainstay of convoy escort vessels. The *Swansea* was assigned to convoy duty out of Londonderry and assisted in the sinking of three enemy U-boats. She was also present at the D-Day invasion, where she patrolled the English Channel and provided support. BRITISH COLUMBIA ARCHIVES A-08115

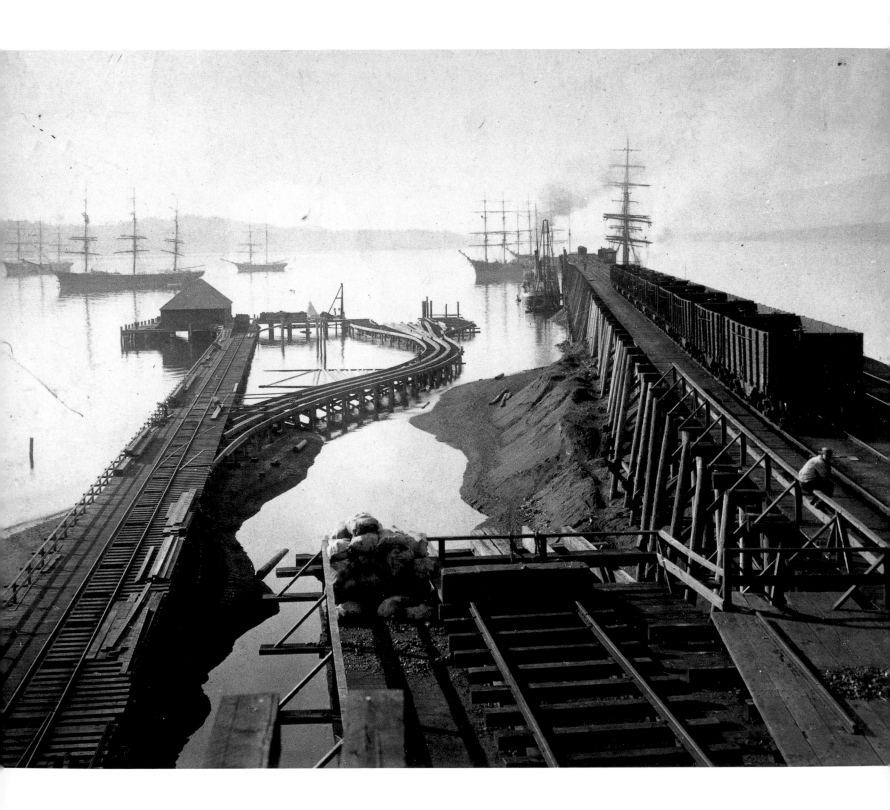

# Trade and Industry

THE PACIFIC NORTHWEST offered a wealth of resources to European newcomers. The vast tracts of virgin forests, the abundance of fish, otter, seals and whales, and the enormous mineral wealth of the region were not long left undisturbed. In 1788, the expedition led by Captain James Cook carried sea otter pelts to China and found that Chinese dignitaries would pay huge sums for them. After the publication of Cook's journals, adventurers such as William Barkley, James Strange and John Meares rushed to join the lucrative trade in furs. At its height, the fur trade to the Orient involved over forty American and British ships, as well as an undetermined number of Russian vessels.

Resources brought trade, and trade brought settlement. Britain wanted to establish supremacy in the area in the most efficacious manner possible and used a method already proven successful in the eastern part of Canada, where it had granted the Hudson's Bay Company exclusive trading rights in the area in return for the establishment of colonies. However, in the west, competitors such as the North West Company could not be excluded, and, for the early years in the development of what was to become British Columbia, trade was governed but not entirely dominated by the Hudson's Bay Company.

The discovery of coal marked the beginning of a rich history of mineral extraction. Since the coal-burning engine had become the main source of mechanical power throughout the industrial world, sources of high-grade coal were vital to economic success. The Hudson's Bay Company was the first to exploit the coal deposits found on Vancouver Island. In 1862, the HBC sold out to the Vancouver Coal and Land Company. Later, in 1871, coal tycoon Robert Dunsmuir opened the Wellington mine that became the best known colliery on the west coast. The coal from these mines found a large market in California. The British Admiralty also had great interest in the reserves on the island, since its modern fleet of coal-fired warships required reliable fuelling depots around the world.

**Coal docks at Union Bay, Vancouver Island, n.d.**
**Photographer: Unknown**
Deep-water sailing ships lie at anchor in Union Bay on Vancouver Island, awaiting their turn to load coal at the Union Colliery Company wharves. The discovery of high-grade coal on the east coast of Vancouver Island in the 1840s sparked the development of a major mining industry. The large and growing demand for anthracite coal came mainly from the cities of the west coast, which had previously imported supplies, at great expense, from the eastern United States or Europe. At the outset, the industry concentrated on surface mining, and the coal was lightered out to anchored ships by canoe and barge. As demand grew and surface sources became depleted, miners were brought in from Britain to extract the rich underground deposits and tramways and rail lines were installed to haul coal directly from the colliery to the ships. This resource and facilities attracted mercantile shipping from all over the Pacific Rim, but the major market for British Columbia coal was in the state of California.
BRITISH COLUMBIA ARCHIVES A-4577

Coal miners from Britain were brought to the colony to build the collieries and work the mines. The export of coal was a major source of revenue when the colony became a province and would continue to be so until the 1920s. By the Depression, however, most of the mines had closed, unable to compete with Alberta coal and cheap Californian and South American oil.

The forest industry grew slowly through the nineteenth century, beginning with the building of two mills near Victoria, one by John Meares and the other by the Hudson's Bay Company. Initially supplying a small domestic market, forestry grew to become the dominant resource industry. The first export of timber from the coast occurred when the early fur traders carried spars along with otter pelts to China. The influx of miners during the California gold rush of 1849 provided lumber producers with a large American export market, and the gold rush of 1858 on the Fraser River created the first substantial domestic market. Another early sawmill was opened in 1861 in Alberni by Captain Edward Stamp, a great promoter of British Columbia timber who opened up the trade to England as well as to South America and Australia. This successful mill eventually closed in 1864 because of the decline in accessible timber, and Stamp moved his operation to Burrard Inlet on the mainland. The building of the transcontinental railway brought more demand for timber, not only for railway ties and trestles but to supply the housing needs of the immigrants brought by rail to the Prairies. The industry has experienced large economic swings throughout the years but continues to be a major source of employment and revenue.

The spectacle of abundant salmon runs on the coast must have astounded the early explorers. The Native people had long used the resource as a food fishery, but the massive exploitation of the stocks did not start until the first cannery opened in 1870. The Hudson's Bay Company had exported small amounts of salt-cured salmon to the Orient and Hawaii, after the otter pelt trade had declined due to overharvesting. However, the processing method limited the extent of trade as the salmon remained perishable. The development of canning revolutionized the industry almost overnight, and soon there were canneries up and down the coast. In 1897, nearly one million cases of salmon were produced for export.

Gradually, the small, independent canneries were consolidated into large operations. Henry Bell-Irving created the first of these in 1891 when he acquired nine canneries and formed the Anglo British Columbia Packing Company Limited. In 1902, British Columbia Packers Association continued the consolidation by acquiring over forty canneries along the Fraser and up the north coast.

All these resources, aided by rail and river, found their way to seaports and the empty holds of waiting ships. As sources of revenue and employment, forestry, mines and fisheries were and continue to be dominant forces in the British Columbia economy. In spite of the change in markets for these products, shipping by sea remains an important means of transport.

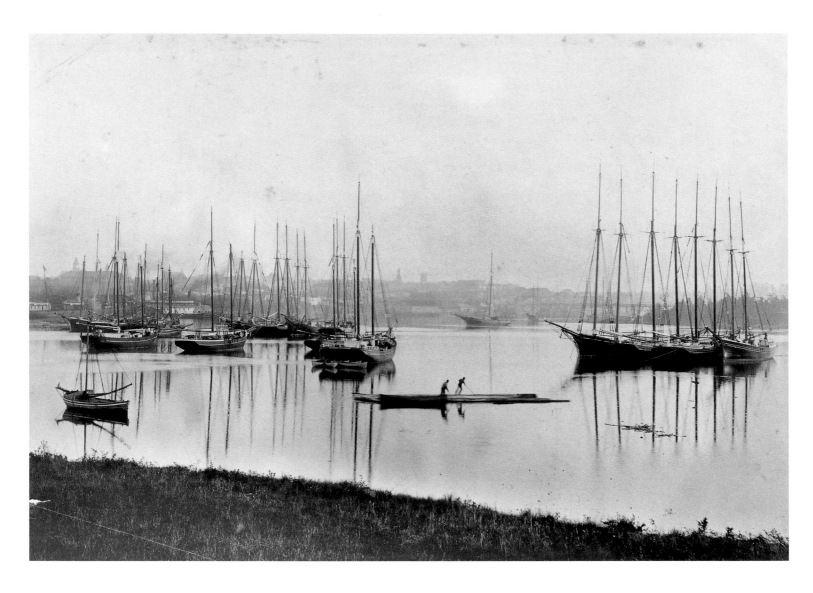

**Sealing schooners, Victoria harbour, c. 1895.**
**Photographer: Unknown**

The rich sealing grounds of the Bering Sea around the Pribilof Islands were discovered in the early nineteenth century. Market demand for seal garments grew considerably during the 1880s, and many Victoria businessmen became involved. Schooners were well suited to this kind of fishery, and a number were built locally for the purpose. Others from the east coast found their way to the Pacific to take advantage of this very lucrative, albeit rough and dangerous, trade. Victoria became the headquarters for the sealing industry on the west coast and, at its peak, had sixty-five schooners registered there. The revenue from the hunt for the years 1881 and 1891 is estimated to have had a value of approximately three million dollars. From the beginning, governments sought to control the industry by attempting to limit the catch, and the hunt often became a cat-and-mouse game between sealers and officials. However, as these efforts had proved futile and the seal population had been badly decimated, a total ban on the hunt was imposed in 1911 by international treaty, and sealing came to a close. MARITIME MUSEUM OF BRITISH COLUMBIA P 1969

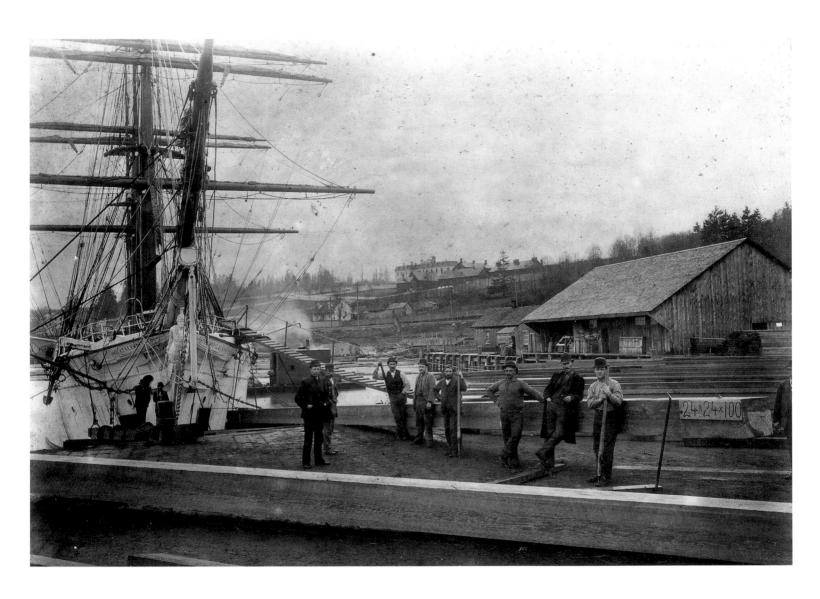

**Barque *Thermopylae*, New Westminster, 27 March 1894. Photographer: S. J. Thompson**

The former tea clipper is seen here loading timber at the Brunette Sawmill wharf in New Westminster. The *Thermopylae* was built in 1868 in Aberdeen, Scotland, for the trade with the Orient. She was an "extreme" clipper, built for speed and capable of carrying 1,390,000 pounds of tea. The ship became famous for setting records by cutting two days off the previous time on her first trip to China and by making 380 miles on one twenty-four hour run. She raced the *Cutty Sark* from China to England in 1872. Both vessels were evenly matched, but the *Cutty Sark* lost her rudder and was forced to concede. Steam-powered ships put an end to the tea clippers, and, eventually, they were sold off for other uses. The *Thermopylae* was bought by a Montreal company and registered in Victoria in 1891. She sailed out of British Columbia until 1895, carrying lumber across the Pacific and bringing rice home on the return trip. The huge, 100-foot-long unblemished timbers about to be loaded are testament to the old-growth forests on the B.C. coast. CITY OF VANCOUVER ARCHIVES BO.N.7.P.51

**Halibut fisherman, c. 1915. Photographer: Unknown**

A fisherman untangles a skate of halibut gear. A skate was a length of line made up of tarred hemp or cotton twine up to 300 fathoms long. At regular intervals along the line, shorter five-foot beckets with baited hooks were added. Two skates were usually tied together to form a groundline, which was laid out on the sea bottom with anchors and buoys at either end. Halibut was fished in waters 400 and 800 feet deep. A skate could have up to 250 hooks and had to be coiled carefully as it was brought back on board. From the early years to the mid 1930s, halibut fishing was done from small dories. It was dangerous and exhausting work, handlining big fish that sometimes weighed several hundred pounds each, a process that left open sores on the hands of the fishermen. A large halibut, brought aboard a dory, alive and thrashing, could easily break a limb or upset a boat. BRITISH COLUMBIA ARCHIVES D-07556

**Phoenix Cannery, Steveston, 1881. Photographer: Unknown**

Thousands of one-pound tins of Fraser River salmon lie stockpiled on the warehouse floor of the Phoenix Cannery in Steveston. These tins were taken to the markets of Great Britain and Europe in the holds of ships sailing around Cape Horn. The earlier trade in salmon had been limited to the shipment of salted or brined fish packed in wooden barrels. Canning began in British Columbia in the 1870s in its most primitive form, with every step of the process being done by hand. The sides and lids were cut out one at a time and soldered together over wooden molds that shaped the tin. One-pound chunks of salmon were sealed inside, leaving only a hole in the top to vent the tin when the product was boiled. The hole was then soldered up and left to cool. The process was laborious and slow, and could not begin to keep up with the huge volumes of fish being caught on the Fraser. The introduction of automated can manufacturing in the late 1890s and the invention of a butchering machine around the turn of the century considerably sped up the whole procedure. BRITISH COLUMBIA ARCHIVES A-06838

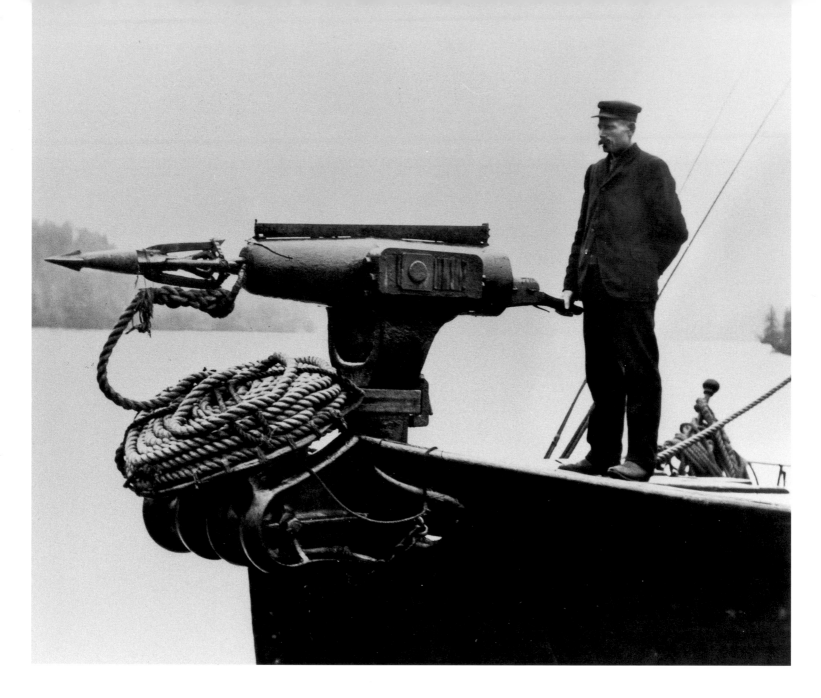

**Whaling ship *Orion*, Barkley Sound, c. 1910. Photographer: Leonard Frank**

This stark and rather formal portrait shows the harpoon gun on the bow of the steamship *Orion*. The gun, which propelled explosive-tipped harpoons, was the first of its kind on the British Columbia coast and part of a new technology employed in the hunting of whales. The *Orion* was also equipped with steam-powered winches to bring in the catch. The design of this 95-foot "chaser boat," brought over from Norway in 1905, perfectly suited the needs of west coast whale hunting. Ships such as the *Orion* were not involved in processing. After a number of whales had been killed, the carcasses would be gathered and hauled to one of the many shore stations. The first whaling station, which began operation in September of 1905, was at Sechart in Barkley Sound. Whaling continued on the coast for six decades, coming to an end in 1967 with the closing of the Coal Harbour station in Quatsino Sound on Vancouver Island. VANCOUVER MARITIME MUSEUM 2855

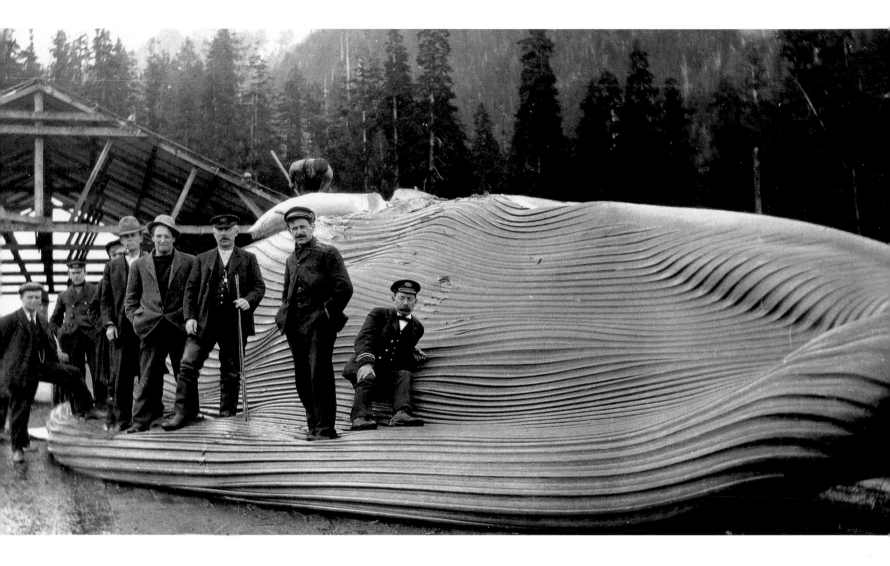

**Kyuquot whaling station, Vancouver Island, 1922.
Photographer: Unknown**

Visitors were always impressed by the immense size
of a whale and often posed for souvenir photo-
graphs beside the dead mammals. In this picture,
some crew and passengers of the CPR steamship *Tees*
pose on the belly of a blue whale at the Kyuquot
whaling station on the northern end of Vancouver
Island. Captain Townsend of the *Tees*, with his sea
boots and fishing gear, gives the impression that he
wants the viewer to think of the whale as being his

catch! The large blue whale, or "sulphur bottom" as
it was known, could reach up to 100 feet in length
and would render between fifty and eighty barrels of
oil and four to five tons of fertilizer. Its flesh would
be sold in the fresh fish market in Japan or used as
animal feed. BRITISH COLUMBIA ARCHIVES D-06010

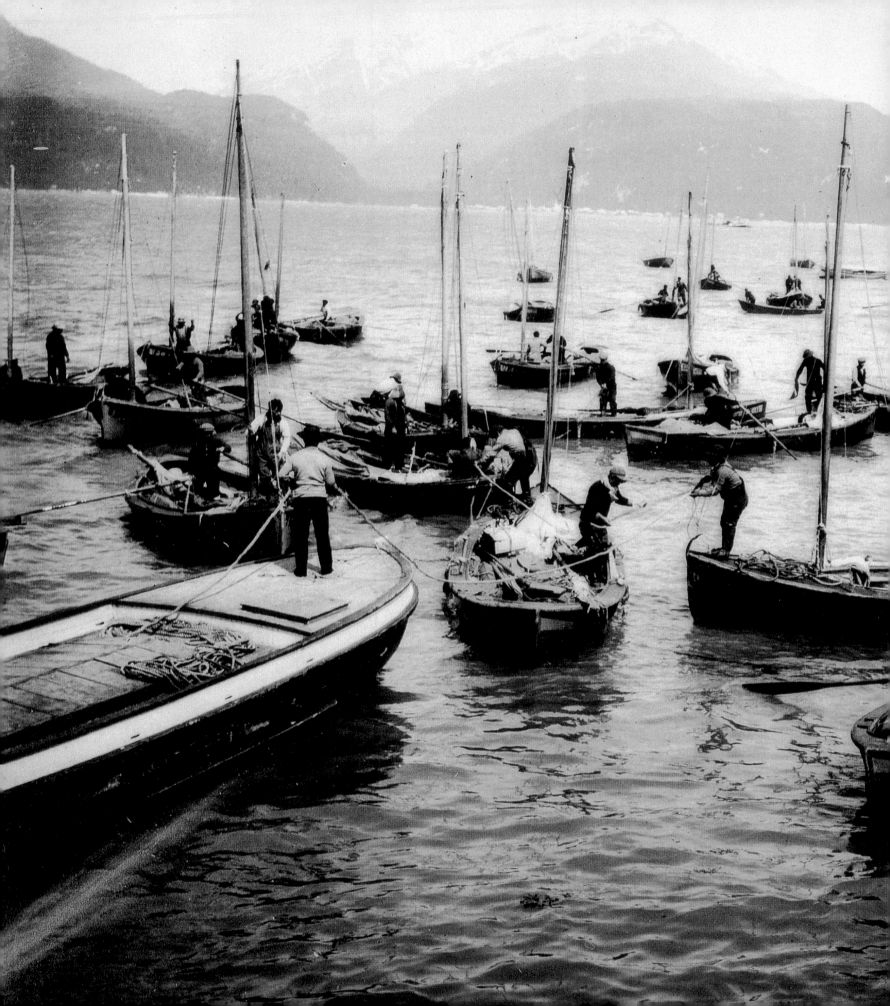

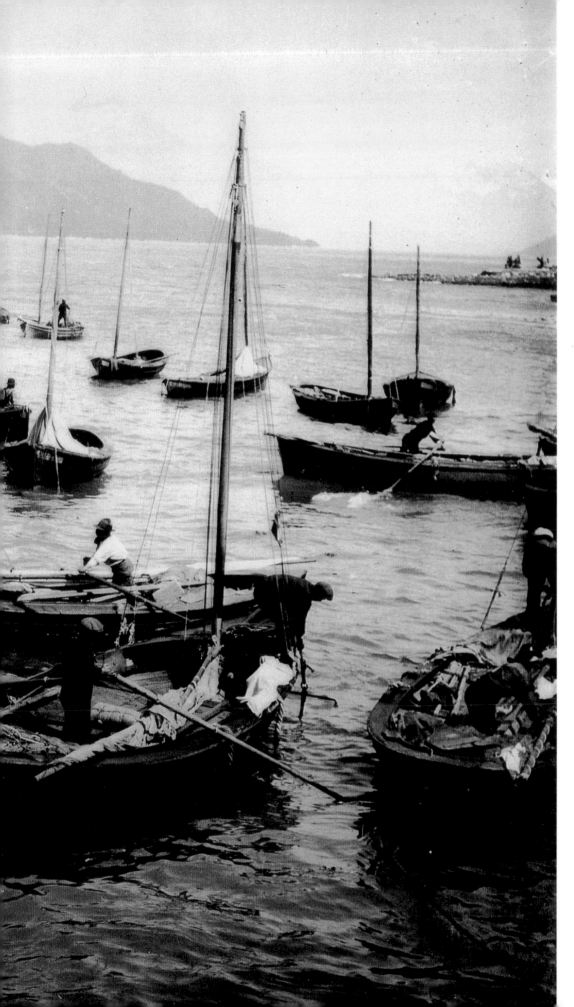

**Gillnet fleet, Skeena River, c. 1914. Photographer: Unknown**

A motorized cannery tender pays out a towline to a fleet of thirty or more Columbia River-style gillnetters on the Skeena River in northern B.C. Until the mid-1920s, gas engines were illegal in fish boats north of Cape Caution, so motorized tenders were used to pull the gillnetters out to the fishing grounds, to collect the catch and to tow the boats back in. The gillnetters were 26 feet long, powered by sail and oar, and carried a two-man crew, usually an oarsman and a fisherman. Gillnetting involved the hauling of coarse twine nets full of salmon over a small roller on the stern and was backbreaking work. Long, wet miserable hours were spent bent over the oars or tending the net, for meagre pay. Gales, fog, strong currents and hidden reefs all added danger to a gillnetter's discomfort. The boats would stay out for a week at a time, with the only amenities a small puptent in the bow for protection from the weather and a five-gallon oil can for heat and cooking. Fishing was closed on Saturday and Sunday, when the men would return to the cannery to maintain their boats and nets and to catch up on sleep before heading out again on Sunday night for the six o'clock opening. BRITISH COLUMBIA ARCHIVES E-07616

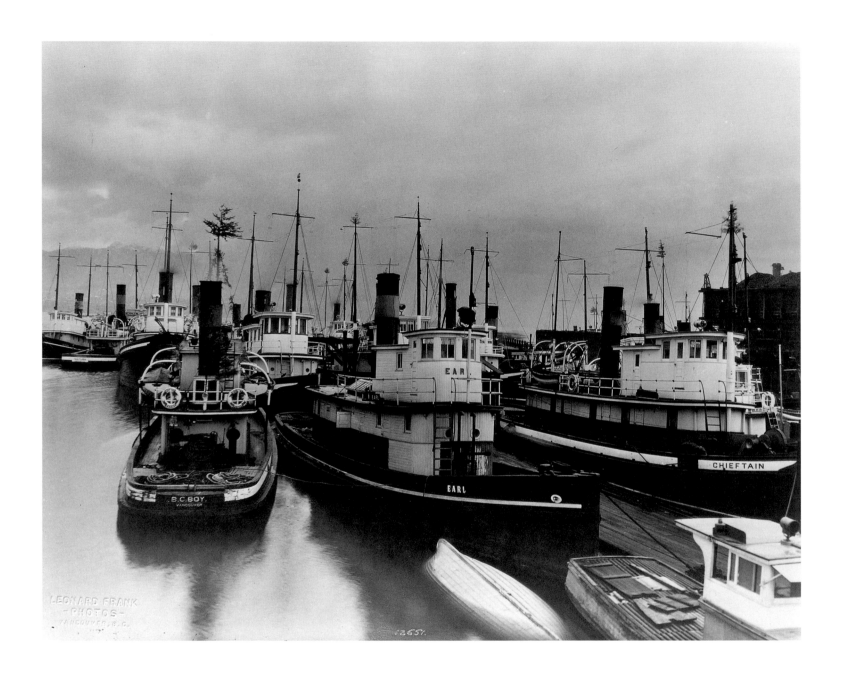

(*Facing page*) **Pacific Coyle Navigation wharves, Vancouver, c. 1930. Photographer: Leonard Frank**

This Leonard Frank photo shows about fifteen tugs belonging to Pacific Coyle Navigation Company at their Coal Harbour wharves for Christmas. According to custom, the fleet tied up for a few days at that time of year, and many of the boats carry a small tree hoisted to the masthead to celebrate the season. From the Hudson's Bay Company's *Beaver* in 1836 to the present day, the tug was and continues to be the workhorse of the British Columbia coast, a necessary part of every maritime industry. In virtually every inlet, harbour, channel and strait, tugs are at work towing booms, acting as cannery tenders, hauling equipment and supplies to remote settlements, assisting in the docking of large deep-sea ships and providing every other imaginable service. MARITIME MUSEUM OF BRITISH COLUMBIA P.985.8.5

**Drying nets, Steveston, c. 1908. Photographer: Philip Timms**

Gillnets, from a Columbia River-style fish boat, are being hung out to dry at a Steveston cannery. The nets used in the Fraser River fishery could be up to 1,800 feet in length, but were only allowed to bar one third of the river's width. The mesh size was dictated by the species of salmon to be caught. The tops of the nets were strung with cork floats and the bottoms laced with lead line. A good fisherman knew how to hang a net with just enough slack to catch fish: too loose and the net would ball up, too tight and the fish heads would not penetrate the mesh. Always subject to mildew and rot, nets were treated with great care, soaked in tubs of copper sulfate to disinfect them and treated with linseed oil to keep the line supple. VANCOUVER PUBLIC LIBRARY 2180

**Table seine boat *J14*, c. 1930. Photographer: National Film Board of Canada**

Like a necklace of pearls, the corkline of a gillnet gathers near a seine boat as the crew commences hauling the net aboard. Before the invention of the gillnet power drum in 1935, seiners had to pull in their nets by hand. The fishing process would begin with a skiff being lowered over the side to haul the net off the seine boat. The net would then be dragged behind the skiff, circling a school of salmon, before being returned to the boat to be hauled in. The revolving table located at the stern of the seine boat allowed the crew to swivel it in the direction of the haul. A large dipnet would then be lowered from the boom to brail out the catch.

VANCOUVER MARITIME MUSEUM 2243

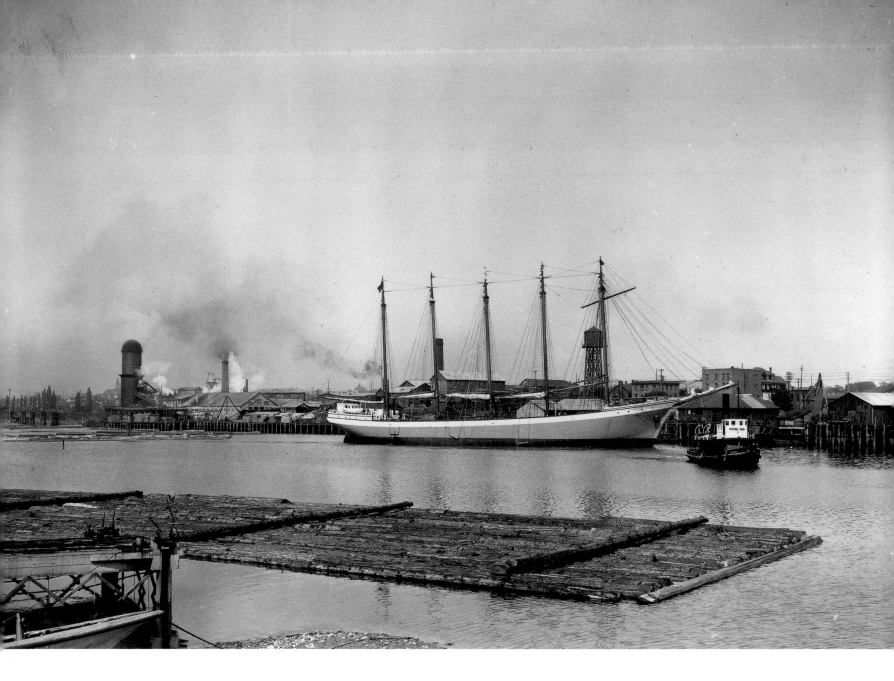

**Inner harbour, Victoria, 1917. Photographer: Unknown**

The lumber industry dominated much of Victoria harbour. Two major mills, the Canadian Puget Sound Lumber Company and the Cameron Lumber Company, are situated on either side. Flat log booms line the foreshore and smoke from a mill's burners fills the sky. These companies were major employers of Victorians. The Cameron mill, along with the Genoa Bay Lumber Mill, also established a ship-building firm, the Cameron-Genoa Mills Shipyard in the harbour. The ship in the photograph is the recently completed *Laurel Whalen*, one of six schooners built at this yard. She is being towed out either for sea trials or to a loading berth to take on a cargo of timber for Australia. BRITISH COLUMBIA ARCHIVES G-3571

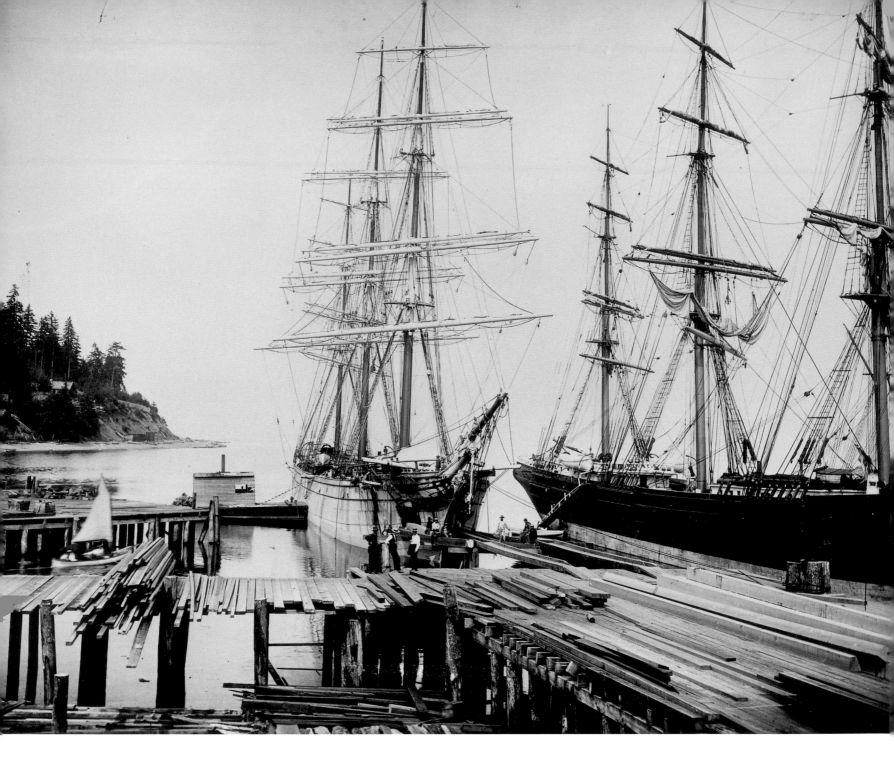

**Sailing ships, Chemainus, n.d. Photographer: Unknown**

Sailing ships load lumber at the Chemainus docks on Vancouver Island. Dozens of Chinese labourers were needed to manoeuvre the 100-foot lengths of Douglas fir from the mill and out across the rough, uneven planking of the company wharf to the waiting ships. Once the timber was near a ship, the stevedore crew would take over, loading the sawn lumber on board by means of ramps fitted up to the main deck or through openings in the bow. Earlier ships had hung block and tackle from the rigging to haul the lumber aboard, while later vessels employed small wood-fired donkey engines to provide power for loading. The local stevedore group was made up mostly of Native men from the surrounding area, who took great pride in their ability to stow record loads, larger than at any other port. The first sawmill to operate in Chemainus was opened in the early 1860s and expanded to become one of the largest operations in British Columbia. MARITIME MUSEUM OF BRITISH COLUMBIA P.4201.02

**Steamship *Stuart Dollar*, Vancouver, 1922.**
**Photographer: Leonard Frank**

The ship in the photograph is the *Stuart Dollar*, load-ing cedar shingles in Vancouver harbour in 1922. The Dollar Steamship Line of San Francisco established a branch of its operation in Victoria, in 1911, to export lumber to mainland China. The company expanded its fleet of four ships by adding to it the newest and largest merchant ships on the Pacific. In order to guarantee a constant supply of lumber, Dollar built a large sawmill in 1918 in North Vancouver at Dollarton, established a logging camp and bought up timber rights at Union Bay. The company's fortunes waned when the Depression of the early 1930s brought timber prices to an all-time low and trade with China was disrupted by the out-break of war with Japan. The mills continued in operation until 1942, when trade with China ended.

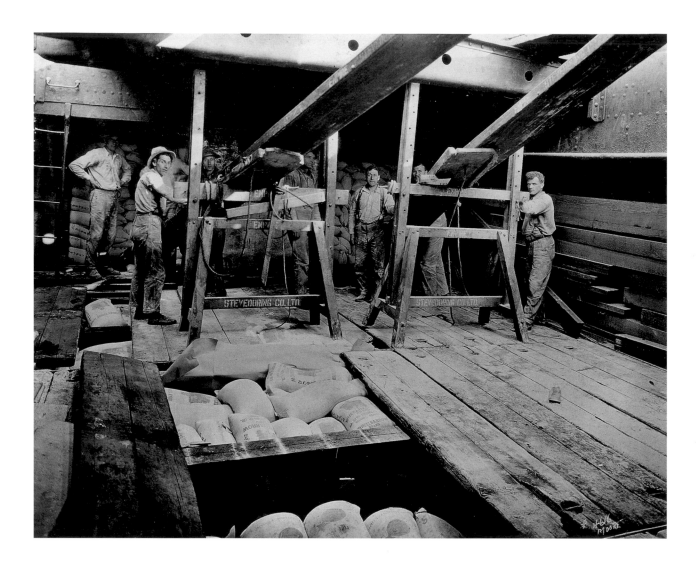

**Empire Stevedore Company Ltd., Vancouver, c. 1925. Photographer: William J. Moore**

Men at work in the hold of a deep-sea cargo ship stop their labours for a moment to pose for this informal portrait. Scenes such as this are rare, since few photographers entered the workplace. One exception was William Moore, a Vancouver commercial photographer who specialized in industrial work and documented many facets of the shipping industry; he also took a great number of panoramic views of the harbour and city. Longshoremen stowed bags of flour by hand into the ship's hold, a labour-intensive method of cargo handling that ensured plenty of employment on the docks. The hold was made up of a series of small compartments, one on top of another, that were filled and then separated by wooden floors. This allowed different cargoes to be kept apart and eliminated the possibility of shifting when the ship was underway. VANCOUVER MARITIME MUSEUM

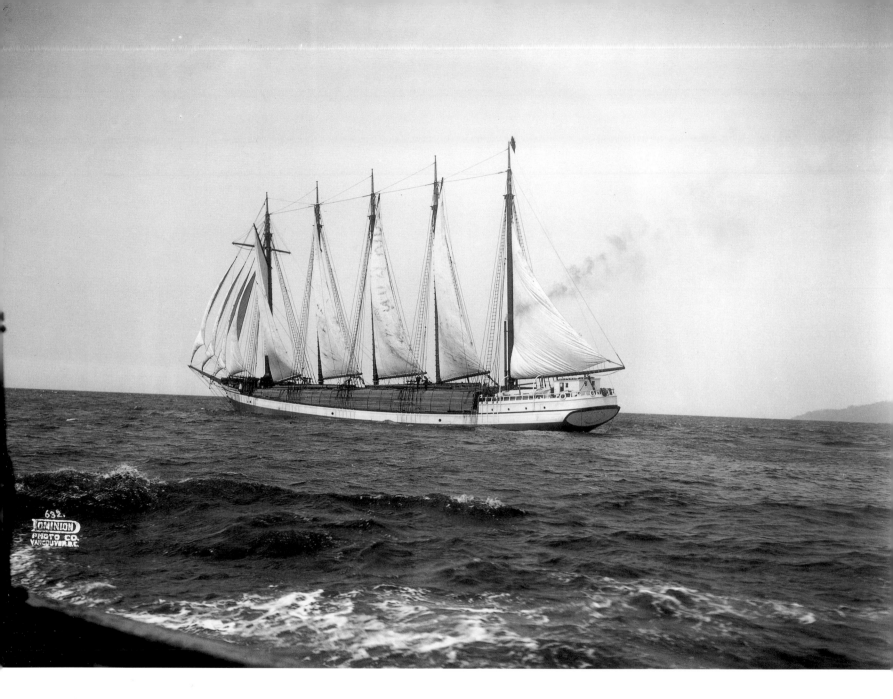

**Schooner *Geraldine Wolvin*, Vancouver, 23 May 1917.
Photographer: Dominion Photo Company**

As reported in the *Vancouver World* newspaper, the *Geraldine Wolvin*, "her snowy white sails hoisted to the breeze and her decks piled high with the pick of British Columbia forest wealth" departs on her maiden voyage to Australia. The five-masted schooner belonged to the Canada West Coast Navigation Company and was one of a small fleet of schooners built to carry lumber to foreign ports during the First World War. She was capable of transporting 1,500,000 feet of lumber, was powered by a 160-horsepower Bolinger auxiliary engine and cost approximately $150,000 to build. In peacetime, however, the fleet proved a commercial failure. The glut of ships on the world market after the war and the drop in freight rates rendered schooners such as the *Geraldine Wolvin* uncompetitive, and most were sold for scrap or used as barges. VANCOUVER PUBLIC LIBRARY 20275

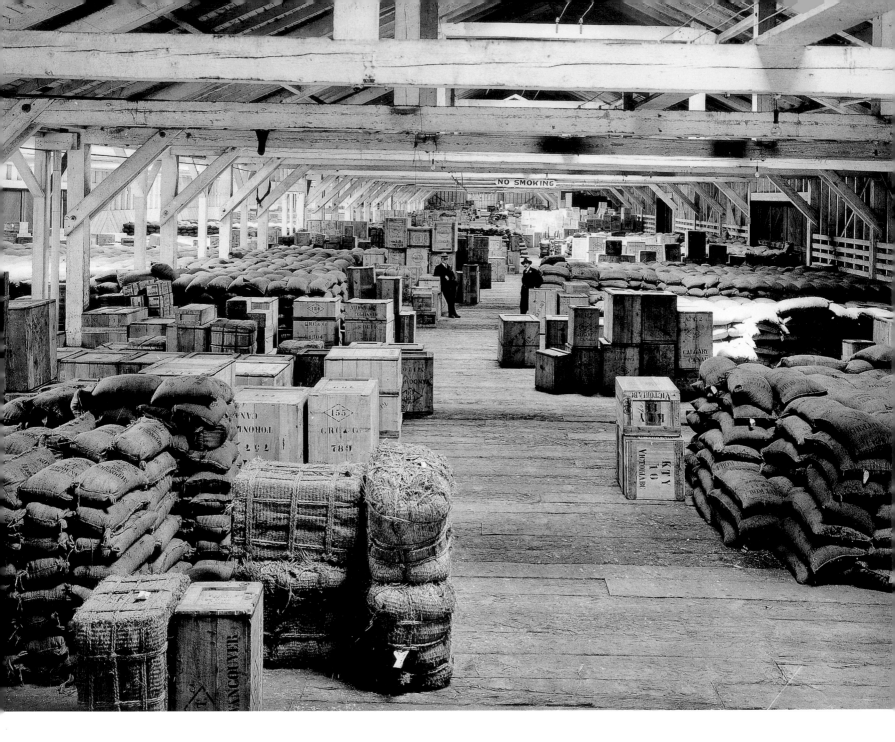

**Interior of Rithet's Pier 2, Victoria, 1930.**
**Photographer: Edgar Fleming**
This photograph, taken by Edgar Fleming of
Victoria, illustrates the variety and volume of con-
sumer goods shipped by sea from the Orient to the
west coast. Inside Rithet's freight shed at Pier 2 are
bales, bags and crates of choice Nippon rice, tea,
silk, sugar, china, spices and consignment products.
All the cargo is well marked for destinations such as
Toronto, Winnipeg, Calgary, Victoria and Vancouver.
Most products for shipment across Canada were
taken directly to Vancouver and loaded onto trains.
This shipment, however, must have been unloaded
from a ship stopping only at Victoria; the cargo
would have to be reloaded aboard a local coastal
steamer for transport to the mainland. BRITISH
COLUMBIA ARCHIVES D-01658

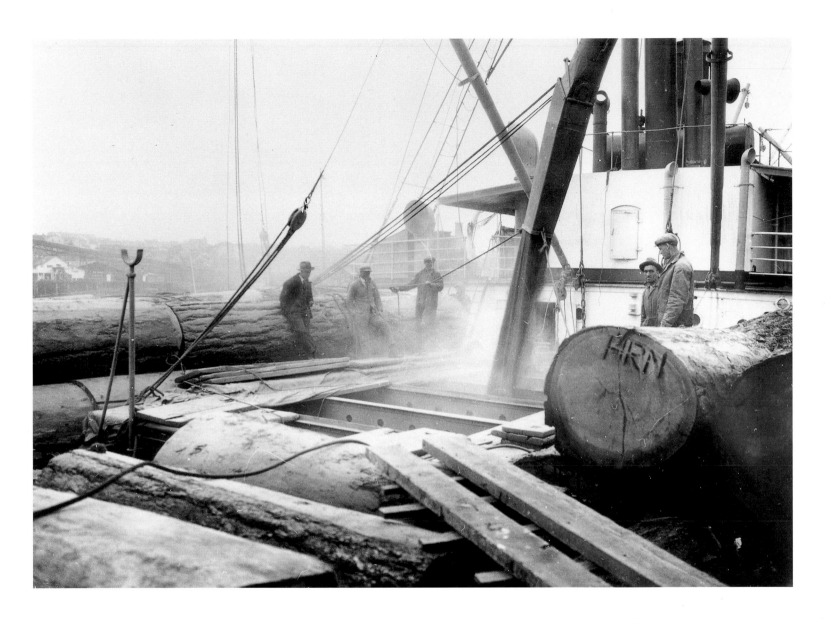

**Steamship *Panama*, Vancouver, 1927. Photographer: Leonard Frank**

Stevedores guide a stream of grain into the hold of a cargo ship in Vancouver harbour, then emerging as a major export centre. During the 1920s, the establishment of wheatpool grain elevators in the city led to a marked increase in the amount of grain shipped from the prairies to be stored in Vancouver and exported abroad. As was the common practice, all available space on board has been used to load a variety of cargo. The photograph shows large, unsawn rounds of timber stowed around the hatches on the ship's main deck. More timber will likely be stacked on top of the hatches after the grain has been loaded and the hatch boards are back in place.

*Admiralty Manual of Seamanship*, vol. 1, 2 & 3. London: Her Majesty's Stationery Office, 1964, 1967.

Appleton, Thomas E. *Usque Ad Mare*. Ottawa: Department of Transport, 1968.

Baskerville, Peter A. *Victoria: Beyond the Island*. Burlington, Ont.: Windsor Publishing, 1986.

*B.C. Studies*.

*Beaver, The*.

Bonnett, Wayne. *A Pacific Legacy*. San Francisco: Chronicle Books, 1991.

Boutilier, James A. *RCN in Retrospect, 1910–1968*. Vancouver: University of British Columbia Press, 1982.

*British Columbia Coast Sailing Directions*, vol. 1 & 2. Hull, P.Q.: Canadian Government Publishing Centre, 1987.

*British Columbia Historical News*

Brock Papers, Maritime Museum of British Columbia, Vancouver, B.C.

Burrows, James. *Port Watch, Historical Ships in Vancouver Harbour*. Vancouver: Vancouver City Archives, 1986.

Delgado, James P. *The Beaver, First Steamship on the Coast*. Victoria: Horsdal & Schubart, 1993.

Drushka, Ken. *Against Wind and Weather: The History of Towboating in B.C.* Vancouver: Douglas and McIntyre, 1981.

Drushka, Ken. *HR, A Biography of H.R. MacMillan*. Madeira Park, B.C.: Harbour Publishing, 1995.

Gibbs, Jim. *Pacific Square Riggers*. Seattle: Superior Publishing Co., 1969

Gough, Barry M. *Gunboat Frontier, British Maritime Authority and the Northwest Coast Indians, 1846–90*. Vancouver: University of British Columbia Press, 1984.

Gough, Barry M. *The Royal Navy and the Northwest Coast of North America 1810–1914*. Vancouver: University of British Columbia Press, 1971.

Graham, Donald. *Keepers of the Light*. Madeira Park, B.C.: Harbour Publishing, 1985.

Graham, Donald. *Lights of the Inside Passage*. Madeira Park, B.C.: Harbour Publishing, 1986.

Greenhill, Ralph, and Andrew Birrell. *Canadian Photography 1839–1920*. Toronto: Coach House Press, 1979.

Falconer, John. *Sail & Steam: A Century of Seafaring Enterprise 1840–1935*. Middlesex: Penguin Group, 1993.

Forester, Joseph E., and Anne D. *Fishing—British Columbia's Commercial Fishing History*. Saanichton, B.C.: Hancock House Publishers Ltd., 1975.

Hacking, Norman R. Early Marine History of British Columbia. Unpublished essay, University of British Columbia, Vancouver, B.C., 1934.

Hacking, N. R., and W. K. Lamb. *The Princess Story*. Vancouver: Mitchell Press Ltd., 1974.

*Harbour and Shipping*.

Harper, S. Triggs. *Portrait of a Period: A Collection of Notman Photographs*. Montreal: McGill University Press, 1967.

Henry, Tom. *The Good Company: Union Steamship*. Madeira Park, B.C.: Harbour Publishing, 1994.

James, Rick. "From Heroes to Hulks," *Victoria Times Colonist*, 19 October 1997, pp. c8-9.

James, Rick. "Staying Afloat: Saving B.C.'s Lumber Industry by Shipbuilding." *B.C. Historical News* (fall 1996): 17–20.

James, Rick. "Wooden Warships," *Victoria Times Colonist*, 22 December 1996, p. c8.

Jupp, Ursala. *Home Port Victoria*. Victoria: Morris Printing, 1967.

Koltun, Lilly. *Private Realms of Light, Amateur Photography in Canada 1839–1940*. Markham, Ontario: Fitzhenry and Whiteside, 1984.

Leacock, Stephen, and Leslie Roberts. *Canada's War at Sea*, vol. 1 & 2. Montreal: Alvah M. Beatty, 1944.

Leonoff, Cyril E. *An Enterprising Life, Leonard Frank Photographs 1895–1944*. Vancouver: Talon Books, 1990.

Longstaff, Major F. V. *Esquimalt Naval Base—A History of Its Work and Its Defenses*. Vancouver: Clark & Stuart Co. Ltd., 1941.

Lubbock, Basil. *The Last of the Windjammers*, vol. 1 & 2. Glasgow: Brown, Son & Ferguson, Ltd., 1927, 1929.

Marine Retirees Association. *A History of Shipbuilding in British Columbia*. Vancouver: College Printers, 1977.

Mattison, David. *Camera Workers—The British Columbia Photographers Directory 1858–1900*. Victoria: Camera Workers Press, 1985.

Mattison, David. *Camera Workers—The British Columbia Photographic Directory 1901-1950* (work in progress).

Mattison, David. *Eyes of a City, Early Vancouver Photographers 1868–1900*, Occasional Paper No. 3. Vancouver: Vancouver City Archives, 1986.

MacBeth, Jack. *Ready, Aye, Ready, An Illustrated History of the Royal Canadian Navy*. Toronto: Key Porter Books, Toronto: n.d.

Macpherson, Ken, and John Burgess. *The Ships of Canada's Naval Forces 1910–1981*. Toronto: Collins Publishers, 1981.

Meggs, Geoff, and Duncan Stacey. *Cork Lines and Canning Lines: The Glory Years of Fishing on the West Coast*. Vancouver: Douglas and McIntyre, 1992.

Murray, Peter. *The Vagabond Fleet*. Victoria: Sono Nis Press, 1988.

Newell, G. R. *The H. W. McCurdy Marine History of the Pacific Northwest 1895–1965*. Seattle: Superior Publishing Co., 1966.

Newell, G., and J. Williamson. *Pacific Lumber Ships*. Seattle: Superior Publishing Co., 1959.

Newell, G., and J. Williamson. *Pacific Tugboats*. Seattle: Superior Publishing Co., 1957.

Olsen, W. H. *Water over the Wheel*. Chemainus, B.C.: Chamber of Commerce, 1981.

Ormsby, Margaret. *British Columbia, A History*. Toronto: Macmillan of Canada, 1958.

Patterson, T. W. *Hellship*. Langley, B.C.: Stagecoach Publishing Co., 1974.

Pethick, Derek. *S.S. Beaver: The Ship That Saved the West*. Vancouver: Mitchell Press Limited, 1970.

*Resolution, Journal of the Maritime Museum of British Columbia*.

Rodgers, Fred. *Shipwrecks of British Columbia*. Vancouver: J. J. Douglas, 1973.

Rushton, Gerald. *Echoes of the Whistle: An Illustrated History of the Union Steamship Co.* Douglas and McIntyre, Vancouver: 1980.

Rushton, Gerald. *Whistle Up The Inlet: The Union Steamship Story*. Vancouver: Douglas and McIntyre, 1974.

Schwartz, Joan M. "The Past in Focus: Photography and British Columbia, 1858–1914." *B.C. Studies* 52:5-15.

Scott, R. Bruce. *Barkley Sound*. Victoria: Fleming Review Printing Ltd., 1972.

Taylor, G. W. *The Shipyards of B.C., The Principal Companies*. Victoria: Morris Publishing, 1986.

Taylor, G. W. *Timber, History of the Forest Industry in B.C.* Vancouver: J. J. Douglas, 1975.

Touchie, Rodger. *Vancouver Island: Portrait of the Past*. Vancouver: J. J. Douglas, 1974.

Turner, Robert. *Logging by Rail: The British Columbia Story*. Sono Nis Press, Victoria: 1990.

Turner, Robert. *The Pacific Empresses*. Victoria: Sono Nis Press, 1981.

Turner, Robert. *The Pacific Princesses*. Victoria: Sono Nis Press, 1977.

Turner, Robert. *Vancouver Island Railways*. San Marino, CA: Golden West Books, 1973.

*Vancouver World*.

*Victoria Daily Colonist*.

*Victoria Daily Times*.

*Victoria Times Colonist*

Webb, Roland. *Yarrows Ltd. and Burrard Dry Dock & Shipbuilding Ltd. Yard Hull Numbers*. Maritime Museum Notes. Victoria: Maritime Museum of British Columbia, 1993.

Weinstein, Robert A. *Tall Ships on Puget Sound: The Marine Photographs of Wilhelm Hester*. Seattle: Universtiy of Washington Press, 1978.

Wilks, Claire Weissman. *The Magic Box: The Eccentric Genius of Hannah Maynard*. Toronto: Exile Editions Ltd., 1980.

Wright, E. W. *Lewis and Dryden's Marine History of the Pacific Northwest*. New York: Antiquarian Press Ltd., 1961.